A Celebration of Scottish Landscape
PAINTERS *of* SCOTLAND

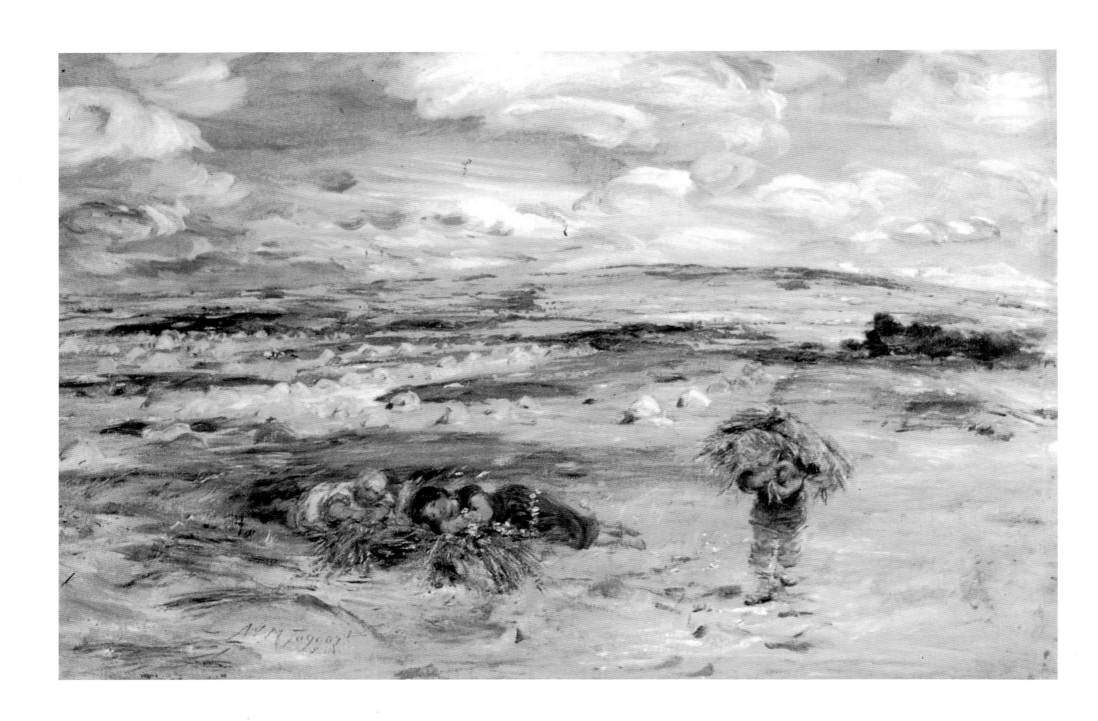

A Celebration of Scottish Landscape
PAINTERS *of* SCOTLAND

VIVIENNE COULDREY

Thomas & Lochar

Frontispiece *Hayfield, **Broomieknowe**, William McTaggart, c. 1890 (Kirkcaldy Museum and Art Galleries)*

British Library Cataloguing in Publication Data
Couldrey, Vivienne
Painters of Scotland: Celebration of
Scottish Landscape
I. Title
759.2911

ISBN 1-85877-003-3

Edited by Faith Glasgow
Designed by Michael Head
Typeset by XL Publishing Services, Nairn
Printed in Hong Kong
For Thomas and Lochar, PO Box 4, Nairn IV12 4HU

CONTENTS

ACKNOWLEDGEMENTS

In setting out to write this book, looking at Scotland through the eyes of the artists who painted it and aiming to introduce Scottish artists to a wider public, I have turned to the experts on Scottish art past and present, to those now working in museums and art galleries, to those who have organised exhibitions and to those who have written art books. A great deal of work has been done to document Scottish art in recent years and I have been able to rely on the expert knowledge of the specialists. Their cooperation with the project has reinforced my own enthusiasm to proclaim the brilliance of Scottish artists beyond the borders of Scotland.

I have been greatly helped in making a representative selection of the artists and their paintings to include in the book. The fact that there are many other outstanding artists it has not been possible to include, for reasons of space or because their pictures are not available for reproduction, only emphasises what a rich vein of creative talent there is in Scottish art.

I would like to thank particularly those who have given permission for paintings from private collections to be reproduced in this book; the directors of Robert Fleming Holdings Ltd for their permission to reproduce many paintings from the Fleming Collection, and Bill Smith who looks after the collection; Patrick Bourne of Bourne Galleries, Edinburgh, for his assistance in locating sites of paintings; the directors of the Clydesdale Bank for their permission to reproduce paintings from their collection; Ewan Munday of Glasgow Galleries for his expert advice and assistance; Guy Peploe of the Scottish Gallery and Bill Bruce of the Mainhill Gallery; Gilly Kinloch for her expert organisation; and Vere Littleton for his generous help and support. My thanks to Guy Booth for providing the art map of Scotland.

I would also like to acknowledge my thanks to Sarah Colegrove and Kate Macdonald of Sotheby's for their patience in obtaining permission for use of pictures, Helen Smailes of the National Gallery of Scotland, Dr Patrick Elliott of the Scottish National Gallery of Modern Art, David Patterson of the City Art Centre, Robin H. Rodger of Perth Museum and Art Gallery, Winnie Tyrrell of the Burrell Collection, Glasgow, Anna Robertson of Dundee Gallery and particularly Vicki Seymour of Kirkcaldy Museum, Fife.

Touring Scotland to discover the places the Scottish artists painted, I am grateful to John Booth who took the majority of the photographs of the locations, to Roslyn Baxter for assistance with picture research, and to members of the Baxter family for their help and hospitality. Many experts and enthusiasts for Scottish painting encountered along the way, for example Douglas Gray of Brig' o' Turk, illumined the scene and made the trip richly enjoyable. I hope they will enjoy the book.

INTRODUCTION

It is well known that Scotland has some of the most beautiful scenery in the world, but the Scottish artists who have painted it are not well known. The familiar image of Scotland lives through its tumultuous history of besieged castles and warring clans, through its writers, Walter Scott, Robert Burns, John Buchan and Robert Louis Stevenson, and through its sporting connections – shooting, deerstalking, fishing, skiing, golf.

Yet the fine scenery has inspired generations of Scottish painters to rise to the challenge of capturing it on canvas. They are not alone; the Highlands in Victorian times attracted English painters of all ranks and abilities, from amateurs (including Queen Victoria) to major figures such as Turner, Millais and Landseer. In this century, however, the landscape has been left to the Scottish artists who have celebrated it with strength and colour.

So who are they then, these Scottish artists? Which areas did they portray? Where did they work, and where is the record of their achievements in landscape? Despite the efforts of scholars and the existence of many fine collections, Scottish painters seem curiously undervalued. Visitors to Scotland, even those familiar with the country, cannot readily name its outstanding artists or the landscapes they painted.

The aim of this book is to introduce the landscape painters of Scotland to a wider public, to outline their story, to follow in their footsteps around the country, to discover the places they discovered. The exact sites have been identified with photographs wherever possible, to show how much the landscape has changed or how much it has stayed the same. These photographic records also give an idea of how heightened and personal is the artist's view of the scene and how much more a work of art can convey in emotion and atmosphere.

The accomplishments of Scottish artists have not been given their due south of the border, and have rarely been trumpeted abroad. Even in Scotland itself, the recognition by critics and appreciation by the public has been slow coming, the support at times crucially lacking. Fortunately there is a tenacity about Scottish artists that makes them thrive on opposition, and increase their efforts and resolve. The national characteristic has served them well. If they could not find recognition and earn a living in Scotland, they went to London; if they could not get their work accepted by the Edinburgh art academy, they would start an academy in Glasgow; if the teaching in their opinion was old-fashioned and out of touch with European art movements, then they would go and study in Paris.

They made good in a hostile environment, often in exile, but they always came back to Scotland sooner or later, like the salmon, returning to their birthplace to paint the Scottish landscape.

As a result they developed a cosmopolitan outlook. They weren't confined and limited as artists often were in England, where hostility to new European art movements was endemic; yet their artistic base remained Scottish. They understood the nature of its landscape, the cultivation and habitation of man set against the expanses of untamed nature, the windswept hills and water, the loneliness of its empty spaces. They captured the spirit of the land, the struggle for survival against harsh forces; and they caught the melancholy that often pervades it, the brooding sense of its history. In painting the landscape they brought something of themselves to it, not simply depicting what they saw before them but conveying their own reaction, their own emotion, heightening it for those who came later.

Landscape painting in Scotland has seen some great achievements. William McTaggart, working at Kintyre, filled his painting with sunlight, conveying the transience of light and atmosphere, the fresh-ness of the open air, the changing moods of northern seas and skies that is essentially Scottish, in his own personal impressionist style. The group of painters given the name of the Glasgow Boys developed their work along wholly new lines of social realism in rural landscapes, with tonal harmonies and new decorative effects. The group called the Scottish Colourists responded to the vibrant colours and brilliant light of the south of France and the style of the French painters, and returned to Scotland with the light of revelation in their eyes to paint their native scenery in terms of colour. Painters of more recent years have startled the public by seeing the landscape in a completely new and abstract way, evoking the mood of a place rather than its reality.

What is apparent to anyone who looks at the work of the Scottish painters for any length of time is that its strength lies in colour. It is colour that has brought about a revolution in Scottish landscape painting this century. Gone are the gloomy glens and the forbidding grandeur of the mountains, melancholy with mists and the sadness of the past, cold with the chill of the northern light. This powerful sense of colour is seen not in strong mediterranean contrasts of light and dark but in a merging of colour richness like blends in a tweed or a tartan: the rich plum red of the sandstone rock of the far north, the deep mysterious greens of the forests, the soft purple of mountain shadows, the pale sands of the western isles, the dark glitter of the lochs, the subtle seasonal shades of the moors, the intensely blue skies of the east coast, the constantly changing greens and greys of the Atlantic coast, the sparkling chiaroscuro of the seas.

To see the magnificent Scottish scenery through the eyes of its artists over the last two centuries is to see a fascinating development in art and a change in the way landscape is viewed. The style changes from classical to romantic and literary, from Victorian to modern, from Impressionist to

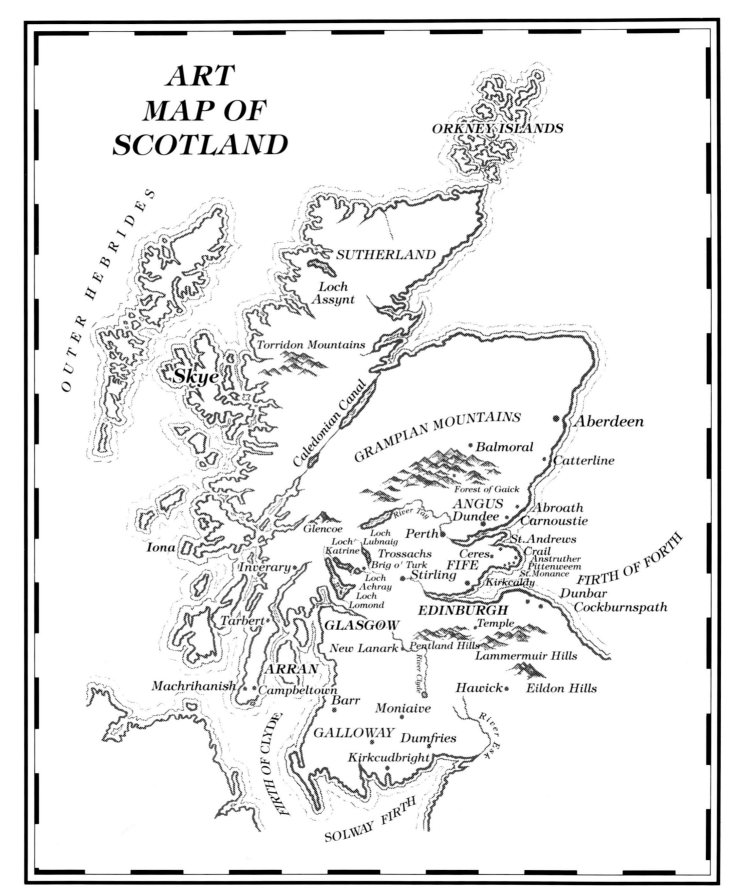

ART
MAP OF
SCOTLAND

ORKNEY ISLANDS

OUTER HEBRIDES

SUTHERLAND

Loch
Assynt

Torridon Mountains

Skye

Caledonian Canal

GRAMPIAN MOUNTAINS

Aberdeen

Balmoral

Catterline

Forest of Gaick

ANGUS
Dundee

Abroath
Carnoustie

River Tay

Glencoe

Loch
Lubnaig

Perth

St.Andrews

Iona

Loch
Katrine

Trossachs

Ceres

Crail
Anstruther
Pittenweem
St.Monance

Inverary

Brig o' Turk

FIFE

FIRTH OF FORTH

Loch
Achray
Loch
Lomond

Stirling

Kirkcaldy

Dunbar
Cockburnspath

EDINBURGH

Tarbert

Temple

GLASGOW

New Lanark

Pentland Hills

Lammermuir Hills

ARRAN

River Clyde

Hawick

Eildon Hills

Machrihanish

Campbeltown

Barr

Moniaive

GALLOWAY

Dumfries

River Esk

Kirkcudbright

FIRTH OF CLYDE

SOLWAY FIRTH

Expressionist, Fauvist, Cubist, Abstract. Sometimes the landscape itself has changed. But the mountain peaks that tower in the romantic paintings of Horatio McCulloch in the 1840s are recognisable in the spare style of D.Y. Cameron ninety years later; the waves coming off the North Sea are still as fearsomely impressive in the work of William McTaggart in 1883 as in that of Joan Eardley in the 1950s; Loch Katrine is not quite as mysterious as when John Knox illustrated *The Lady of the Lake* for Walter Scott in 1820, but Iona is still as lonely as when S.J. Peploe and F.C.B. Cadell painted there in the 1920s.

Ever since Victorian times, when industrialisation spread in England and Wales and the lowlands of Scotland, people have felt a longing to escape from the cities and a nostalgia for the natural rural scene. Today, more than ever, with the pressures of city stress and the blight of pollution, there is a deep desire for the peace and beauty of the countryside and people look to Scotland for it. The Scottish landscape has not been spoilt by the many thousands of tourists who come every summer; its remote places are still peaceful and empty. But the commercial planting of tracts of coniferous forests in so many areas must be criticised. Apart from its detrimental effect on wildlife, the spreading blanket of dark green forest gives a deadening uniformity to the scenery; it has added to the problem that some artists have encountered in Scotland that there is just 'too much green'.

Places discovered by artists, when they leave the studio and teachers behind and head out into the countryside with their easels and paints, have frequently become popular with everyone else. In Barbizon and the Forest of Fontainebleau, the artists painting under their umbrellas were an attractive part of the scene for the daytrippers from Paris. St Ives' reputation as an artists' paradise has attracted streams of visitors.

The haunts of artists in Scotland are not so well known, but they are not on the whole inaccessible, for young artists with limited means could not afford to travel far from Edinburgh or Glasgow. Tarbert in Kintyre has the soft light and beautiful views down Loch Fyne, enough to make anyone long to take up a paintbrush; St Monance on the Fife coast still possesses the picturesque appeal that attracted William Gillies to paint there; and Kirkcudbright in Galloway has a sleepy charm that draws artists in force.

Scottish artists are winning wider recognition now. It has been realised that, working independently, they have frequently moved ahead of those in England, particularly in landscape. They made a strong showing in the *Landscape in Britain* exhibition at the Hayward Gallery, London, in 1983, although they were almost excluded from the Royal Academy exhibition *British Art in the Twentieth Century* of 1987.

Art collectors have taken a great interest in their work in recent years and the prices at which their canvases change hands at auction have shown a steady increase. Some fine private collections of Scottish paintings have been built up by business and banking firms as well as by individuals. In addition to the collections in the major museums and galleries in Edinburgh, Glasgow, Perth, Aberdeen and Dundee, there are collections in smaller, less obvious places. In Kirkcaldy, for example, the town art gallery has benefitted from the collection of John Waldegrave Blyth.

Blyth was the kind of collector to whom Scottish art owes much, one of that breed of wealthy Scots businessmen and industrialists who put their wealth into their art collections. From 1909, working through the outstanding dealers of the time, Alexander Reid in Glasgow and Aitken Dott in Edinburgh, often adamant and determined in his love of paintings and in his taste, Blyth supported the artists in the face of severe criticism. He filled his house with pictures – McTaggarts in the dining room, Peploes in all the bedrooms – until every available space was occupied; then he loaned pictures to the Kirkcaldy Art Gallery, where visitors can enjoy seeing them today.

Industrial benefactors and collectors have played an important part in the story of Scottish landscape art; so too have the leading teachers and dealers. But the development of Scottish painting is above all a tribute to the vitality of individual artists who, through their efforts and their talents, have taken it from obscurity to the forefront of European artistic development. Scotland has every right to be proud of her landscape artists.

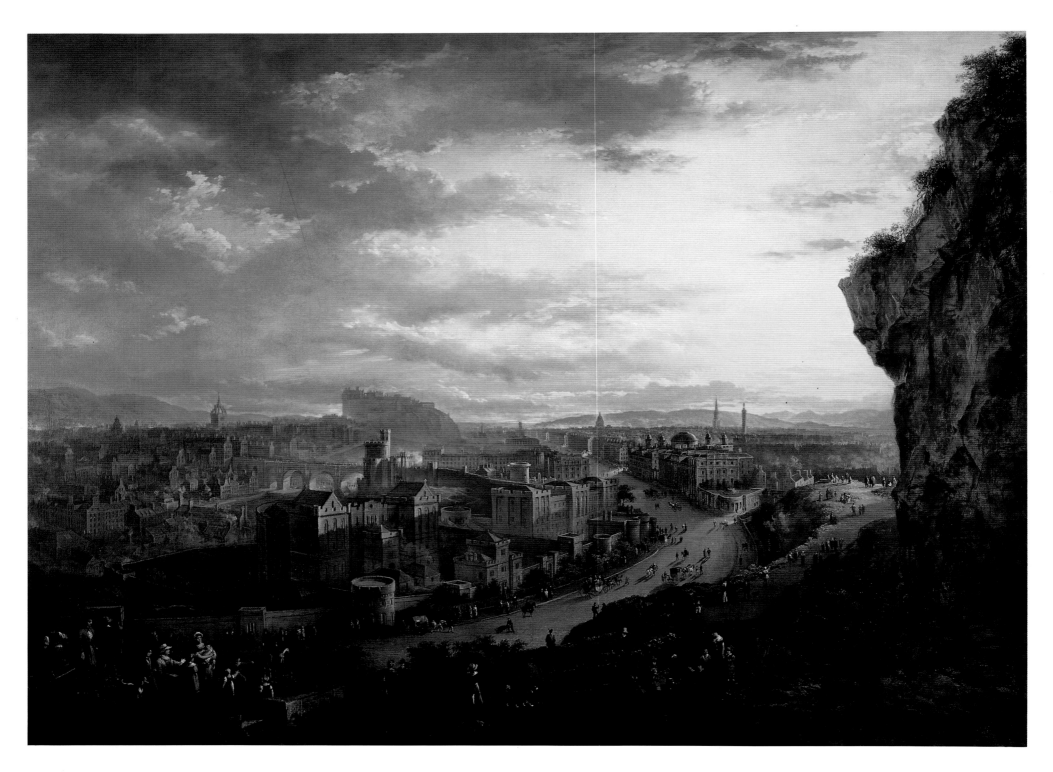

Edinburgh from Calton Hill, *Alexander Nasmyth, 1825*
(Clydesdale)

CHAPTER ONE

LAND OF COLOUR

If Italy is the land of light, Scotland is certainly the land of colour.

JOHN MacWHIRTER

THE story of Scottish landscape painting begins in a golden era that became known as the age of enlightenment in Scotland, the end of the eighteenth century. The battle for independence as a nation had been lost, but out of that turbulent time and all its spiritual and political upheavals came an upsurge of cultural and intellectual excitement in its place.

It centred upon Edinburgh, which became one of Europe's leading cultural cities, a place where philosophers, scientists, writers, painters and poets worked together and inspired each other in a free exchange of ideas. It brought forth the great men of Scotland – David Hume, Adam Smith, Walter Scott, Robert Burns – and among them Allan Ramsay, the first Scottish painter of international reputation.

Ramsay worked in London – 'You will not find a man in whose conversation there is more instruction, more information, and more elegance than in Ramsay's,' declared Dr Johnson. Ramsay painted portraits, and his influence was crucial to one of his studio assistants, Alexander Nasmyth, who learnt from him his grasp of drawing, his acute observation and his appreciation of Italian art.

Ramsay and Italy made a great impression on Nasmyth, but then he returned to Scotland to paint landscape and he has been described as the founder of Scottish landscape painting. He got it off to a splendid start.

His first landscape paintings have a distinctly Italian look, a tranquillity and classical breadth that takes in the majesty of the mountains and a wide sweep of view, often framed with trees and centred upon a castle in the middle distance. The human presence in the landscape is presented in a serene light, for Nasmyth is confident of harmony between man and nature.

After his return to Scotland, Nasmyth continued to paint portraits, among them two portraits of Robert Burns. The two men shared a passionate interest in landscape and became close friends. Poet and painter often tramped the Pentland hills together, sometimes taking long dawn walks after a night's drinking. Just as the poetry of Burns is rooted in the landscape of his native part of Scotland, of Ayr and Doun, and as he deliberately set himself to immortalise it in words, so Nasmyth's aim was to portray the beauty of the landscape, its history, and the humanity of the scene in his painting.

Both Nasmyth and Burns were involved with the scientific advances then being made, for there was a close relationship between art and science at this time. Through the newly developed science of geology they discovered for themselves the anatomy of the earth itself; it became another dimension in the fascination with landscape that is evident in Nasmyth's structured paintings and in Burns' poetry:

> And I will luve thee still, my dear.
> Till a' the seas gang dry.
> Till a' the seas gang dry, my dear,
> And the rocks melt wi' the sun.

Nasmyth was a talented engineer and assisted in the design of the first steamship to sail on Dalswinten Loch. He was a landscape engineer, a consultant on the layout of the grounds and the siting of Scottish houses, working for the Duke of Argyll at Inverary, the site of the first planned 'new town'. He painted *Inverary from the Sea* in 1801 and it is a picture that expresses his own philosophy. The planned human order of town, castle and grounds are at the centre and in harmony with the natural world of the hills surrounding Loch Fyne – God's in his heaven, the Duke's in his castle, all's right with the world.

He also played a part in the layout of the New Town of Edinburgh and recorded in his pictures how it was developed in relation to the medieval city. He documented its progress in *Edinburgh from Princes Street with the Royal Institution under Construction*, 1825. This and his other paintings of Edinburgh show its magnificent natural setting enhanced by the works of man, thriving on commerce, the citizens at ease with their city. It was Nasmyth's dream that they were building Utopia.

A painter of such gifts had a very important role as a teacher. He was a great influence on David Wilkie, who became a popular domestic and historical genre painter, and on the next generation of landscape painters, John Thomson, Hugh Williams and John Knox, who painted panoramic landscapes in the area of the Clyde. There was great love and admiration among Nasmyth's pupils and associates for his work. Wilkie said: 'He was the founder of landscape painting in Scotland and by his taste and talents took the lead for many years in the patriotic aim of enriching his native land with the representation of her romantic scenery.'

After Nasmyth there was a change from his serene hopefulness of harmony between man and nature, and from the topographical accuracy of his painting, to a style that, while intensely Scottish in character, was not so precisely identified but more generally romantic and literary. These atmospheric studies were influenced by the scenes enacted there in fact or fiction, particularly the fiction of Walter Scott. His novels and poetry were rooted in Scottish history and landscape; these elements combined in his storytelling to spine-chilling effect to set his readers shuddering in their drawing rooms, fearful for the poor souls suffering in remote places in such wild weather, in such anguish and danger.

Illustrators of his work set themselves to match his vision, heightening the drama of the scene before them, exaggerating the fearsome height of

cliffs, sheer drops to savage seas below, dark forbidding glens and chasms, threatening skies. This can be seen in the work of Sam Bough, John Thomson and J.M.W. Turner. Turner made his Grand Scottish Tour in 1801 and painted his vision of the most famous beauty spot then on the tourist circuit, the waterfalls on the River Clyde. He too was in the poetic painting tradition, expressing the truths of nature with metaphors and allegories, adding, selecting and altering the view to make the most dramatic composition. The effect is a literary gothic landscape that seems more old-fashioned than Nasmyth's cool, classical and enlightened views.

The next outstanding landscape painter was Horatio McCulloch, named in memory of Horatio Nelson. He was apprenticed to a house-painter but attended drawing lessons from John Knox, and with him the story moves to Glasgow and the west of Scotland. Through Knox, McCulloch learnt Nasmyth's sense of ordered construction of a landscape, and the importance of direct observation of nature. He had an intense love of nature and he set off on painting trips all over the Highlands and the Western Isles. He painted watercolours on the spot and then worked them up into large-scale oil paintings in his studio, keeping their freshness and vitality. He had a freedom from academic restraints, and his paintings have an attractive naturalness that made his work very popular in Scotland, with engravings sold in great numbers. He rarely left Scotland, and never sought recognition in London, but his pictures introduced Scottish landscape to England. They revealed a world of great scenic beauty, the wildness and solitude that Queen Victoria admired so much, unspoilt and undefiled.

McCulloch was highly regarded by his contemporaries who claimed him as their national painter, doing for the grand Scottish landscapes what Constable had done for more homely English scenes. His best work has a conviction and vitality that has lived on and was still evident in the exhibition of his work in Glasgow Art Gallery in 1988.

He established a distinctive style of painting with pictures such as *Loch Lomond, Loch Katrine, Glencoe, Misty Corries* and *Haunts of the Red Deer*, and it became so popular that it was successfully adopted by the painters who followed him.

In the mid-nineteenth century the Highlands were being discovered by more and more travellers from the south, following the example of Queen Victoria and Prince Albert, whose regular visits to Balmoral began in 1848. Some acquired extensive

Scottish estates with willing Highland servants, at reasonable cost; some went for fashionable deer-stalking holidays; but many were attracted there because it was a wild, beautiful and romantic place familiar to them through the writings of Scott and the paintings of McCulloch.

The Queen spent the happiest days of her life there, delighting in the dramatic scenery, undertaking daunting expeditions and sketching from nature under instruction from Edwin Landseer. Landseer was a prodigy at painting animals. He first visited the Highlands to improve his landscape painting; he went on deerstalking expeditions there with Prince Albert and he became the Queen's favourite painter.

McCulloch and Landseer established the popular Victorian idea of the Highlands – Scott's 'land of the mountain and the flood', of lochs and lonely glens and stags at bay. Improved transport, particularly the extension of the railways, was making it possible for more people to travel north. These were years of agricultural prosperity after the Hungry Forties, and the tranquillity of the countryside contrasted with the grimy, crowded industrialisation of the towns and inspired a sentimental affection. Visitors from the cities saw nothing of the hardship of the workers on the farms, living in remote cottages or struggling to survive off their smallholdings; they just saw the peace, the beauty, the awesome loneliness.

Among those who travelled to the Highlands in 1853 were the painter John Everett Millais, the writer and art critic John Ruskin and his wife, Effie. Ruskin's volumes of *Modern Painters* were being published at the time and he was the champion of Turner and of the Pre-Raphaelites in England. He developed an eloquent treatise on landscape painting, moving away from the grandeur of scenery that was dramatic, picturesque, awe-inspiring but 'never spoke to the heart', to concentrate on the 'truth of the foreground'. He made the point that landscape did not have to be on a grand scale; a mossy bank could have as much significance as a mountain range. The small scene was imbued with an intensity and significance seen at close hand through the eyes of the artist, working outdoors.

It was with this philosophy in mind that the party headed for the tiny hamlet of Brig o' Turk in the Trossachs for Millais to paint Ruskin's portrait. They deliberately chose a quiet spot where the distinguished author could stand musing by a rocky stream instead of by the fashionable Loch Katrine of *Lady of the Lake* significance.

Work on the portrait proceeded slowly. Millais discovered the problems of working outdoors in the Highlands, seated on wet rocks 'in biting rain which appears to come down *nine* days a week!' At the same time a most extraordinary love triangle was developing and Millais found it more congenial to paint portraits of Effie Ruskin with foxgloves in her hair.

Despite the complications and Millais' occasional despair, this picture of Ruskin and his later painting *Chill October*, painted in a backwater of the Tay, were outstanding achievements, notable for the detail of the foreground, the lichen-covered rocks, the realistic movement of the water and the flying spray 'truly such as was never painted before'. Ruskin's words were given form in Millais' painting, and together they were strong influences on the future of Scottish landscape painting.

At this point in the middle of the century, a group of students entered the Trustees' Academy in Edinburgh, heralding one of those momentous periods when the brilliance of the students is matched by the excellence of an outstanding teacher – in this case, Robert Scott Lauder.

Lauder battled against the old-fashioned academic teaching methods of the Royal Scottish Academy at that time, and encouraged his students in their search for self-expression. The benefits of his teaching can be seen in the work of William McTaggart, John MacWhirter, Peter Graham, Hugh Cameron, George Chalmers, William Orchardson, John Pettie and many others.

Of this group, Orchardson and Pettie made their reputations in historical paintings; others found fame and fortune in London, visiting the Highlands every summer to paint the scenes the Victorians loved. Graham's painting *A Spate in the Highlands*, showing a river bursting its banks and a torrent pouring forth, created a sensation when it was shown at the Royal Academy in London. He went on to great popularity with morose-looking cattle in misty glens, storm-lashed cliffs and rocky islands.

MacWhirter's landscapes of Lochranza, Loch an Eilan, Glen Affic, views in Skye, the Kyle of Loch Aish and moonlit views of Loch Ailort glow with colour. Widely travelled, he could compare the Scottish scenery with Italy, America, the Swiss lakes, the south of France; he described Italy as the land of light and Scotland as the land of colour. 'The grey olive, the stone-pine and the white walls of Italy require sunshine to show them to advantage; but Scotland has colour when there is no sun; gloom and

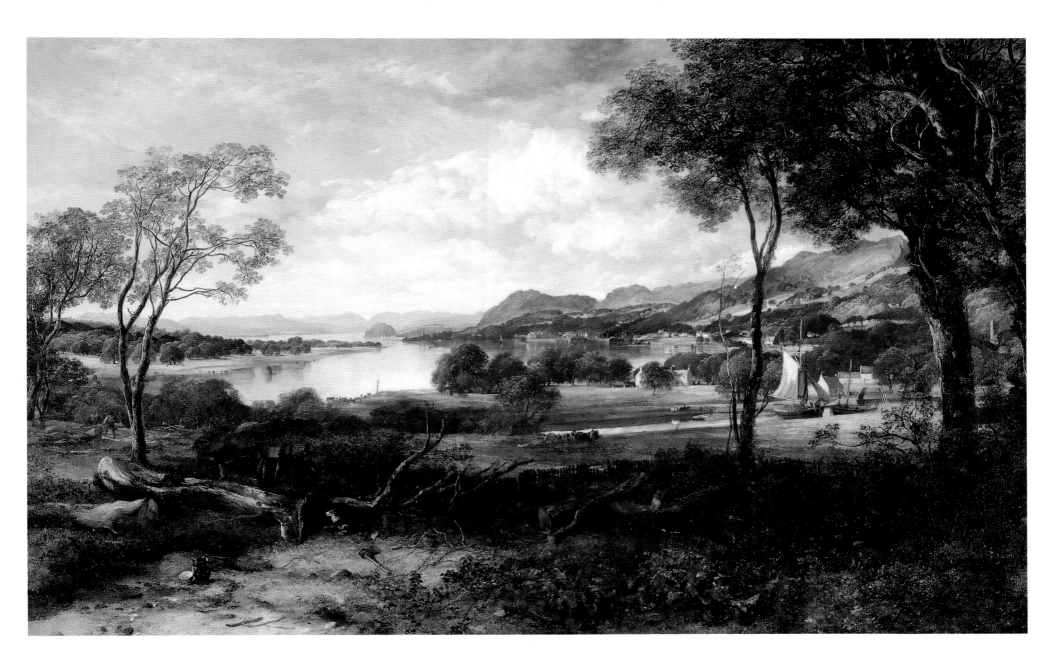

The Clyde from Dalnottar Hill, *Horatio McCulloch, 1858*
(Clydesdale)

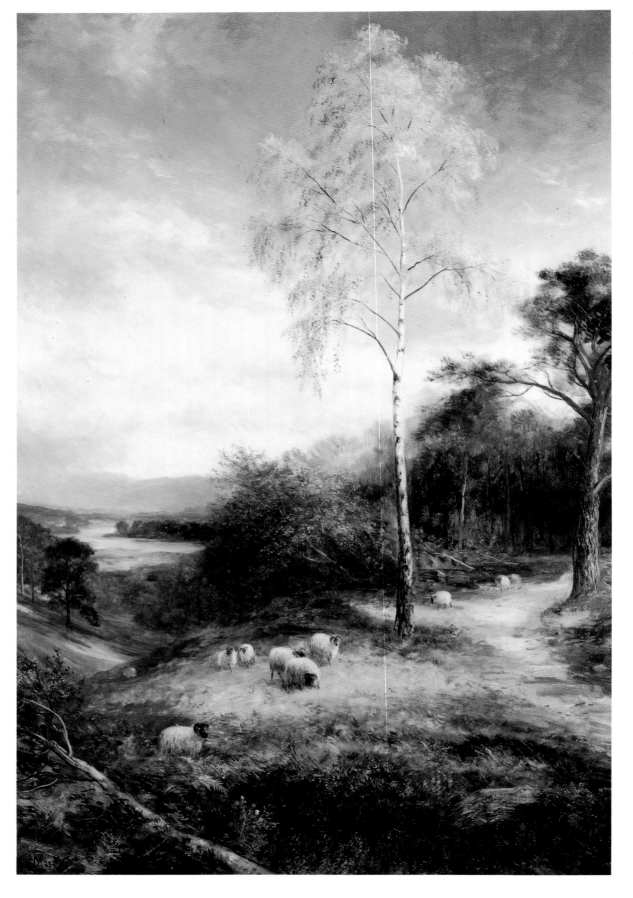

cloud aid the beauty and colour of the Highland landscapes,' he wrote.

MacWhirter, well-established in London and enjoying a high reputation and income from his Highland landscapes, did his best to persuade his friend William McTaggart to join him. McTaggart never moved to London, however, and never painted outside Scotland. He benefitted, like them all, from the teaching of Lauder, but he was an original, breaking right away from the clichés of Scottish landscape which went back to Scott and gratified Queen Victoria. His view of landscape was personal to him and his technique was radical.

McTaggart was born in Kintyre, the son of a crofter, but his great gifts as an artist and his confidence in what he was doing took him from that remote peninsula to study in Edinburgh and then to develop on his own with a freedom of style and certainty of touch.

His painting *Spring*, 1864, of a gentle sunlit landscape with two children daydreaming by a meadow stream, is a picture of simple delight at springtime in the countryside, with a spontaneous freshness of colour. It showed his great potential, the first sign of the genius to come, and it marked a new era for landscape painting.

Both in oil and in watercolour McTaggart found a freedom of technique to express the sparkle and flicker of light, the delicacy and the brilliance of colour, producing exciting prismatic canvases with strong nervous springy brushwork and a wholly new kind of spontaneity. He painted scenes of serene summer tranquillity on the coast of Kintyre – a rowing-boat drawn up on the sands, children playing in the shallows, so much at home in the water they become absorbed into it, hills merging with the sky, waves breaking gently on the shore – all seen in a sea light of magical translucency. He captured the exquisite calm and opal clarity of the western islands; he painted stormy seas with wild and surging waves at Carnoustie on the east coast, and dappled landscapes of harvest-time around Broomieknowe, Midlothian, where he settled in 1889.

His painting has been compared with the work of the French Impressionists, for he captures the transience of light and season and atmosphere on canvas, celebrating his own pleasure in the beauty of the countryside bathed in sunlight, as they did. Yet he was painting like this many years before the first Impressionist exhibition in Paris, at a time when the

A Lonely Birch, John MacWhirter, c. 1880 (Sotheby's)

future Impressionists – Monet, Renoir, Sisley – had just met as students at the *atelier*.

In his later paintings such as *The Paps of Jura*, showing the view from Machrinhanish on Kintyre across to the distant mountains, the line of white breakers stretches from one side of the canvas to another, so that the viewer feels the breadth and openness of the sea.

He went beyond all the conventions to his own vision of the future and 'looked straight into the heart of modern art,' according to the art critic of the *Manchester Guardian*; but it is as a colourist that McTaggart first wins the affection of the critical.

In his paintings McTaggart 'never touches the Tourist Scotland'. James Bone said of him: 'He leaves Scotland to posterity still as a legend and an idyll although he saw in the twentieth century... I think as years go on he will be hailed more and more as the still small voice of the uncontaminated Scots country; lyricist of the joys, not of the holidays in the country, but of the people who live there.'

McTaggart achieved poetic effects without choosing obviously poetic views. 'After all, it's not grand scenery that makes a fine landscape,' he said; 'you don't find the best painters working in the Alps. It's the heart that is the thing. You want to express something that appeals to our common humanity.'

At about the same time in France, Renoir was saying: 'Give me an apple tree in a suburban garden – what do I need of Niagara Falls!' They never met, but McTaggart would have found the French Impressionists kindred spirits.

Scottish art in the nineteenth century was fostered by a number of official bodies. The Scottish Academy in Edinburgh started in 1826. Modelled on the Royal Academy in London, it was an important influence and in its early years all the best painters in Scotland belonged to it. By the second half of the century, however, it was becoming very narrow and restrictive. This naturally caused resentment, particularly in Glasgow which was then approaching the peak of its industrial and commercial prosperity and where new and exciting talent in painting was emerging.

Inspired by McTaggart, this new group was characterised by a move towards realism, away from grand panoramic views, sentimental anecdotes and historical genre painting. They named the older school of academic painters the Gluepots for using a heavy brown medium, megilp, to give their anecdotal paintings the look of Old Masters. This new generation of painters came to be known as the

Glasgow Boys. Finding that the Royal Scottish Academy in Edinburgh was closing ranks and making it impossible for a Glasgow artist to see his work hung on exhibition walls, they came together with patrons, dealers, collectors and laymen to establish the Glasgow Institute of Fine Art.

Members of this vigorous group included W.Y. Macgregor, who was the initial leader, James Guthrie, E.A. Walton, Arthur Melville, George Henry, E.A. Hornel, James Paterson, John Lavery and several others. They went to France to study, attended *ateliers* in Paris and set up their easels together outdoors in summer, notably at Gres-sur-Loing near Fontainebleau. They were influenced by Whistler, by the French Barbizon painters and particularly by the rural social realism of Bastien Lepage.

Recognition of their work outside Glasgow didn't come until an exhibition at the Grosvenor Gallery in London in 1890; it was then that the name the Glasgow Boys was coined and a book was published about them, celebrating their work.

The group congregated at Brig o' Turk in the Trossachs for the summer of 1881 to paint together, and it was there that Guthrie found the subject for his *Highland Funeral* which established his reputation. Later they discovered Cockburnspath on the east coast, and in the village there between the uplands of the Lammermoors and the rocky coast along the North Sea, nearly every red-tiled cottage had an artist lodger in the early 1880s. Easels were pitched everywhere and the white umbrellas of the painters dotted the fields, the harbour, the square and the shore. It was the Scottish version of the Bastien Lepage school of realism. They chose to paint the quiet corners of the village, the labourers at work, the back lanes and hillside crofts in a low-key, even-toned style with square brush strokes, like newly turned earth. They worked close to their subject, like McTaggart, but unlike him were not concerned with the atmosphere or transient effects of light and shade.

Most of the painters stayed only in the summer, but Guthrie stayed all through the winter as well. There he painted *A Hind's Daughter* among many other pictures, the one that epitomises the group's style. The girl who is the daughter of the skilled farm-worker or hind stands in a cabbage garden: 'The classic image in Scottish realist painting... later dubbed sweepingly the Kaleyard School.' There are examples of cabbage patch paintings from most of the Glasgow Boys.

Working together at Cockburnspath, the Boys inspired each other and found a way forward. William Macgregor worked on the east coast, taking a house at Crail. His paintings there and his still life *The Vegetable Stall* were some of the greatest of the Glasgow school, but his assumption of leadership and superior attitude did not endear him to the group.

James Paterson began to spend summers at Moniaive; he was primarily a landscapist, whereas the rest of the group included figures in their scenes. He too had French training, and his landscapes have classic composition. One of his finest, *Autumn in Glencairn*, has a powerful sense of space and distance, with the massed clouds reflected in the water. Arthur Melville developed a distinctive watercolour style and lifted the medium to new heights of achievement. He travelled to the Middle East, but returned to Scotland, where his paintings of Loch Lomond and Brig o' Turk capture the atmosphere as well as the scene.

At Cockburnspath, George Henry had painted *Noon* influenced by Guthrie's style, but there was a distinctive bravura in his paintings that marked him as the most radical of the group. In 1885 he joined Edward Hornel at his home in Kirkcudbright, in Galloway, which subsequently became the centre for the Glasgow artists. Galloway, often missed by visitors from the south in their haste to get to the Highlands, has a mild climate, with luxuriant growth of flowers and trees. Celtic legends abound and it is, like Cornwall, a natural haunt of artists.

The productive partnership of Henry and Hornel was stimulated by this land of myths and legends, twisting burns and gentle hills, and they moved towards a decorative unreality in which perspective was ignored. In Henry's painting *Galloway Landscape*, the steepness of the hillside is exaggerated, trees and cattle ranged against it in profile, and the twisting burn becomes an art nouveau whiplash disappearing off the bottom of the canvas. 'It came to represent all that was vigorous, imaginative, bold and accomplished in the work of the Glasgow Boys,' says Roger Billcliffe, their biographer.

In Hornel's paintings the horizon and the sky disappear; a confined space is created, a claustrophobic sense of being lost deep in a wood, with figures glimpsed half-hidden in the branches.

Their pictures are truly evocative of Galloway, the beauty and atmosphere of the place, but they shocked the artistic establishment and were mocked and sneered at. Neither artist had any money; they relied on support from a few dealers and supporters. Yet, irreverent and irrepressible, these two wild men moved Scottish painting forward ahead of London at a time when the metropolis was still trying to come to terms with Degas and the Impressionists, let alone Cézanne and Gauguin.

The story of the Glasgow Boys demonstrated that the young need not be put down by older well-established artists; they had asserted their own beliefs and found their own way forward. In doing so they had made the profession of artist acceptable in Scotland, and life became a little easier for the next generation. In the new century, the Romantic age was over, and Scotland was left to her own artists.

There was an ebullience about the young Glasgow artists, part of the vitality of the city at that time, and they seemed to thrive on opposition that would have crushed more tentative talents. It is characteristic of Glasgow spirit that when the brilliant Fra Newbery was appointed as head of the Glasgow School of Art, he changed it from a provincial art school with evening classes into an important centre of art training which established an excellent reputation under his guidance. It was his bold decision, when an architectural competition was launched to find a suitable design for a new art school building, to select Charles Rennie Mackintosh's design. Despite controversy, it has proved an outstanding success as a building that fulfils its function and moves assuredly into the future with its design – Scotland's outstanding contribution to the art nouveau movement in architecture – and it has attracted attention ever since.

Controversy continued for Mackintosh, who finally retreated from Glasgow and from architecture to paint watercolours in the south of France. There was still opposition, too, for up-and-coming Scottish painters trying to gain recognition in their own country. The old Scots saying that put down the aspirations of the young – 'I ken't his faither' – continued for generation after generation.

The term Colourist has been applied to four painters – S.J. Peploe, Leslie Hunter, F.C.B. Cadell and J.D. Fergusson – but they didn't work as a group or train together. What links them is their style and their feeling for bright vibrant colour; this feeling for colour was the result of their common formative experience of painting on the Mediterranean coast. The Colourists worked as individuals or in pairs, but all through their careers they moved between Scotland and Paris, experiencing the exciting bohemian café life of the French capital, and influenced by the great retrospective exhibitions of Van Gogh in 1901 and Cézanne in 1907, the Whistler memorial exhibition of 1905 and the dazzling performances of the Diaghilev Ballet Russe. They were much more receptive to new ideas in art than their English contemporaries. They became familiar, for example, with Matisse, whose work provided another shock for London. France liberated the Colourists; they responded to it and brought its lively warmth to the cool light of Scotland. 'Paris is simply a place of freedom,' Fergusson said, 'it allowed me to be Scots as I understand it.' They travelled, but they always came back.

Peploe was the most successful of the four, best known for his still lifes. He first painted landscapes at Comrie, then at Barra, and visited Kirkcudbright regularly. His landscapes have a sense of conviction about them, and convey his own passion through cool controlled handling and fresh strong use of colour.

Cadell first introduced Peploe to Iona, for he spent every summer there. His relaxed style conveyed his love for the peace and loneliness of the island with its impressive sea views, stark white sands and dramatic weather.

Hunter, born in Rothesay, was brought up in California and seemed always to be looking for Californian warmth and glamour. He painted in Fife, and his series of paintings of Loch Lomond link with a series made in the south of France, with the same high-key light and colour intensity. Restless, disorganised and unsettled, he was always looking for a new approach and came nearest to it with his Loch Lomond paintings, one of which was bought by the French government at the successful *Les Peintres Ecossais* exhibition of 1931.

Fergusson painted Scottish landscapes but spent more and more of his time in France. His paintings were shown in the Post-Impressionist exhibition in London in 1913 and he was successful during the 1920s. He wrote on modern Scottish painting, he could argue his case in the Paris cafés, and his work reflected his own personal philosophy. He made many trips to the Western Isles and toured the Highlands; he too enjoyed Kirkcudbright and the good light and mild climate and fraternity of artists there, many of whom he had known in Paris.

Three of the Colourists died in the 1930s, but Fergusson lived on to influence a new generation of artists, dying at the age of 86 in 1961. He and his wife, the dancer Margaret Morris, had a flat in Glasgow which they made a centre of artistic

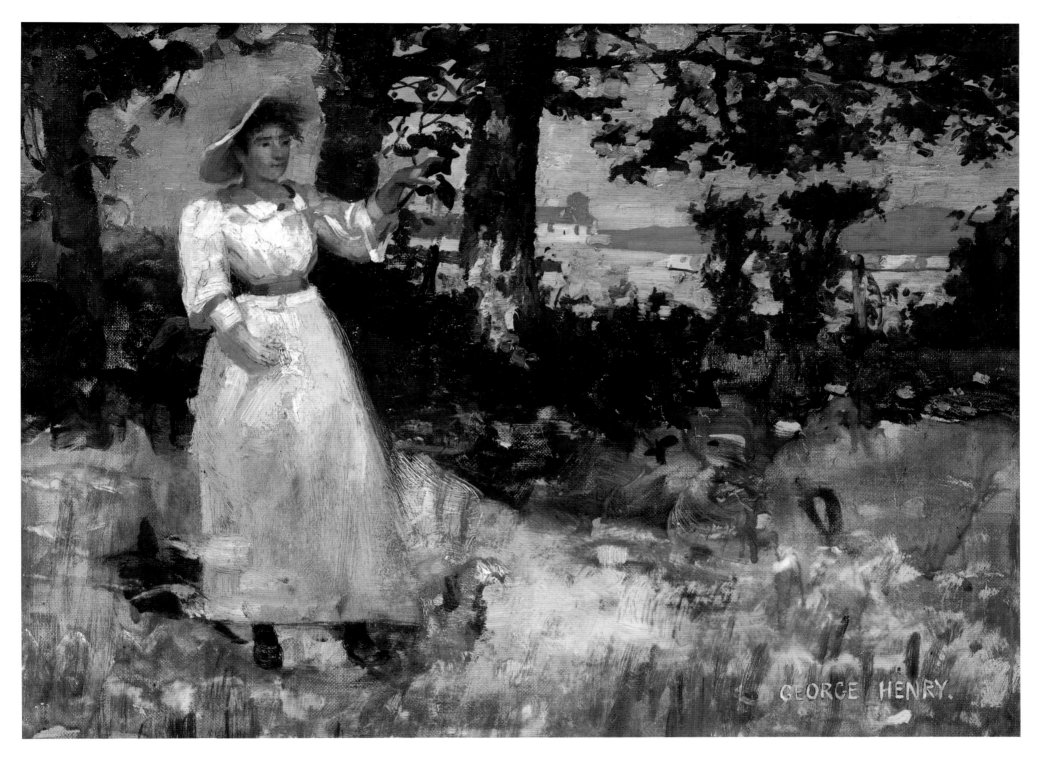

Summer, *George Henry, c. 1890 (Sotheby's)*

achievement, and Fergusson established the New Scottish Art Group for Glasgow's progressive artists. His interest in music, dance and literature was reflected in his painting; he had an instinct for rhythm which makes sense of a picture just as it informs the shape and meaning of other art forms.

In the new century, landscape painting in Scotland had taken on a distinctively new and modern look which can be seen in the work of D.Y. Cameron. His work stands outside the mainstream of the Glasgow school, though he was born and studied there. It has been said of him that he lacked the humanity and spontaneity of the Glasgow Boys, and though his use of colour is distinctive he was not part of the Colourists' development. D.Y. Cameron landscapes return to the grandeur of the mountains that were beloved of the Victorian painters. But his economical, uncluttered, strongly simplified style in paintings such as *Wilds of Assynt* and *Eagle's Crags* makes his work essentially modern. His chosen landscapes in the far north of Scotland, still undefiled and unpopulated, reveal his own personal vision of the hills. His paintings bear the hallmarks of an artist who was himself a quiet, retiring man and also a master of etchings.

James McIntosh Patrick also began his career as an etcher, but he turned to watercolour and oil in the 1930s with landscapes that are meticulously detailed, closer to English landscapes than to those of his Scottish contemporaries. His beautifully painted oils of the Angus countryside, won immediate acclaim and popularity. They show Angus as it was before the war, and in them McIntosh Patrick asserts his right to select and reject in his observation of the scene, leaving out ugly intrusions of modernity because he maintains he truly doesn't see the electricity pylons on the hillside or the white lines painted down the middle of country roads. His paintings of local scenes around his Dundee home in all seasons are still extremely popular, for there is a powerful nostalgia for the countryside as it used to be, and people go in search of it.

McIntosh Patrick paints a pastoral scene that is essentially human, a landscape shaped by man, farmed for centuries, a place where people live and work and feel secure. Other Scottish artists of this century paint an unpopulated land, with a sense of detachment that is cool, almost clinical at times. Whereas the landscapes of McTaggart or McIntosh Patrick draw the spectator into the picture with inviting warmth, conveying the artist's own joy in the scene before him so infectiously that one longs to wander along that seashore, follow the path by the river or wander over that hillside, the landscapes of the Colourists and others of the 'nobody at home' style of painting inspire a different kind of admiration. They provide a soothing balm to eyes fraught with the stress of modern life, but do not invite the same kind of involvement in the scene.

There is little sense of what rural life is like in the paintings of Peploe or Cameron, and scarcely any sign of human habitation. Landscape painting has come a long way from the crofts and kaleyards and with the next generation of artists it moves steadily farther away into an expressionist, abstract style that sometimes disconcerts the spectator.

In the 1930s William Gillies was developing an expressionist style of painting landscape, touring the fishing villages on the North Sea coast to Ardnamurchan and the Highlands north to Suilven on high-spirited excursions with his friends. These painting trips were kept up for years; his energy and industry were prodigious. He was known as the *enfant terrible* of Scots painting in his youth, but he was entirely devoted to Scotland, loved and understood the landscape and enjoyed the climate. He mastered the changing skies and the effect of the weather on the scene; and he painted with a freestyle spontaneity, while still respecting the topography, so that it is possible to identify the exact views.

The controversial Munch exhibition of 1931 – the first in Britain, arranged by the Scottish Society of Artists in Edinburgh to stimulate Scottish painting – had a powerful effect on Gillies and his contemporaries in a new group of outstanding Edinburgh artists which was emerging. Gillies was invited to join the Society of Eight, which had earned the highest reputation in Scotland for professional standards and liberal progressive work. There Gillies found himself in company with James Guthrie and John Lavery, original Glasgow Boys, and with the Colourists Peploe and Cadell who started the society.

William Crozier, despite his early death, was another important figure in the development of the Edinburgh school. Crozier, like so many, was drawn to the south of France because of the light and the strong contrasts that emphasised structures and simplified the geometric shapes of houses and land masses. Painting in Scotland, he had the problem that the northern light blurs the contrasts to an all-over misty effect. In *Edinburgh from Salisbury Crags* he succeeds brilliantly in creating a cubist city, a stylish construction of roof levels and rock faces.

William MacTaggart, another member of this group and grandson of William McTaggart, was a friend and contemporary of Gillies, with whom he shared a studio. He had the advantage of a famous name but also the problems of trying to live up to it. He travelled widely and became a successful president of the Royal Scottish Academy, painting bold landscapes of East Lothian in rich glowing colours and finding his own individual style.

Gillies became head of drawing and painting at the Edinburgh College of Art in 1946, and the centre of a group of Edinburgh artists who had been chafing during Scotland's artistic isolation from Europe during the war years, and now wanted to see changes.

In the immediate post-war period, Edinburgh once again became an exciting artistic centre. The early years of the Edinburgh Festival had a heady atmosphere, full of optimism and enthusiasm. William MacTaggart was largely responsible for the series of art exhibitions that enriched the festival.

These years saw the emergence of three Scottish women painters – Elizabeth Blackadder, Anne Redpath and Joan Eardley – who by force of talent overcame the difficulties of exhibiting their work in a male-dominated art world.

Anne Redpath, born in Galashiels, studied at the Edinburgh College of Art, won a travelling scholarship and spent time in Florence, Paris and Bruges. Marriage and three sons kept her from painting, the family living then in the south of France, but she returned to Hawick in 1934 and devoted the rest of her life to her work, living by painting, a committed and hard-working artist, until her death in 1965. She became a central figure in Edinburgh artistic circles and was the first woman painter to be made a full member of the Royal Scottish Academy.

Anne Redpath painted the Border country and Skye with exceptional individuality and a degree of naïvety, the consciously naïve element she admired in Matisse. She found she had to be distant from her subject to capture its essence – visiting Skye as a stranger, then later painting it.

Joan Eardley, who studied in Glasgow, painted at Catterline on the north east coast and seems to lose herself in her seascapes. Her intense abstract paintings evoke powerful images of nature, and expressive brushwork conveys the force of sea and wind.

A Perthshire Landscape, *S.J. Peploe, c. 1910 (Sotheby's)*
The brilliant palette of a Colourist in the Highlands, and a fresh approach in the new century.

Kippford, *William Gillies, c.1950 (Bourne Galleries)*

As in her earlier paintings of the children of the Glasgow slums, her work has a haunting and emotional power. She is not standing back from the stormy seas she paints at Catterline; she seems to be almost engulfed in them. In all her work there is an undertow of despair.

To the south, on the Borders, William Johnstone too moved away into the abstract, yet his painting *The Eildon Hills* reverts to landscape. This is the primordial landscape of Celtic legend that links with Fergusson and his rhythm paintings in Glasgow, and with Hugh MacDiarmid, who wrote a series of poems based on Johnstone's paintings. In 'Scots Unbounds' MacDiarmid celebrates the magical colours of Scotland and the Scots vocabulary of colour, the theme that runs through Scottish landscape painting:

Syne let's begin
If we're to dae richt by this auld leid
And by Scotland's kittle hues
To distinguish nicely, 'twixt sparked and
 brocked,
Blywest and chauve, brandit and brinked,
And a' the dwafill terms we'll need
To ken and featly use,
Sparrow-drift o' description.

CHAPTER TWO

PAINTERS OF THE LOWLANDS

BEGINNING AT THE BORDERS

Oh Tam! Gie me a Border burn
That canna rin without a turn
And wi' its bonnie babble fills
The glens among oor native hills.
How men that ance have ken'd aboot it
Can leave their after-lives without it
I canna tell, for day and nicht
It comes unca'd for to my sicht.

J.B. SELKIRK (JOHN BUCHAN)

IT is easy to pass across the English–Scottish border without noticing it, for it twists and turns like any border burn. There is little formal indication today beyond Carter Bar stone and Gretna Green, scene of many runaway marriages, to mark the change from one country to another, and the same kind of landscape scenery continues.

The Borders were for centuries the scene of bloodthirsty skirmishes, raiding parties and major battles. Abbeys were razed and castles ruined, and there are no towns or villages of great antiquity. The Border chiefs followed the maxim of the great Robert Bruce and relied on the natural cover of woods and hills as their main bulwarks against the foe, only building look-out keeps on sites made inaccessible by nature with rocks, precipices and torrents. They have not left a landscape of battle-fields and fortifications but a legacy of legends and ballads. This is the land of the border ballads, the tales of Thomas the Rhymer who dwelt three years with the Faerie Queen in the Eildon Hills; it is Burns country and Scott country as well. It has a quiet charm – 'More pensive in sunlight Than others in moonlight' was Wordsworth's impression of the scenery.

It is a land of hills rather than mountains, a country of rivers and pastures. Even the busy industrial places, Hawick and Galashiels, are still country

towns. Once it was richly wooded, but over the centuries its forests were destroyed and the trees now stand singly or in small groups near the farmsteads. The hills are bare, 'wavy lines of hills as if arrested in water-flow', shaped by the action of ancient glaciers, wind and rain and streams.

These hills have not the unearthly beauty and melancholy of the Highlands; they are gentle and rounded, bright with golden gorse in June. Clear streams and small copses divide the pastureland where sheep graze. Sheep made the fortunes of the Borders and these serene uplands are not haunted by the cruel memories of Highland clearances, the evictions of families to make room for the flocks.

The soft colours of the Border landscape find their way naturally into the tweed made by the Border towns. The monks began the wool trade, kings favoured it, and weavers had special privileges and were exempt from military duties in time of war. Weavers were often the balladeers; while their hands were employed they could sing all manner of songs. Walter Scott played his part in making tweed popular, setting the fashion when he appeared in London wearing trousers of shepherd's plaid.

Border artists have connections with the weaving of tweed. **Tom Scott** (1854–1927) was the son of a tailor born in Selkirk. He painted entirely in watercolours and was self-taught. Scott studied the work of Constable and gained a considerable reputation in his own lifetime as one of the best landscape watercolourists. He painted the hills and valleys of the Borders with a feeling for the seasons and the weather variations and a deep understanding of the land and its literature, which gives his small intimate paintings such as *The Tweed at Philipshaugh* and *Border Landscape* an intensity and authenticity.

When **Anne Redpath** (1895–1965) was growing up in the Borders and deciding at an early age that she wanted to be a painter, Tom Scott was the preeminent local example of a successful artist and

member of the Royal Scottish Academy. Unfortunately he also set an intemperate example; he was well known for selling his watercolours in local public houses, and this was anathema to Thomas Redpath, her father, who was an ardent teetotaller, a member of Hawick Congregational Church and a town councillor. A story well known in Hawick is told of Thomas Redpath speaking as guest of honour at a Burns Night supper in the town, and choosing this most inebriated occasion to lecture his audience sternly on the evils of drink and the disastrous effect it had on the Bard.

To satisfy her father, Anne Redpath had to combine study at Edinburgh College of Art with a teacher training course. Thomas Redpath was a pattern weaver in Galashiels, a designer of tweed with a reputation as an original and inspired colourist and even his most sober designs had a strong thread of colour running through them. His instinct for colour harmonies and contrasts was inherited by his daughter, who became one of the most exciting twentieth-century Scottish artists.

She immediately made her mark as a student and was awarded a travel bursary, spending a year in Florence and Siena, where the frescos of the Lorenzetti brothers in the Palazzo Pubblico impressed her and influenced her later work. In 1920 she married the architect James Michie and they lived in Cap Ferrat, where their three sons grew up. During those years she devoted herself to her young family, painting only infrequently, but enjoying the company of the other Scottish artists who visited the south of France and basking in the technicolour world of the American millionaire for whom Michie was private architect.

In 1934 everything changed. The millionaire became bankrupt in the Wall Street crash, Anne separated from her husband and returned to her parents' home in the Borders with her three sons. She then had to support herself by painting.

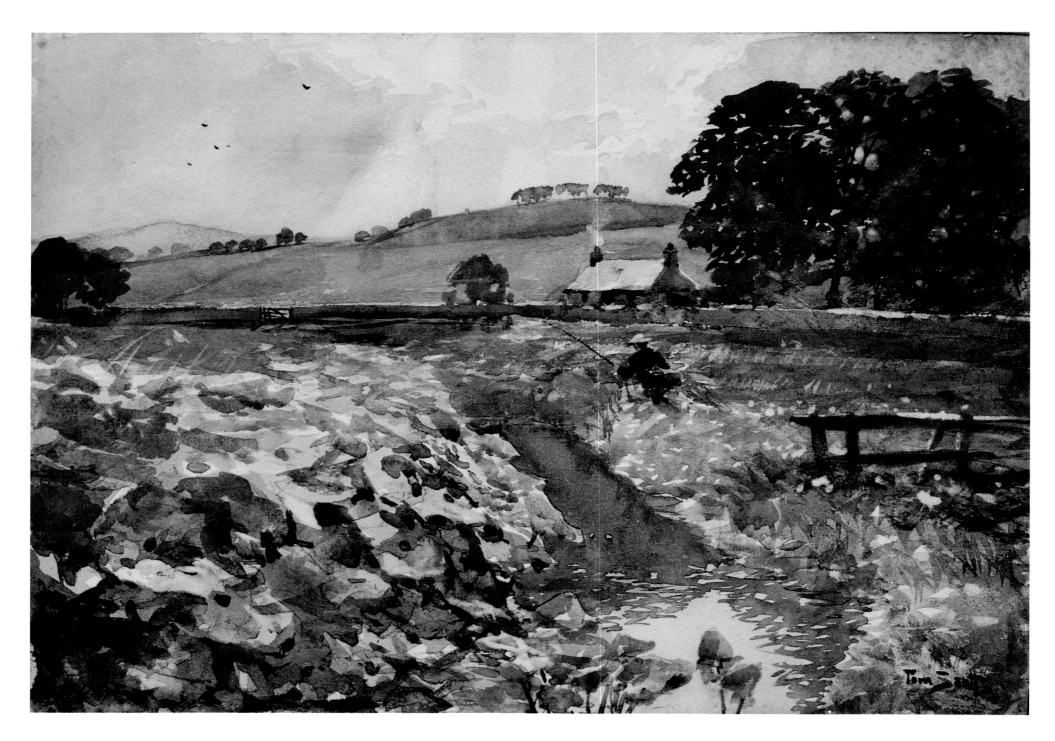

Fishing a Border Burn, *Tom Scott, c.1920 (Mainhill Galleries)*
Working almost entirely in watercolour, Tom Scott found his inspiration in the gentle, rolling landscape of the Borders.

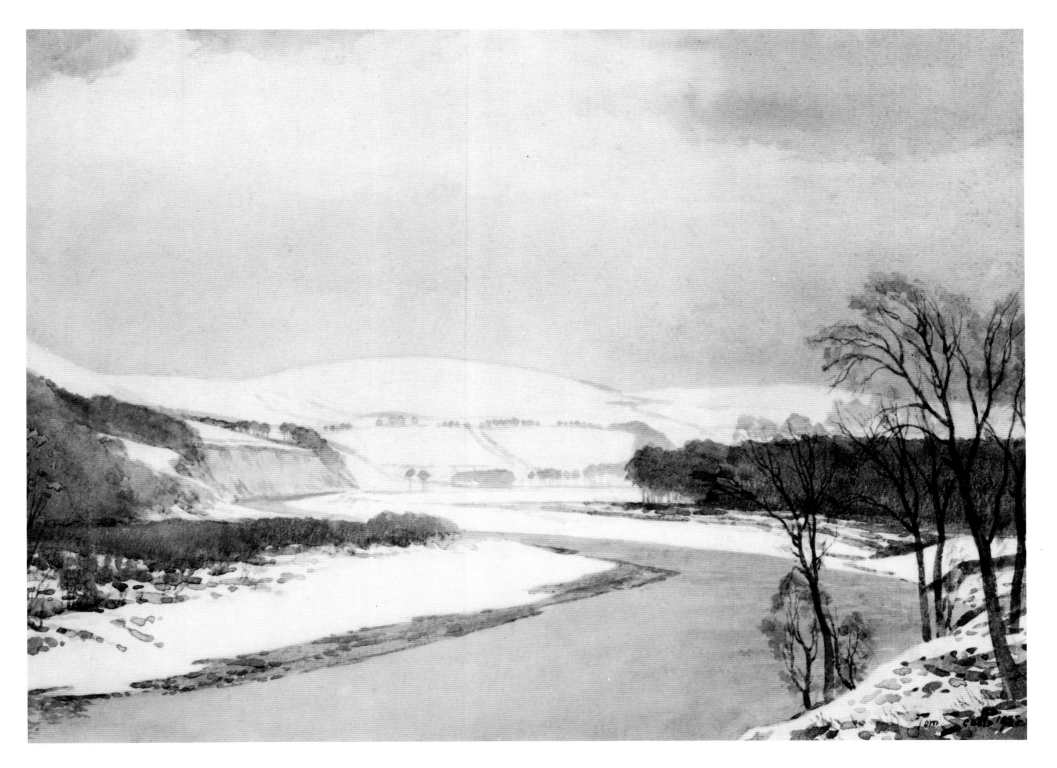

The First Snow, River Ettrick, *Tom Scott, 1922 (Mainhill Galleries)*

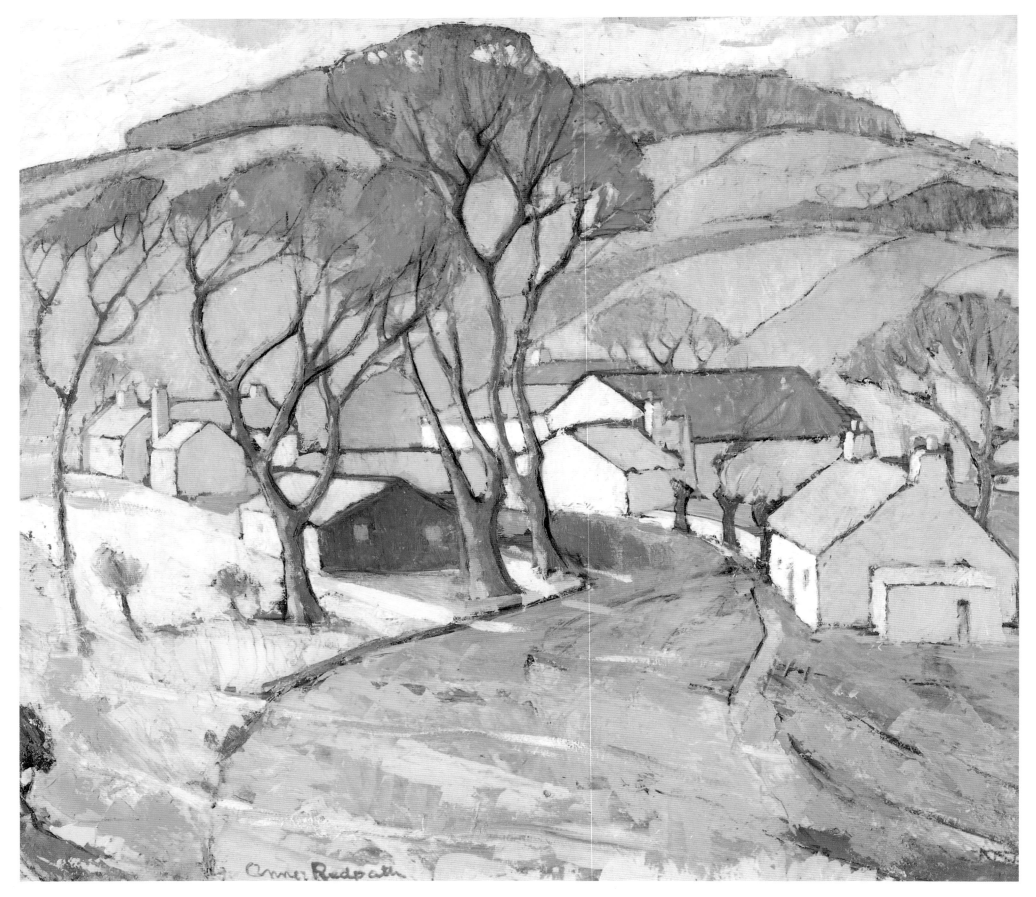

The technical skills of her student days of promise now had maturity and individuality and she had the independence to create a personal vision. She said: 'The picture is a summary of the artist's knowledge of the scene rather than a direct observation of it – a distillation of experience recollected in the studio.'

She worked on still lifes, showing the influence of Bonnard and Matisse, and painted the countryside around Hawick where she bought a house. *Frosty Morning, Trow Mill*, 1936, has a quiet stillness and cool harmonies; *A Border Farm* captures the gentle sunlit nature of the countryside. She also painted in Skye in 1946 and travelled widely in Europe, and her later work, inspired by the Mediterranean, is regarded as her greatest.

Anne Redpath moved from the Borders to Edinburgh in 1949, at that time an exciting artistic centre when the Festival in its early days was she said, as 'heady as Mardi Gras'. She held successful one-woman exhibitions and was elected to full membership of the Royal Scottish Academy in 1952, the first woman painter to achieve that status. She lived by painting, not teaching, and was always financially insecure; but she was at the heart of the Edinburgh artistic world, famous for her hospitality, her left-wing views and her delight in buying *haute couture* clothes when she sold a picture.

Among Anne Redpath's fellow artists there were mixed opinions about painting the Border landscape. Some found it 'too green, too green', but **William Johnstone** (1897–1981) became obsessed with it. He was the son of a Border farmer and was introduced to painting by the Border watercolour painter Tom Scott. He attended Edinburgh College of Art but said that it was the Eildon hills that made him a painter.

His career is difficult to follow as so much of his work has been lost and he often over-painted, but *The Eildon Hills*, 1929, is an impressive example of how these mysterious legendary hills fascinated him. After experience of art in Paris and America, he returned to Scotland and discovered the Celtic myths of his native countryside. He had strong links with Hugh MacDiarmid, who wrote a poem about his extraordinary abstract painting *A Point in Time*; but he constantly reverted to primordial landscape, overlaid with abstract human shapes evolving.

Frosty Morning, Trow Mill, Anne Redpath, c. 1950 (Flemings)
Born in the Borders, Anne Redpath became one of Scotland's outstanding women artists.

Johnstone saw modern art returning to the ancient art of Celtic Scotland – to landscape felt and experienced from within, rather than merely observed from outside.

THE WILD MEN OF GALLOWAY

Blows the wind to-day, and the sun and the rain
 are flying
Blows the wind on the moors to-day and now,
Where about the graves of the martyrs the
 whaups are crying,
My heart remembers how!
Grey recumbent tombs of the dead in desert
 places,
Standing stones on the vacant wine-red moor,
Hills of sheep, and the howes of the silent
 vanished races,
And winds, austere and pure:
Be it granted me to behold you again in dying,
Hills of home! and to hear again the call;
Hear about the graves of the martyrs the
 peewees crying,
And hear no more at all.

 R.L. STEVENSON

The south west corner of Scotland is under-visited; most travellers coming over the border head steadily north towards Edinburgh and the Highlands. They miss Galloway. They miss a lot.

This was one of the most remote regions of Britain until it was opened up by road-building towards the end of the eighteenth century. The southernmost tip is the closest crossing point to Northern Ireland, and this led to the development of roads to link Carlisle and Portpatrick, crossing the Fleet estuary at Gatehouse where an industrial village was developed by an improving landlord.

The long indented coastline extends from the north shore of the Solway Firth and the estuary of the River Nith, around a series of bays down the Mull of Galloway, then north round the Rhins and Loch Ryan and on to Ayrshire. Though this is essentially lowland scenery there are high moorlands around at Glen Trool, quoted in Stevenson's verses. There are small abrupt hills, little terraced fields of green, copses, burns winding through the valleys; this is a free open design of landscape with classical natural contours. 'The tossing hills of Kirkcudbrightshire' are all bright green, a vivid and intense emerald like that of Ireland, with white-

washed farm buildings set in the hollows among groups of trees. There is nothing here to evoke savage memories, dark shadows of the past, gothic fear and trembling. The soil is less fertile than Dumfriesshire, so the land is not as intensively farmed and there is a good balance between man and the rural environment.

Galloway is a great place for those who like their solitude accessible and in a mild climate, rather than on remote islands or windswept northern wastes. The area appealed to novelists – Stevenson's *The Master of Ballantrae*, Scott's *Guy Mannering* and Buchan's *The Thirty Nine Steps* were all set here, as well as Stevenson's poem 'Blows the Wind Today'.

The writer Ivor Brown, visiting Kirkcudbright in the 1950s, said: 'The town itself has a forgotten look, but artists in force have remembered it and made it a home; it has a medieval aroma to which castle, Mercat Cross and Tolbooth contribute. I had a feeling, rather a sleepy feeling since the air is very gentle, that I had wandered into a piece of France.'

The French connection may not strike every visitor today, but Kirkcudbright remains a place for artists.

In the late 1880s Kirkcudbright was adopted by the Glasgow Boys. **Edward Atkinson Hornel** (1864–1933) was born in New South Wales in Australia, moved to Kirkcudbright with his parents and made it his base for the rest of his life. After spending three rather unsuccessful years at the Trustees Academy, he went to Antwerp to study. On his return he met **George Henry** (1858–1943) in the autumn of 1885 and began a friendship that was artistically productive and mutually inspiring, one of the most exciting in Scottish art.

Henry was born in Ayrshire and studied at the Glasgow School of Art; he had already worked with Guthrie, Walton and Crawhall at Brig o' Turk in the Trossachs and at Cockburnspath, his style influenced by the square-brushed rural realism which the Glasgow Boys had introduced. Persuaded by Hornel to try Kirkcudbright, he painted his most successful work there and the landscape itself played a large part in the development of his style.

He was the most rebellious of the whole group, with a cheerful disregard for social conventions, though he was considerate of the feelings of Hornel's mother and didn't embarrass her by taking along to Kirkcudbright any of the models he was currently living with. He was always short of money, and worked in Glasgow as a clerk while studying.

Hornel was described by his biographer A.S.

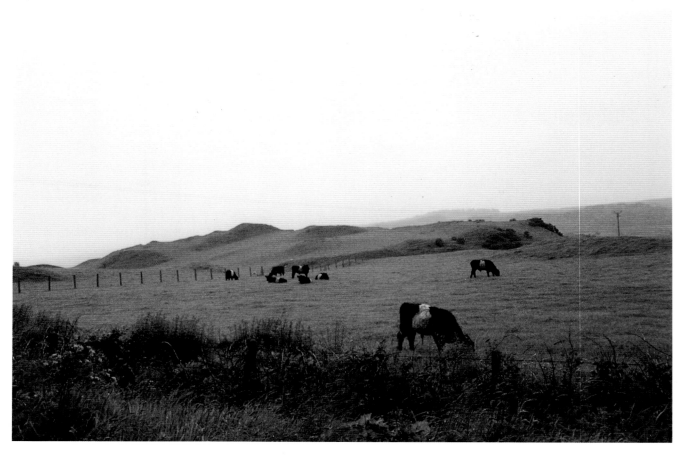

Galloway, 1993. The distinctive cattle still graze the green and peaceful hills.

Hartrick as 'a fine looking man of strong character and stronger language'. They worked well together, easels side by side like Monet and Renoir in the forest of Fontainebleau, sharing brushes, paints and ideas; often they worked on the same canvas. Their letters to each other, relating their progress and the in-fighting within the group of Glasgow Boys, are robustly critical of the art establishment.

In 1889 Henry painted *A Galloway Landscape*, a picture that indicated a wholly new departure in landscape art. In this picture the sunlit landscape is treated decoratively: the perspective is ignored, the slope of the hill exaggerated until it becomes two-dimensional, the trees and cattle set in profile against it, and a sinuous burn winds round the base of the hill, disappearing off the side of the canvas. Hartrick wrote that he knew the exact spot where it was painted and that Henry invented the burn, but the painting conveys a sense of place in spirit rather than in representation, the antithesis of the naturalistic landscape of the 'kaleyard' approach. It is symbolic, the whiplash curve of the burn itself an art

nouveau motif, yet it evokes the beauty and atmosphere of Galloway's gentle countryside where there are so many such hills, winding burns and grazing 'belter' cattle with their wide white waistbands.

The mood of the sunlit landscape is conveyed through the harmony of clouds, trees and light on the grass. The grazing cattle are so much part of the land that they merge into it like patches of shadow. It is 'one of the most beautiful landscapes of its time', to quote Duncan Macmillan in his standard work on Scottish art.

Henry painted several other outstanding pictures in the area, in particular *Landscape at Barr* between the coast and the Carrick hills – a picture so freely painted, brilliantly coloured and modern that it is hard to believe it was painted in 1891.

These paintings puzzled and outraged critics and public alike. Henry was accused by art critics of 'taking liberties with our sense of the realistic', his pictures described as 'not art' and dismissed as a joke. In London, when *Galloway Landscape* was shown at the Grafton Gallery in 1893, public reaction was sarcastic, people asking 'What is it?' and commenting that 'Ireland must be a funny place'.

Hornel's paintings of *Brighouse Bay* and *In the Town*

Crofts produced similar criticism, though not quite so vehement. When Liverpool Art Gallery in 1892 purchased his picture *Summer*, it provoked a furious newspaper controversy which raged for many months, the curator complaining that his life was made a burden to him by people asking him to 'explain' the picture to them.

It was all reminiscent of the reaction to the work of the Impressionists in France in the 1870s – the scurrilous and savage attacks, the mockery and opposition, the accusation made that the artists were insane. But Hornel and Henry were made of stern stuff and demonstrated the tenacity, ebullience, energy and resolution of their fellow countrymen.

The two wild young men of Galloway working in isolation from the mainstream didn't give a damn. They took Scottish painting and placed it in the forefront of European development, up there with the Post-Impressionists, with Gauguin and Cézanne, when others in London were still cautiously considering the work of Degas.

Hornel and Henry worked together on mysterious and exotic paintings – *The Druids* and *The Star in the East*. In 1893, fascinated by the Japanese art infiltrating European taste, they travelled together to Japan, financially supported by the dealer Alexander Reid and the collector William Burrell. Some of Hornel's best work was strongly influenced by Japanese art and his landscapes become more figurative, featuring children in flowery settings, their faces mingling with the wild roses in the woods or the blue flax on the shoreline – enclosed fairytale images without horizons. He developed this mosaic-like Persian carpet effect and the pictures made him commercially successful in his lifetime; they have continued to fetch high prices ever since. He was able to buy Broughton House, a fine eighteenth-century town house in Kirkcudbright, when he sold a painting for £400 in 1901.

He continued to live in Kirkcudbright, remaining a bachelor but looked after by his sisters who kept house for him. He enjoyed being the father figure among the new generation of artists who came to Kirkcudbright around the turn of the century, and he revelled in the creation of a fine studio, library and garden at Broughton House, which he later bequeathed to the town.

Henry was ill in 1892 and the visit to Japan was not so successful for him. His oil pictures stuck to each other on the voyage home and only his watercolours survived the trip. He turned against his Japanese experience and wouldn't talk about it, painting only

Galloway Landscape, *George Henry, c.1889 (Glasgow Art Gallery)*
An evocation of the Galloway landscape with a decorative pattern of clouds, trees, grazing cattle, sunlit pastures and winding burn.

what was necessary to pay off his debts. The friendship cooled and they no longer worked together, Henry settling in London and painting portraits, his work becoming less adventurous and more lucrative in later life.

Several of the other Glasgow Boys visited Kirkcudbright, including E.A. Walton and James Guthrie (1859–1930), who painted *Pastoral* there in 1887. It is a tranquil painting, with sheep moving across the sunlit meadow like an abstract pattern of shadows, and a foreground of leafy plants, that shows how he too responded to the Galloway atmosphere and softened his style from the austere eventoned pictures of his Cockburnspath days.

As Kirkcudbright developed as an artist's colony other painters gathered round. E.A. Taylor (1874–1951) and Jessie M. King (1875–1949) set up home at Greengate in the High Street, where there is now a plaque over the archway door that gives a glimpse of an attractive garden beyond.

Taylor mentioned the silvery light of Kirkcudbright to **Charles Oppenheimer** (1875–1961) at a time when he was trying to decide where to make his home to concentrate on painting. Half English, half Scottish, Oppenheimer was born in Manchester, his father a manufacturer of mosaics. Though he studied mosaic design, a visit to Italy confirmed his real determination to be an artist and when he saw Kirkcudbright he knew at once that this was the place for him. He settled there with his wife, living next door to Hornel, and painted there with enthusiasm for 52 years, maintaining that 'the Highlands are too sensational. Fine to visit. Fine to climb. But not adaptable enough for painting.'

Paintings such as *The Tolbooth and Old Town, Kirkcudbright* and *Waterside, Kirkcudbright* are subtle, gentle, pleasing, and his work was popular and successful. In 1934 Oppenheimer was commissioned to paint the final stages of construction of Tongland Dam, two miles up-river of Kirkcudbright and part of the Galloway Hydro-Electric Scheme which was at that time the largest in Britain. It was an unusual instance of an artist being commissioned to use his artistic skills to reassure local people that this ambitious scheme was not going to spoil their riverside. The result is a fine and dramatic picture, *Galloway Dam*. Visitors to the dam today can see how in the intervening years the construction has blended into the countryside.

Several of the Colourists returned to Scotland from France during the First World War. Missing the inspiration of Paris, they discovered Kirkcudbright

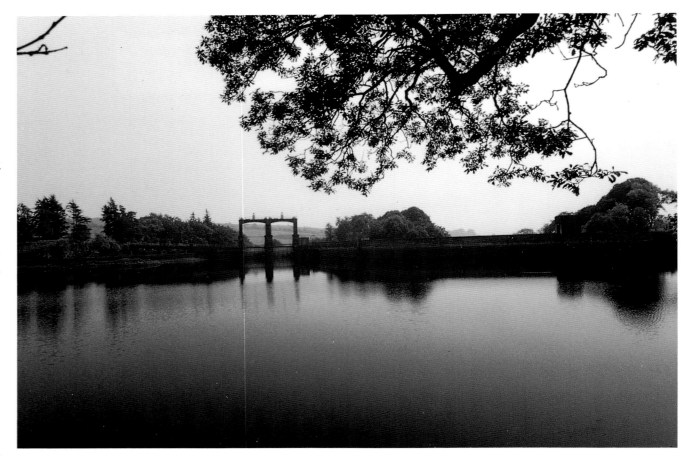

Tongland Dam, 1993. The photograph was taken near the point where Oppenheimer painted his 1936 picture; it is now a tranquil scene.

with delight and met again with friends from their student days in Paris. **S.J. Peploe** (1871–1935) came to terms with painting in Scotland again, staying with Taylor in Kirkcudbright. His high-key French colours were replaced by darker shades and greater emphasis on line and draughtmanship. This is evident in the superb *Kirkcudbright* of 1916, the strong colour applied in broad strokes. It shows Peploe at his best, producing a painting that is essentially Scottish, of the north, with a cool northern light, the cold look of the stone and the dark green foliage of the trees brilliantly conveyed in a striking dramatic picture. The influences that inspired him are evident – Van Gogh, Gauguin, Cézanne – but it is an individual and original work by a Scots artist.

During the war years Peploe and J.D. Fergusson enjoyed a close friendship, with intense discussions of their work and sessions of mutual criticism. They consolidated their work during those years, as can be seen from Fergusson's fine picture *A Lowland Church*. It is set among the rounded hills and greenery of Galloway, which he depicts as a typically Scottish town: small, grey and white, neat and tidy.

William Gillies was another frequent visitor to

Galloway, staying with John Maxwell at Dalbeattie and painting at Kippford (see page 20). William Myles Johnstone (1893–1974) also moved there in 1940 and developed an individual abstract style of painting coastal scenes.

The town continues to attract artists to the present day. Broughton House is at the heart of it; Hornel's gift to Kirkcudbright was designed to foster and encourage a love of art. The house, to which the art gallery and studio was added, contains a collection of paintings by Hornel and other artists, fine antique furniture and oriental curios. His studio contains many of his partially worked canvases and shows how the artist set about his work. There is also a library with a special Galloway collection – everything ever published on Galloway can be found here.

The garden, beautifully sheltered, extends from the house to the river, and the mild climate and fertile soil make possible the nurturing of delicate hot-house blooms in rich profusion, making it a feast

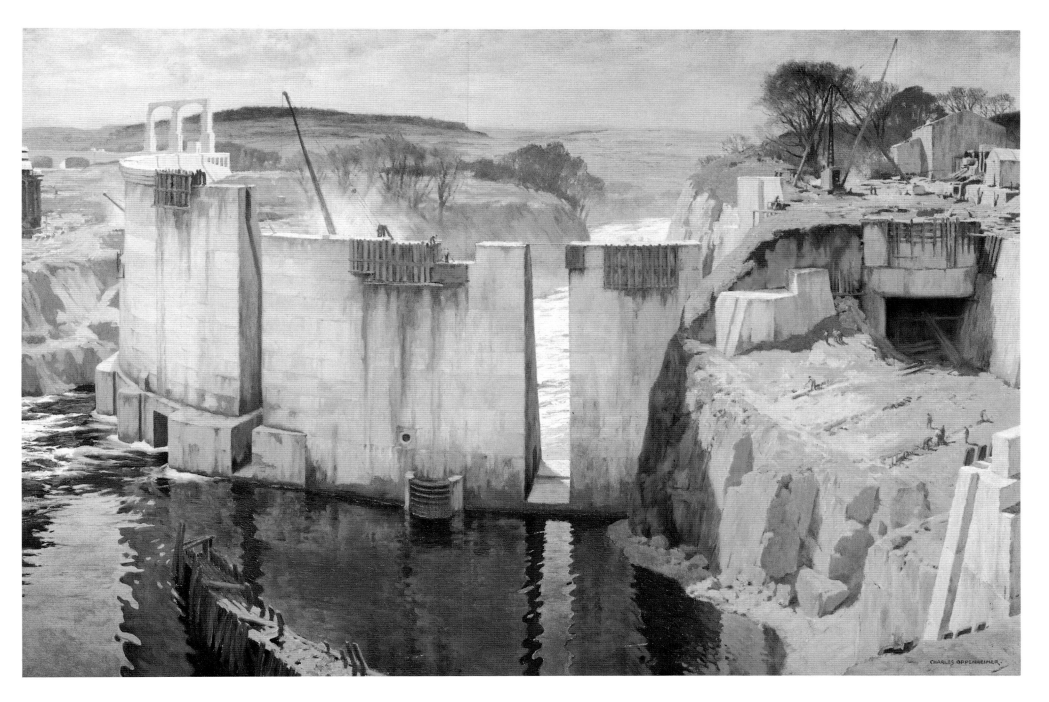

Galloway Dam, *Charles Oppenheimer, 1936 (Bourne Galleries)*
This painting is of the final stages of construction of the Tongland Dam in 1936, part of the Galloway Electric Scheme, at that time the largest in Britain.

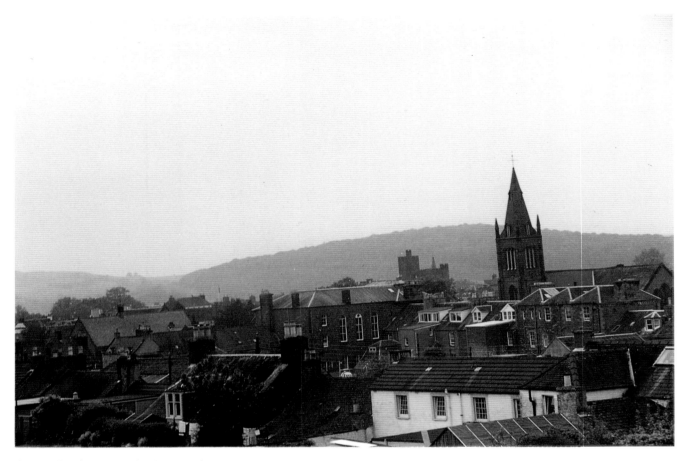

Kirkcudbright, S.J. Peploe, 1916 (Flemings)
Peploe avoids the picturesque view and produces a strikingly dramatic picture that is essentially Scottish, with strong colour contrasts of pale stone buildings and dark green foliage in a northern light.

of colour with bright poppies and crinodendrons. The section laid out in Japanese style lies near the house. Hornel designed this vista to be seen from the studio door, with a clump of bamboo, a flowering cherry tree and a lily pond watched over by the statue of a crane.

The garden was intended to be a sanctuary, a place of peace and repose where man could be close to nature. To linger in this serene and beautiful place is to share in the artist's pleasure in creating it.

The Harbour Art Gallery in Kirkcudbright is a whitewashed building by the river, sheltered enough for palm trees to grow beside it. The medieval Tolbooth building has now been developed into a major art gallery, opened by Her Majesty the Queen on 9 June 1993. This is a town where ordinary people take an interest in art and buy original paintings to hang on their walls (though the expense of opening the art gallery has not been without some criticism from local citizens who point out the importance of a new bridge).

Kirkcudbright is a town where people live and work, rather than a holiday place. There are a dozen fishing trawlers at the quay and a fish-packing factory providing employment. Work is under way to

Kirkcudbright, 1993. The photograph was taken from almost the same place as Peploe set up his easel for his painting; it demonstrates how the inspiration and technique of the artist has heightened the scene.

Broughton House, Kirkcudbright, home and studio of the painter E.A. Hornel, where there is an exhibition of his work.

A Japanese garden in the beautifully sheltered grounds extending from his studio door to the river.

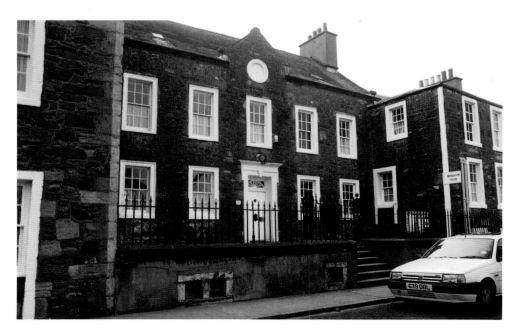

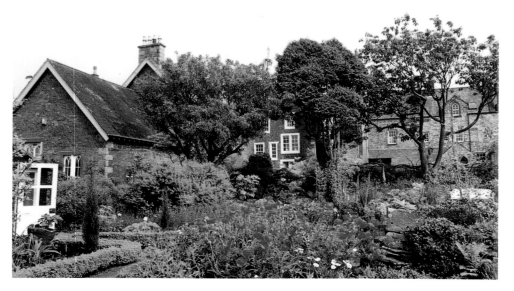

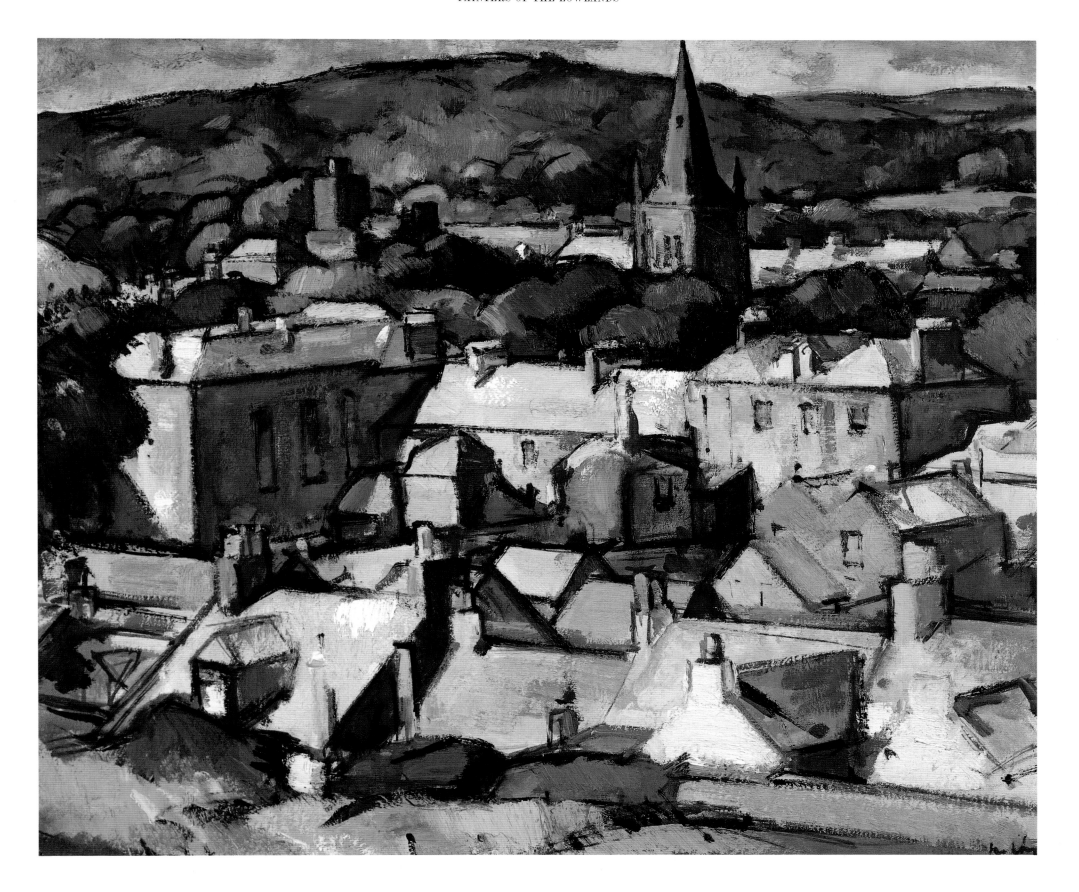

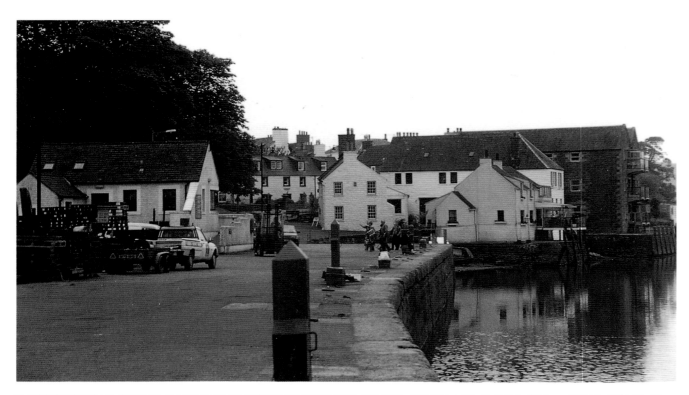

The riverside at Kirkcudbright, painted frequently by many painters, including Oppenheimer.

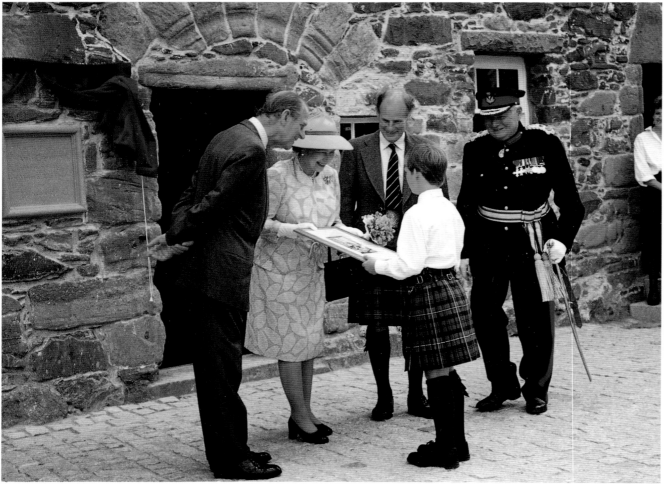

(Below left) Her Majesty the Queen unveiled a plaque to open the new Tolbooth Art Centre, Kirkcudbright, in June 1993, and was presented with a framed print of the Tolbooth by local artist Linda Mallett, commissioned by Stewartry District Council.

(Below right) The Harbour Art Gallery, Kirkcudbright, by the harbour.

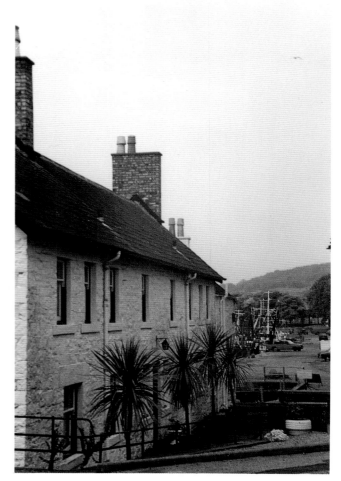

*A **River Landscape**, E.A. Hornel, c.1920 (Sotheby's)*

lay a gas pipeline to Dublin under the narrow lanes to Brighouse Bay where Hornel painted, though the blue flax and pink campions still make the shoreline as flowery and pretty as it was in his day.

A series of beautiful south-facing beaches extends along the Solway coast, but they are scarcely signposted and remain largely undiscovered and unspoilt. Accommodation is limited in the town, and though there is a restaurant serving locally caught fish and very good Galloway beef it takes some finding. Galloway and Kirkcudbright have a lazy kind of laid-back charm, discreet, unostentatious. This is a place for artists to feel at home.

PATERSON AT MONIAIVE

James Paterson (1854–1932) had always enjoyed painting in the Dumfriesshire countryside and in 1884 he bought a house in the village of Moniaive, between Dalwhat and Craigdarrock Waters. He was the first of the Glasgow Boys to marry and settle in one place, and he was also the most devoted to landscape.

His friends often visited him from Glasgow and there are photographs showing him painting in the open air with a large umbrella to protect his canvas from the direct sunlight. He cuts rather a dash in these photographs – the gentleman painter in his velvet jacket, knickerbockers and beret.

Paterson's friendship with William Macgregor was of mutual benefit and support, similar to those of Hornel and Henry, Walton and Guthrie, producing group strength among the Glasgow Boys as well as individual confidence. His letters to Macgregor reveal how he kept in touch with the group, although he was thought to be aloof and rather too respectable for the revolutionary image they liked to cultivate. He was also financially better off than they were.

Paterson was born in Glasgow, the son of a successful businessman, and he worked in business for several years before being allowed to study art in Paris. His French training was very important; he experienced contemporary developments in French art, learning a lot from Corot for whom he had great admiration, and he visited Italy, Egypt and Switzerland.

Back in Scotland, he spent some months working with Macgregor in Bath Street, Glasgow, which had become the centre for the Glasgow group. They also worked together at St Andrews, Nairn and Stonehaven, but few pictures survive. Macgregor saw himself as the leader of the group and ran life drawing classes, but Paterson was primarily a landscapist and went his own way.

He established himself in the village of Moniaive, but whereas his colleagues in Cockburnspath and in Kirkcudbright painted the village people at work in farms and cottage gardens, for Paterson figures were incidental. His great skill was in capturing the moods of the countryside. He produced idyllic rural scenes, peaceful and quiet but not romanticised; he was just as much in touch with reality as the others were. The finest landscapes in rich imaginative colours – *Autumn, Glencairn, Moniaive, Last Turning Moniaive*, and *Winter Sunshine, Moniaive* – are classic landscape compositions, with figures walking away into the distance, reflections of the sky in the water, clouds massing overhead and a sense of space and distance created by the receding line of a river, fence or path.

Some of Paterson's rural watercolours of the valley of the River Nith were reproduced in a book called *Nithsdale*, published in 1893, which he wrote and illustrated. He was a painter who thought through his personal approach. He did not believe in 'flirting with a new area to paint each recurring summer, but to marry metaphysically some well-chosen space, seeking not the obvious picturesque but allowing nature's features gradually to find their way to the heart'.

Paterson's distance from Glasgow and his role as a literate painter led to the establishment of the *Scottish Art Review*, the mouthpiece of the Glasgow school, which he championed and partly funded. In the late 1890s he began to spend more time in Edinburgh and painted Edinburgh from Arthur's Seat and from Craigleith Quarry. He moved there in 1905 when he became Librarian and then Secretary of the Royal Scottish Academy; in 1922 he was made President of the Royal Scottish Society of Painters in Watercolour.

After the death of his wife in 1910 he began to paint abroad and his colours, restrained in Scotland, became more vivid and daring in France, Corsica, Italy and the Canary Isles.

With his fine colour sense, Paterson was typical of Scottish landscape artists. He added to his natural instincts as a colourist the experience of art training in Paris, then brought that knowledge back to his roots in Scotland and painted the scenery that was dear to him in his native land. He never took the path to London in search of a better income or a chance to have his work exhibited. He made his living as a landscapist in Scotland and remained an individual, not bowing to the edicts of Edinburgh or the demands of the Glasgow group.

His work does not decline in quality in later life, as happened with several others of the Glasgow Boys; it remains fresh and vibrant.

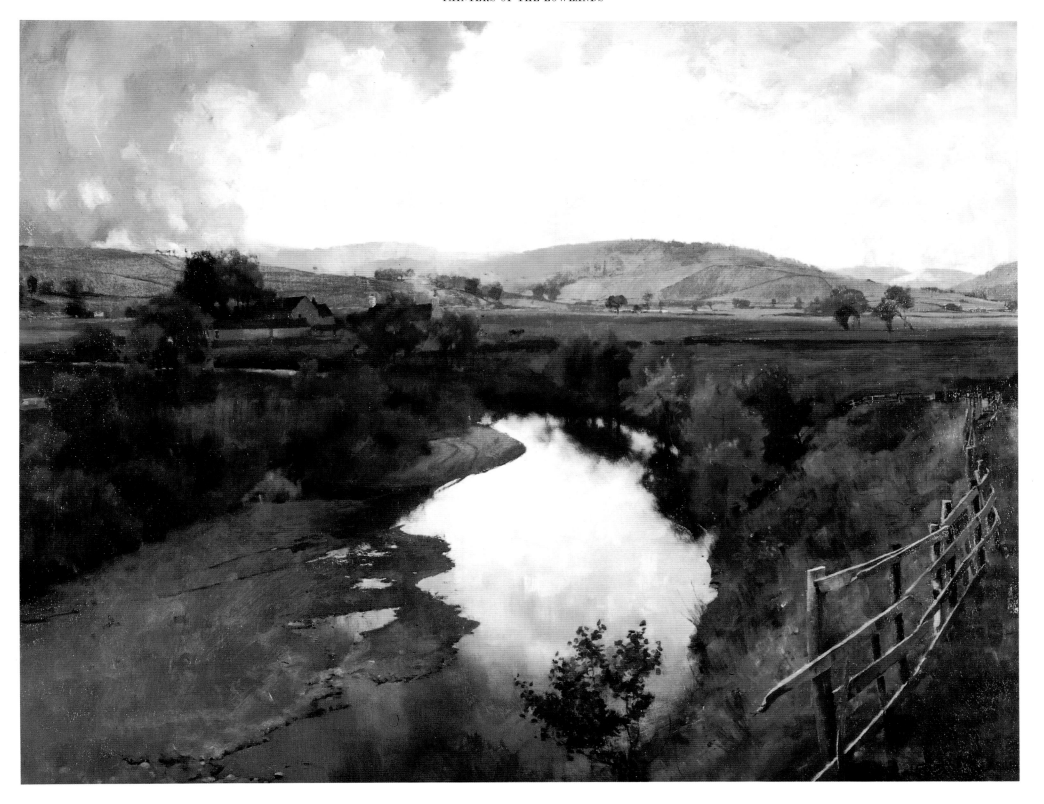

Autumn in Glencairn, Moniaive, *James Paterson, c.1886*
(National Gallery of Scotland)
Paterson settled in Moniaive in 1884 and enjoyed painting the
countryside there. He remained the only one of the Glasgow Boys
to devote himself entirely to landscape.

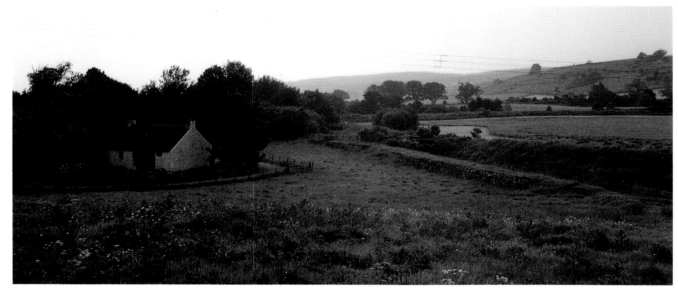

Views of Moniaive from Paterson's house and from Glencairn Church.

Scott and his Illustrators

Sir Walter Scott made the Trossachs and the Highlands popular with a multitude of readers who set off north in search of the romantic scenes he described. Yet he lived in the Lowlands, in the Border counties of Selkirkshire and Roxburghshire. Abbotsford was his home, the Eildons, Moorfoot, Lammermoors and Cheviots were his hills. On the road from Melrose to Dryburgh was a view where Scott always stopped his horse and where, according to legend, the horse stopped after its master's burial.

It was the Lowlands that first inspired him. His love of poetry and romance derived from the old songs and the Border ballads. Artists illustrating his work had to seek out the most dramatic scenery they could find to match his vision and his spine-chilling storytelling.

John Thomson (1778–1840) painted Fast Castle on the east coast, high above terrible seas, a dark dramatic picture made more wild and forbidding because Fast Castle is associ-ated with Wolf's Crag Castle in *The Bride of Lammermoor*. Thomson, known as John Thomson of Duddingston because he succeeded his father as minister and moved to the manse at Duddingston near Arthur's Seat, gained a reputation for 'those terrible seas and skies which only Thomson can paint'. Sam Bough (1822–1878) conveyed the awesome loneliness of Muschat's Cairn where Jeanie Deans must go to meet the mysterious stranger in 'The Heart of Midlothian'. J.M.W. Turner's illustrations of Scott's work show tiny figures dwarfed by the majesty of mountains, strug-gling against the odds.

It has been said that with so much emphasis on the dramatic Highland settings, Scott did not convey to English readers the quiet and subtle charm of his own Lowland countryside, and many travellers from south of the Border were surprised by its beauty. Jane Austen wrote in a letter about her brother Henry's tour of Scotland in 1813: 'He met with scenes of higher beauty in Roxburghshire than I had supposed the South of Scotland possessed.'

It was the landscape of the Lowlands that inspired 'The Heart of Midlothian' and one of his most haunting poems – 'Proud Maisie' (1818).

Proud Maisie is in the wood,
Walking so early;
Sweet Robin sits on the bush,
Singing so rarely.

'Tell me, thou bonny bird,
When shall I marry me?'
'When six braw gentlemen
Kirkward shall carry ye.'

'Who makes the bridal bed,
Birdie, say truly?'
'The grey-headed sexton
That delves the grave duly.

'The glow-worm o'er grave and stone
Shall light thee steady.
The owl from the steeple sing,
"Welcome, proud lady".'

Muschat's Cairn, Sam Bough, an illustration from The Heart of Midlothian *by Sir Walter Scott (Melrose Edition, published in London by the Caxton Publishing Co).*

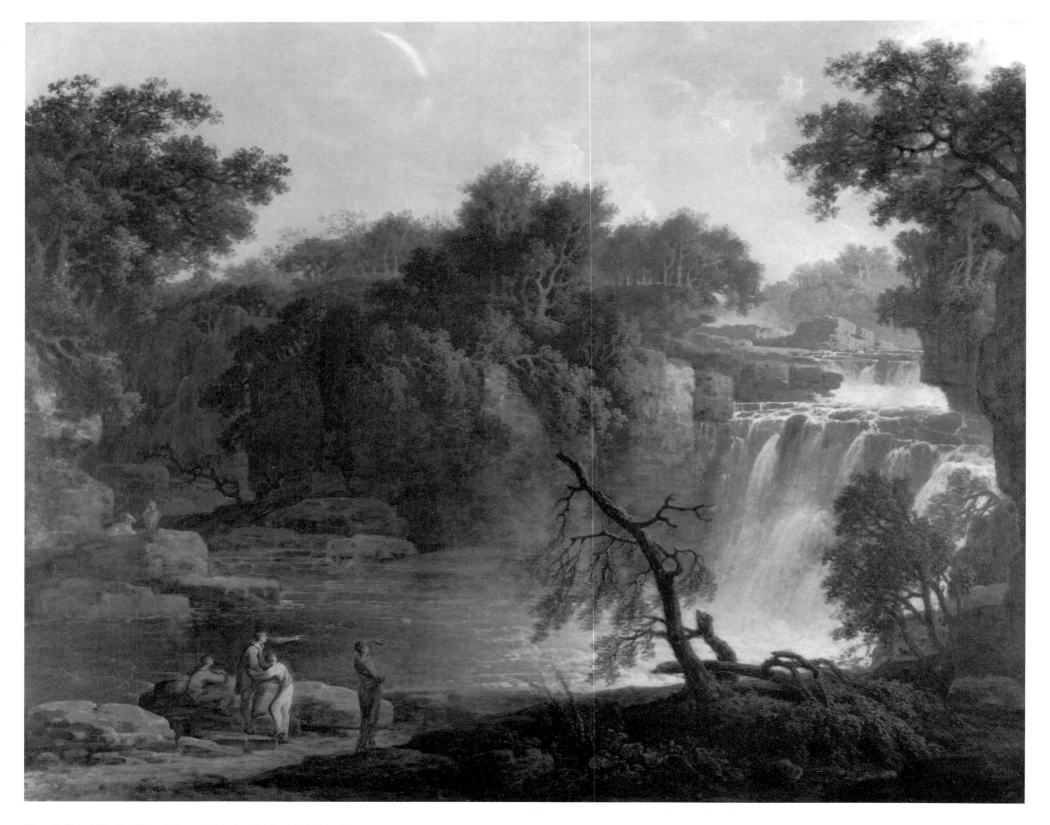

The Falls of Clyde: Cora Linn, *1771, Jacob More (National
Gallery of Scotland)*

PAINTERS OF GLASGOW AND THE CLYDE

THE FALLS OF CLYDE

THE Falls of Clyde in their spectacular setting, a wooded gorge below the ancient royal burgh of Lanark, were the most popular place in Scotland for eighteenth-century travellers. Turner, the Wordsworths and Coleridge were among the English visitors who found these sublime falls beautifully picturesque, the waters dashing over the rocks in an aweful torrent untamed by man. They were considered a natural national monument then and in their setting were thought to be on a par with classical Greek and Roman landscapes.

They were also an inspiration for many artists. The earliest and most ambitious work celebrating the falls was a series of oil paintings by Jacob More – *The Falls of Clyde* – now in the National Gallery of Scotland. **Jacob More** (1740–1793) was trained at the Trustees Academy in Edinburgh and worked with Allan Ramsay in Rome. His paintings of the three most impressive waterfalls on the stretch of the River Clyde above and below Lanark – Bonnington Linn, Cora Linn and Stonebyres Linn – have a classical and dignified serenity in keeping with the status and magnificence of the falls. More, who designed stage scenery before turning to landscape painting, is considered Scotland's greatest neo-classical painter and he gained recognition in Europe in his own lifetime.

J.M.W. Turner (1775–1851) visited the falls in 1801 on his first Grand Scottish Tour, making sketches on the spot which he later developed into a detailed watercolour, *The Falls of Clyde: Cora Linn*, with added naiads disporting on the rocks. The work was exhibited at the Royal Academy in 1802 and the viewer was referred in the catalogue to the poem 'Hymn to the Naiads' by Mark Akenside. This was to make it clear that these were no ordinary women bathing in the cold Clyde, but symbols of the underlying force of nature.

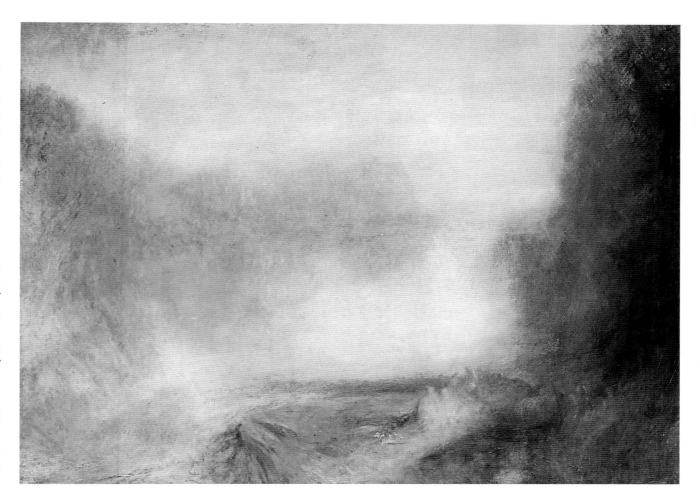

The Falls of Clyde have been harnessed by a hydroelectric plant in recent years, but they are still spectacular in full flow after heavy falls of rain. There is now a Falls of Clyde Visitor Centre in New Lanark in the old dyeworks building, part of a Scottish Wildlife Trust Reserve. New Lanark, an industrial village, itself the product of the Industrial Revolution, is now the subject of a major industrial conservation programme.

Turner's trip to Scotland was the most ambitious he had undertaken. He 'thinks Scotland a more

The Falls of Clyde, *J.M.W. Turner, 1801 (Liverpool Art Gallery)*
Turner visited the Clyde waterfalls on his first grand Scottish tour in 1801 and was greatly impressed with their majesty, the powerful forces of nature. He made sketches on the spot and later added naiads bathing.

picturesque country to study in than Wales', wrote the painter Joseph Farington. 'The lines of the mountains are finer, and the rocks of larger masses.' Although Turner sketched wherever he went, he

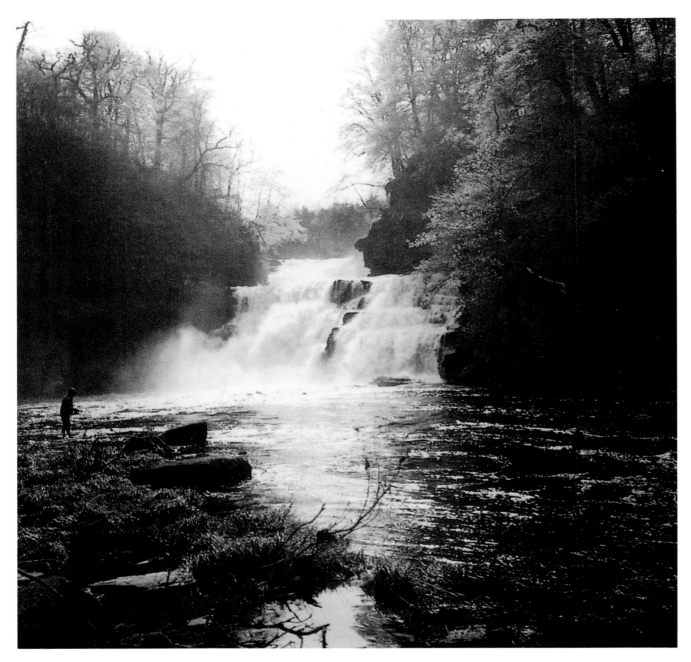

The Falls of Clyde, 1993. The Falls, in their spectacular setting of a deep wooded gorge, were Scotland's premier tourist attraction in the eighteenth century. Now part of a Scottish Wildlife Trust reserve, the waterfalls of Cora Linn and Bonnington Linn in full flow are still a remarkable sight.

adapted the features of a landscape in one place to the season, weather and lighting conditions in another to make the best picture when he was back in his studio. He would alter and omit elements of a view that didn't fit in with his ideas, and often his landscapes bear little resemblance to the place in reality. He said: 'To select, combine and concentrate that which is beautiful in nature and admirable in art is as much the business of the landscape painter in his line as in the other departments of art.' Jacob More's and Turner's paintings of the Falls of Clyde are both recognisably the same place, however, and in the same tradition.

The classical dignity that More brought to his paintings is also evident in Horatio McCulloch's *The Clyde from Dalnottar Hill*, 1858 (see page 13), for he was a painter in the same genre. McCulloch introduced more naturalism, and careful observation distinguishes this outstanding work, but he still rearranged the foreground to improve the composi-

tion. His early landscapes have an Italianate feeling, and blue skies of heavenly calm. Only gradually in landscape paintings by artists in the early nineteenth century did the weather begin to play its part.

The Falls of Clyde continue to inspire artists. Duncan Shanks, who was born in Airdrie in 1937 and studied at Glasgow School of Art, later becoming a lecturer there, painted *Cora Linn* with a brilliant kaleidoscope of broken colour conveying the spray of falling water.

ART AVANT GARDE IN GLASGOW

Glasgow has become a famous name in art, synonymous with vigorous *avant garde* creativity, but until the second half of the nineteenth century Edinburgh was culturally pre-eminent in Scotland and Glasgow's citizens were generally regarded as 'shopkeepers, mechanics or successful pedlars'.

Painters such as Horatio McCulloch, born in Glasgow and apprenticed to a house painter while he took lessons in art from John Knox, set out on painting trips all over Scotland; but they settled in Edinburgh. William McTaggart, coming to Glasgow from far Kintyre in determined search of art training, was advised he must seek it in Edinburgh.

Later in the century, as Glasgow approached the high point of commercial prosperity, there was a powerful upsurge of creative confidence among the younger generation of artists. They took on the Establishment, challenged the pre-eminence of Edinburgh and made Scottish art a new and exciting force in the land.

They became known as the Glasgow Boys, but when they started out the city didn't give them great encouragement. The Glasgow Art Club, founded in 1867, declared that it 'comprises in its membership all the leading artists in Glasgow and the West of Scotland', yet it rejected the applications of James Guthrie, W.Y. Macgregor, E.A. Walton and James Paterson and it was these artists who formed the nucleus of the new group. Many of them had trained in Paris and they were influenced by the new ideas of social realism in art as expressed by Bastien-Lepage and J.M. Whistler.

Muslin Street, Bridgeton, John Quinton Pringle (Edinburgh City Art Centre)
A solitary painter with a small output, overlooked in his lifetime, he is now being re-discovered and his work is much sought-after.

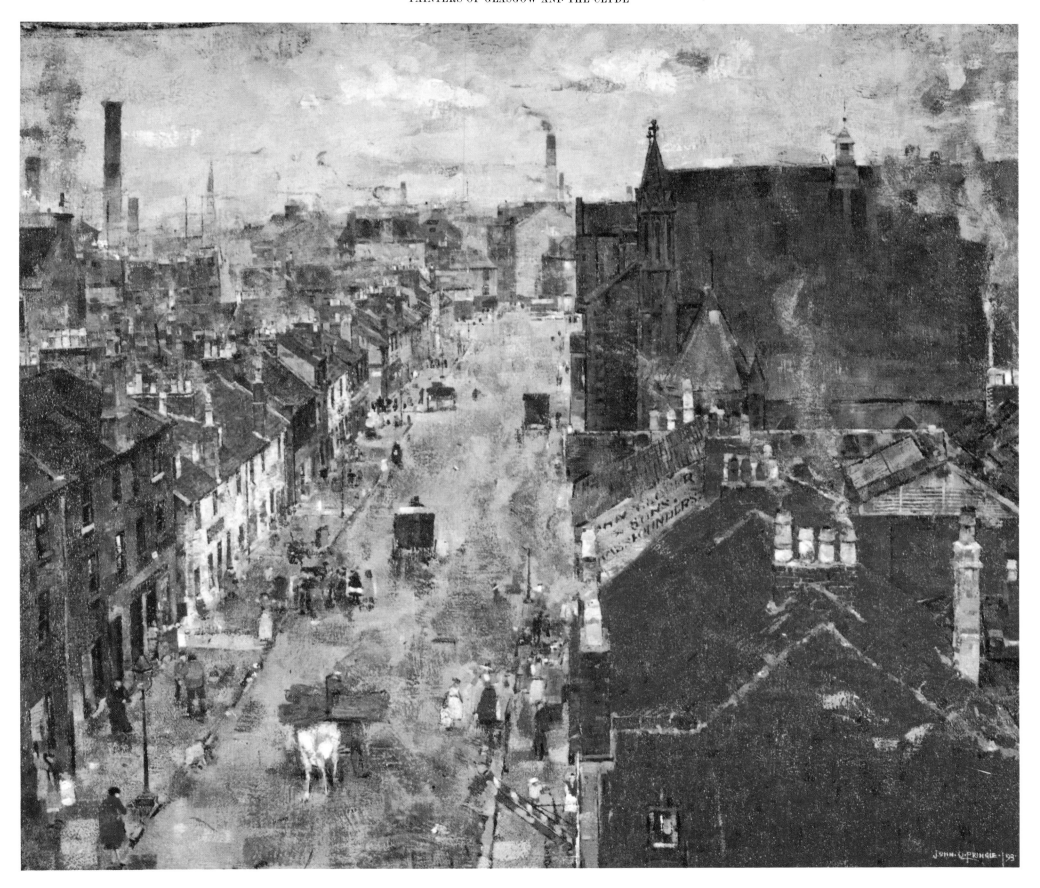

The group evolved out of friendships – Paterson and Macgregor who worked together on the east coast; Walton, Joseph Crawhall and Guthrie who painted at Rosneath on the Clyde, then at Brig o' Turk where they were joined by Henry; Lavery, Kennedy, Melville and others who worked together at Gres-sur-Loing near Fontainebleau; then Henry and Hornel at Kirkcudbright.

During the 1880s Macgregor ran a life-drawing class in his Glasgow studio and many of the young artists came together there. The summer months were usually spent working in small rural communities such as Cockburnspath or Kirkcudbright, an idea inspired by Bastien-Lepage at Damvillers and the Newlyn school in England. Determined to record rural life as it really was, they painted the local cabbage patches in a series of outstanding pictures and earned themselves the name of the Kaleyard School.

They returned to work in Glasgow when the summer ended. Around 1883 **E.A. Walton** (1860–1922) painted a remarkable series of watercolours of Helensburgh, a prosperous suburb of Glasgow, and its well-dressed people. These watercolours are regarded as some of the finest of the Glasgow school, with their clarity of image and colour and decorative sense.

John Lavery (1856–1941), too, chose the suburban life of Glasgow when he painted *The Tennis Party*, a painting of great technical skill with a sunny leisured atmosphere far removed from the grime of industrial life. It is a cool green and white image of late Victorian leisure with a frieze of background trees. A woman on the tennis court in a long bustled dress holds her racquet high, a young man is poised to return the ball, while among the spectators a man in plus-fours smokes his pipe as he leans elegantly on the fence.

Lavery is one of the most interesting artists of his time. He had extraordinary technique and covered a wide range of subjects, including portraits, horse-racing scenes and fashionable interiors as well as landscapes. Though born in Belfast, he studied in Glasgow, then London and Paris. He became associated with the Glasgow school of painters when he spent the summer of 1883 painting at Gres-sur-Loing near Fontainebleau, where a number of fellow students were attracted by the new ideas of Bastien Lepage and identified with the reality of rural life.

He received a commission to paint Queen Victoria's visit to the Glasgow International Exhibition in 1888 and his subsequent successful career in London set the pattern for several of the Glasgow rebels who abandoned their controversial style in later life.

By the time David Martin's book *The Glasgow School of Painting* appeared in the 1890s, celebrating their work in a city that hadn't always supported them, most of them were busy establishing their careers elsewhere. But their adventurous ideas and their keen interest in European painting had been shared by a number of enlightened collectors and dealers in Glasgow, notably Alexander Reid, and they had achieved what they wanted – acceptance as artists in their own country.

It could be said that most of the Glasgow artists didn't paint the real Glasgow, but the solitary painter **John Quinton Pringle** (1864–1925) certainly did. He was frequently overlooked in his lifetime, for his output was small. Other artists appreciated his work and it is now being rediscovered and is much sought-after. Pringle, born in the east end of Glasgow, was the son of the stationmaster at Langbank and in 1896 he set up his own shop at 90 Saltmarket carrying out optical repairs.

A contemporary described the shop as 'probably not only the worst run shop in Glasgow, but perhaps the worst run shop in Europe. It was hard to pay Pringle anything… but it was also hard to get anything out of him if you had committed it for repair.' He painted at weekends and after hours, in oils, applying the paint in a mosaic of small brush-strokes, and in watercolour.

His best work has a haunting quality – *Poultry Yard, Gartcosh*, 1906, *Whalsey Bay with Girl in White*, 1924, and above all *Muslin Street, Bridgeton*, the outstanding Glasgow painting of a part of the Gorbals long gone, smoke pouring from the grimed chimneys, houses huddled in close-packed rows, with a gritty sense of struggling humanity. This painting is in the keeping of the City of Edinburgh Arts Centre, but has not been on display for several years.

D.Y. Cameron (1865–1945) was another artist who launched his career in Glasgow, at a particularly exciting time. Glasgow born and trained, he knew the Glasgow Boys but worked apart from them, partly because his early work was in etching and partly because his temperament and background as the son of the manse, a keen churchman devoted to church music, made him less gregarious and revolutionary than others in the group.

He had the familiar difficulties of persuading his family that he should train as an artist, but his career took off through a chance meeting with George Stevenson, a partner in the family firm of Glasgow shipowners, exporting coal and iron. Stevenson, an enthusiastic amateur etcher himself, spotted some sketches by Cameron in a shop window in a narrow side-street off the Great Western Road when he was forced to stop to adjust a loose stirrup. He was so struck by the pen-and-ink sketches that he bought them and after some trouble he succeeded in finding D.Y. Cameron (who 'never, never, never liked to be called David'). He taught him everything about etching and persuaded him to become an etcher by profession.

Cameron exhibited with Macgregor, Paterson and others at the New English Art Club in 1892, at the Grafton Gallery in London in 1893 and in Paris at the Salon Champ de Mars in 1895. He first came to prominence as an etcher with scenes of Glasgow and the Clyde, Perthshire and the Borders. *The Clyde Set* of twenty etchings, published in the monthly art magazine *Portfolio* in 1889, was a detailed architectural study of Glasgow, the Clyde valley, and Greenock with sailing ships moored in the busy harbour.

He was acknowledged as one of the greatest print-makers of the twentieth century in the 1920s, with his etching and drypoint of 1911 *Ben Ledi* regarded as one of his finest prints, rich and full toned. Often his etchings sold for larger sums than the oil paintings of his contemporaries; one fetched a world record $2,500,000 in 1925. Cameron was awarded many honours, including an Honorary Degree of Law by Glasgow University, greatly pleasing to one who had left school at sixteen. He was an influential figure in the art world of London and in Scotland, though he refused nomination for the presidency of both the Royal Academy and the Royal Scottish Academy. Cameron's work has been largely forgotten in recent years, but the integrity and quality of his art will surely be rediscovered.

Cameron's early experiences were an example of how the commercial and industrial prosperity of Glasgow was beginning to support the arts, a trend which culminated in Glasgow's international exhibitions of 1888 and 1901. The nucleus of the civic collection came from Archibald McLellan, a wealthy Glasgow coachbuilder and friend of Sir David Wilkie. McLellan bequeathed his collection of Old Masters to the city and also the galleries he had built in Sauchiehall Street.

The growing interest in art, and increasing numbers of collectors wanting advice on foreign and

Upper Clyde Valley from **The Clyde Set**, *D.Y. Cameron,*
1889 (Garton and Co)
Cameron launched his career in Glasgow and produced some of
the greatest prints of the nineteenth century and some of the most
expensive in the world.

Scottish artists, led to the establishment of Glasgow art dealers. Craibe Angus was one of the first, opening a gallery in 1874 and dealing particularly in paintings of the Hague school which were highly popular in Scotland. Alexander Reid was the most notable dealer, having worked in Paris for Boussod and Valadon with Theo Van Gogh, whose brother Vincent painted two portraits of him. Reid's gallery, La Société des Beaux Arts, opened in 1889. He was the first dealer to show the Impressionists in Scotland and to handle Whistler's work. He became one of the foremost dealers in Britain, continuing until the 1930s, and Sir William Burrell, the industrialist art collector, said of him: 'He did more than any other man has ever done to introduce fine pictures to Scotland to create a love of art'. Reid helped the Glasgow Boys to get started and it was with their support and campaigning that the adventurous Glasgow City Art Council bought Whistler's portrait *Thomas Carlyle* in 1903.

The Art Nouveau School of Art

Charles Rennie Mackintosh was born in 1868 in 'raw, rich Glasgow, the city in which only engineers prosper', according to the German art critic Herman Muthesius. He trained there as an architect and created the buildings there which won him acclaim on the Continent as a brilliant, innovative art nouveau designer. Yet he never received recognition in his own city, and in fact he didn't like art nouveau.

It is doubly ironic that art interest in Glasgow has since centred upon the school of art which he designed, and that the design was later hailed as the outstanding British example of art nouveau, for he fought against the sinuous erotic curves of art nouveau with stern straight lines.

When he was 28 years old and working as an assistant in the architects' office of Honeyman & Keppie, Mackintosh entered a competition to design a new building for the Glasgow School of Art. This was a time when the school was flourishing under the inspired direction of Francis Newbery, but it was a daunting commission. The site was narrow and steep, the accommodation required was extensive, and the funds for construction, equipping and furnishing the entire building at first amounted to only £15,000.

''Tis but a plain building that is desired,' said the governors of the school in 1897, and a plain building they got, stark, massive, like a medieval fortress rising from the steep incline of Dalhousie – extraordinary in an age devoted to surface ornament.

'At first sight it is austere, rectilinear, functional, its stark walls stripped bare of sculptural ornament. Yet within and without functional glass and wood, metal and stone are conjured into decoration. Austerity is relieved with a wilful asymmetry, straight lines break into graceful curves, dark corridors open into white airy spaces. It stands with one massive wall of stone planted squarely in Scotland's past and another of glass leaping upward into the future:

the Glasgow School of Art,' to quote the book on Charles Rennie Mackintosh produced by the Glasgow School of Art.

The bold choice of Mackintosh's design was due to Newbery, who appreciated his adventurous modern vision. Work began in 1897 but Mackintosh, as a mere draughtsman, was given little acknowledgement and the building went unremarked. The final section was not started until 1907; during those intervening years Mackintosh was at his most successful and creative.

Mackintosh and his friend Herbert MacNair, a fellow student, had married the artist sisters Margaret and Frances Macdonald. 'The Four' collaborated on designs for furniture, metalwork, illustration and interior decoration, with commissions from friends and patrons. They worked together on tea room interiors, at a time when tea shops were a new social phenomenon in Glasgow, designed as places of refreshment, meeting-places, and often art galleries as well, to counteract the influence of the gin shops. They also took commissions for large private homes, integrating architecture and interior design in a way that had never been done before. Margaret worked closely with Mackintosh on commissions and was always a vital inspiration to him.

Still Mackintosh's pioneering achievements were never taken seriously in Glasgow and by 1913, he had given up hope of working as an architect in Glasgow, terminating his partnership with John Keppie. On holiday in Suffolk with Fra Newbery and his wife, Mackintosh sketched and painted again, something he had always enjoyed. He produced delicate watercolour flower studies, moving towards symbolism and developing his own symbols, the awakening bulb, long flower stems and buds.

He tried to re-establish himself as an architect and designer without success. It was then a time of economic decline in Glasgow after the First World War, and not much easier in Chelsea, where he and his wife settled. Architects are always the first to suffer in

economic depression when there is not the confidence to invest in major projects. Thus, when Mackintosh's achievements should have earned him status and recognition, there was no place for him.

Yet he remained vigorously creative, supported by his happy marriage. The story that he declined into alcoholic self-pity is denied by the quality of his later work and by his letters revealing his enjoyment of life. By 1923 they were living in the south of France at Collioure and later Port Vendres, and he was concentrating on landscape painting.

The landscapes he produced are constructed with the eye of an architect, man-made features incorporated as part of the natural structure of the land. His later watercolours have been described by the watercolour specialist Julian Halsby as among the most remarkable in Scottish art. The decorative style of the flower studies and the powerful individuality of the Mediterranean landscapes were produced in isolation in France, depriving Glasgow of the driving force and innovation of the talents of Mackintosh and The Four, and leaving no Mackintosh landscapes of Scotland, though a watercolour painting of Glasgow Cathedral in the Glasgow University collection shows how much has been missed.

It is a sad story that ends, as for so many artists who have been misunderstood and whose work has been denied recognition in their lifetime, with acknowledgement only after his death of the masterpieces he had created and his singular futuristic vision. Mackintosh died in 1928 of cancer of the tongue; his wife survived him for five years. When she died, the entire contents of their home and studio, including several of his chairs and the French landscape paintings he had been preparing for exhibition, were valued at £88.16s.2d. Yet despite his poverty and obscurity *The Times*'s obituary acknowledged that 'the whole modernist movement in European architecture looks to him as one of its chief originators'.

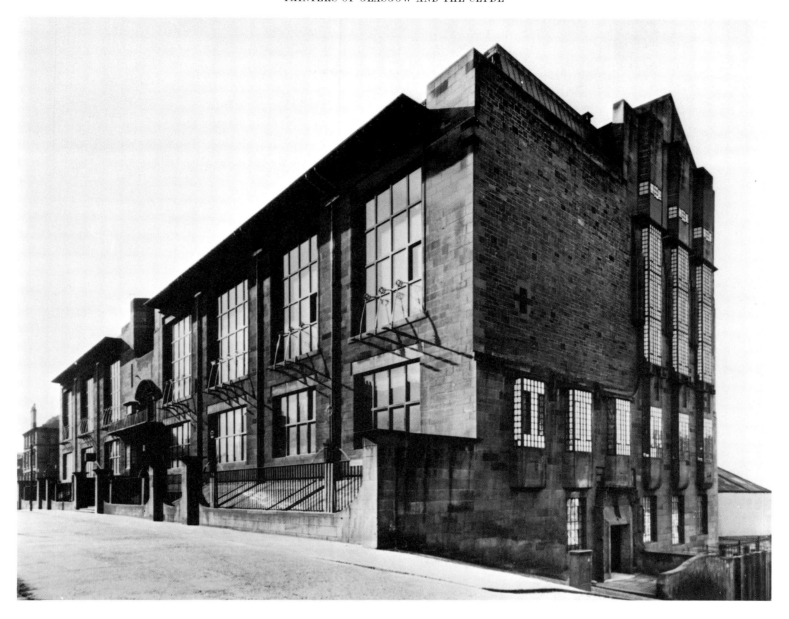

FERGUSSON AND FRIENDS

John D. Fergusson (1874–1961) came late in his long career to Glasgow when he returned to Scotland at the outbreak of the Second World War. He chose to settle in Glasgow because it was the most Highland city – he said Edinburgh was a suburb of London. He had always been an outspoken individualist.

Born in Leith and educated in Edinburgh, Fergusson gave up medical studies in order to paint; he then rejected art school training when he discovered he wasn't allowed to work from a model until his third year. From the start he had made up his own mind. He was largely self-taught, working out his own theories and articulating his beliefs. He adopted a technique of his own, painting in oil on 5 x 4 inch wood panels which he could slip into his pocket. It soon became clear that Edinburgh was too limiting and he set off for Paris in 1895.

There he went to the Salle Caillebotte and the Luxembourg, where he saw the work of Monet, Renoir, Sisley and Pissarro. He was drawn to the tonal painting of Velasquez, Manet, Whistler and Courbet. Outgoing and gregarious, he joined in the café sessions and aired his own artistic beliefs; he became a personal friend of Picasso, Braque, Vlaminck and de Segonzac. He sketched elegant ladies in fashionable dress in the Paris boulevards, in the music halls, at the Russian ballet, all in a style

North facade of Glasgow Art School, designed by Scotland's art nouveau architect, Charles Rennie Mackintosh. 'The north facade is one of the greatest achievements of all time, comparable in scale and majesty to Michaelangelo.' Robert Venturi, 1985.

rather like that of the Fauves, but with subtle use of colour.

In Paris he met Margaret Morris, who was there with her company of dancers, appearing at the Marigny Theatre. They became known as Fergus and Meg, and combined their interests in art and ballet and France for the rest of their lives. In her *Biased Biography* of her husband, Margaret Morris quotes Fergusson's notes on painting, on the Glasgow Boys as opposed to the Academics:

By painting I mean using oil paint as a medium to express the beauty of light on surfaces. What we used to call in Scotland 'quality of paint' – with solidity and guts – not drawing a map-like outline and filling in the spaces, with an imitation of the colour of the object with the paint.

That is the difference between the 'Glasgow School' paintings and academic paintings. I try to describe it as the difference between Harris tweed, composed of all sorts of colours in wool, and any cheap material dyed one flat colour.

Fergusson moved to France to settle in Paris in 1905 – and soon he had succeeded in persuading his friend Peploe to join him. **S.J. Peploe** (1871–1935) had held successful exhibitions of his work in Edinburgh. He sold 60 paintings at his second exhibition at the Aitken Dodd gallery for £450 in 1910, in order to marry Margaret McKay – the girl he met on one of his trips to the Western Isles – and move to Paris.

Generally considered the most conservative and staid of the four Scottish Colourists before going to France, Peploe responded to the intellectual stimulus of Paris. His style changed and he gained friends and confidence. There was a corner table at Boudet's restaurant where they used to meet, and the waitress from the Cote d'Or region, generous as the finest Burgundy, used to mother them and serve them 'bon chateaubriand à quatre-vingt dix', cooking it herself and presenting it to them 'as if they had a perfect right to be artists'. It was heady stuff for the young Scots, who had to fight derision and mockery on their home ground.

The amazing creative decade before the First World War in Paris has often been described, but never enjoyed more than by Fergusson. He was at the heart of it, involved with Katherine Mansfield, with Middleton Murry and Michael Sadler as art editor of *Rhythm*, the arts magazine named after his painting of 1911 (now in the University of Stirling). Many of his friends were musicians, and he was interested in the latest music and its relation to modern painting. He writes most vividly of his friendship with Peploe:

… from the start, Peploe and I had been together. When Hunter came back to Scotland from San Francisco after the earthquake, Alex Reid made the three of us and Cadell into a group. We became known in Paris as 'Les Peintres Ecossais'. John Ressich, the writer, fought very hard for us with great sympathy

and intelligence and entirely disinterestedly… We went everywhere together, to meet Picasso, to go on painting holidays to Etaples, Paris-Plage, Dunkirk, Dieppe, Etretat, Le Treport, to Royan where Peploe's son was born, to Cassis, to Antibes.

As I think about Peploe, I remember a day when we were painting in a wood near Paris-Plage. The light on the tree trunks set me wondering. What paint should I use to express it? When Peploe came up we agreed that it needed something like pastel. That was the beginning of our awareness that oily paint is not for everything. There were many beginnings like that which each of us, in his own way, developed in his painting… I am writing too much – just as though I were talking to Peploe; but it is difficult to be brief about a wonderful friendship that lasted a lifetime. It was, I think, one of the best friendships that has ever been between two painters.

During the First World War Fergusson was back in Scotland, shuttling up and down the country between Margaret Morris and her dance company in London and landscape painting in Scotland on a Highland tour which produced *The Drift Posts* and *A Puff of Smoke Near Milngavie*. The twenties were a successful time for him, with his first one-man show in Scotland, and exhibitions in London, Paris and New York with Peploe, Hunter and Cadell. Then he returned to France and continued to live in Paris and Antibes, while the other three Colourists came to terms with painting in Scotland.

When he finally returned to Glasgow, he and his wife moved into 4 Clouston Street on the top floor of a corner house with views over the Botanic Gardens to the hills beyond. He wanted to help young artists towards a free and independent art, while Margaret Morris formed the Celtic Ballet. They became the focus of a group of creative people in Glasgow which included Erik Chisholm the composer, Hugh MacDiarmid the poet, William MacLellan the publisher and many other painters.

The New Art Club was formed with Fergusson as president; membership cost £1 and could be paid quarterly. There were monthly exhibitions of paintings, with no jury and a modest hanging fee, the painters gaining recognition from critics throughout the country as the New Scottish Group, destined to carry on the Glasgow Boys/Colourist tradition in Scottish painting.

Fergusson felt the Celtic people were the most creative of the western world, and he became deeply interested in Celtic design. He wrote the book *Modern Scottish Painting* in 1943, having the advantage of being able to express himself on art as well as practise it. He also had the advantage of living much longer than his fellow Colourists, long enough for public opinion to catch up with what he was doing.

Dr Tom Honeyman, who opened Fergusson's exhibition at the McLellan Galleries with a brilliant laudatory speech, became director of the Kelvingrove Art Gallery and Museum in Glasgow. In the same spirit of art for all, he made the gallery a place to go in the evenings and each opening of a new show a special occasion – though he was much criticised for incurring the expense of offering a free cup of tea or coffee.

In June 1950 Fergusson received an honorary LL.D from Glasgow – very happily, for by then he felt he belonged to Glasgow.

ON THE BONNY BONNY BANKS

'Loch Lomond is one of the world's glories,' wrote H.V. Morton when he set forth 'In Search of Scotland' in the 1920s in his famous bull-nosed Morris. 'The hills lie against one another fading into the blue distance; the autumn leaves, russet, red and gold, go down to the edge of the water, and Loch Lomond lies for twenty four miles in exquisite beauty.'

Glasgow could never lose its soul with Loch Lomond on the doorstep, he declared. 'A man can go out from Glasgow and climb Ben Lomond and see Scotland; he can see his own country lying for miles in a chain of dim blue monsters.'

The first painters of Loch Lomond came from Glasgow; Horatio McCulloch in 1861, was the most important, influenced by Turner and inspired by Walter Scott and above all by his own love of Scottish landscape. His painting *Loch Lomond* is one of many of his large-scale oil paintings of impressive Scottish landscape, now in the Glasgow Art Gallery. Establishing the style of romantic grandeur with naturalism that made him popular and influenced Scottish landscape painting until the end of the century.

The Drift Posts, John Duncan Fergusson, c.1920 (Flemings) One of the most original of Scottish artists, Fergusson returned to Glasgow in 1939 and lived there for the rest of his long, fruitful life, helping a new generation of painters.

Arthur Melville's watercolour of Loch Lomond of 1893 is also at the Glasgow Art Gallery. **Arthur Melville** (1855–1904) was one of the masters of British watercolour painting and his technique was described as dazzling. He worked on to wet paper, sponging out superfluous detail and allowing areas of paint to run together, with colour added as the paper dried.

He was born of a large family in Angus, working in a local shop and attending evening classes in art. He travelled widely, studying in Paris and painting with several of the Glasgow Boys in Gres-sur-Loing. He achieved a transparency and immediacy in his painting which appeared spontaneous and was sensitive to conditions of light and atmosphere. 'Melville had the supreme painter's gift of conveying not atmosphere only of air and sunlight, but also the psychic atmosphere, shall we say, of a scene – its effect upon his own mind, the glamour, the romance, for instance of the East as affecting a Western stranger,' wrote *The Studio's* critic in 1906.

Melville produced vivid scenes of the Middle East, Spain, Algiers, Venice, the superb *West Front of St Magnus Cathedral, Kirkwall* and *The Sheiling Brig o' Turk*.

George Leslie Hunter (1879–1931) discovered Loch Lomond in the 1920s in the course of his search for a quality of light that would remind him of California, where he grew up. Hunter, like all four Colourists, was peculiarly aware of the effect of light and the power of colour.

In some ways Hunter was lucky, for he seems to have had some family funds which allowed him to concentrate on training as an artist and move around freely; but in others he was unlucky. Working as an illustrator and producing pictures for his first one-man exhibition in San Francisco, he lost all the work he had done in an earthquake and had to return to Glasgow and start again with nothing to show of his work. He subsequently came to the attention of Alexander Reid, who gave him his first one-man show in Glasgow in 1913.

Painting in the Fife area, he used watercolour not in the English manner but more as if it were oil, with strong colour and bold brushstrokes. His search for more inspirational light in Scotland took him to Loch Lomond. His first paintings there, such as *House Boats, Loch Lomond*, 1924, are rather over-worked and heavily outlined, the painting agitated

and restless like the painter himself at that time.

After a successful visit to the south of France, producing fresh and vibrant colour in the best work of his career so far, Hunter returned again to Loch Lomond and carried over the same high-key assurance and vitality from his French experience into a large series of oils and watercolours in the 1930s. At the Paris exhibition *Les Peintres Ecossais* of 1931, the French government bought one of his Loch Lomond pictures.

He was the most erratic of the Colourists. His work is never repetitive because he appears to be constantly searching through his drawings for a new approach. His life was a series of dramas: in the south of France, for example, he painted feverishly, so utterly absorbed in his art that he neglected his health and presented a wild, unkempt appearance. On one occasion he mistook a bottle of turpentine and drank it. He handed over paintings to the restaurateur M. Roux at the Colombe d'Or in St Paul de Vence in payment for meals, living an archetypal bohemian artist's life. His biographer, Dr Tom Honeyman, checking out the countless paintings left at the restaurant after Hunter's death, found that even the waiters there spoke English with a broad Glaswegian accent.

He had his supporters – such as Reid, who paid him a retainer for his work – and admirers who claimed that he was 'a more powerful colourist than Matisse and equally refined'. But he rebelled against any kind of discipline or domesticity and was often at odds with himself. When, on one occasion, neighbours reported violent and noisy arguments in his studio at night and called the police to prevent a breach of the peace, he was found to be alone, arguing with himself.

His best times in Scotland were at Loch Lomond, where the light was the closest he found to that of the Midi and the experience of working on a single theme gave him fresh impetus and energy. The colour and sparkle of light on the water of the loch is the true subject of his pictures, set off by the brightly coloured houseboats and boats tied up at odd angles, and a lighthearted holiday atmosphere.

He was a fierce critic of his own work. The story is told of him standing on the bridge in Balloch where the River Leven flows out of the loch, throwing rejected canvases over the balustrade to be carried away in the stream.

Artistic Rivals

In 1993 Glasgow and Edinburgh competed to provide a home for the new National Gallery of Scottish Art, a £30 million purpose-built centrepiece of Scottish art. Glasgow commissioned schemes from architects Norman Foster and Terry Farrell, offered a free and open site in Kelvingrove Park, close to the home of the Burrell Collection. Sir Norman Foster's design proposed an elegant curved structure, partly sunk in the ground; Terry Farrell's design was more monumental, a landmark building with a series of top-lit galleries.

Angus Grossart, chairman of the ten National Galleries trustees making the final decision, awarded Glasgow the prize at the end of the year. He acknowledged that three factors influenced the decision in Glasgow's favour in the deliberations of the trustees – the prospect of developing a fine open site, a possible £10 million European Union loan, and the visitor potential. Last year the Kelvingrove complex of museums and galleries in Glasgow attracted 868,000 visitors, almost 200,000 more than Edinburgh's three galleries.

There has been strong opposition from Edinburgh since the announcement was made, for 900 of the 2000 Scottish paintings owned by the National Galleries of Scotland are stored in three Edinburgh premises for lack of space to display them. The National Portrait Gallery in Edinburgh is likely to lose most of its collection to the new gallery. At the time of writing (February 1994) it is not yet known which of the designs will be adopted for the site in Kelvingrove.

Glasgow, which has always believed in making its presence felt in the world of art since the time of the Glasgow Boys, looks forward to the new gallery opening in 1998 and hopes the decision will influence the city's bid to become the United Kingdom City of Architecture in 1999 .

Autumn, Loch Lomond, *Arthur Melville, 1893 (Glasgow Art Gallery)*
A great watercolourist, Melville used a special 'blottesque' technique here to capture the Scottish autumn colour.

New Concept in Landscape Art

An imaginative project transforming the M8 Glasgow–Edinburgh motorway into a vast open-air art exhibition had its official opening in September 1993. It is fitting that Britain's first cultural motorway should link these two cities, always in the forefront of art development and excitement. The dedication of a huge earth sculpture signalled the start of the art project which is intended to create a new dimension in outdoor art in Britain.

The first part of the scheme, a thousand-foot long earth sculpture consisting of a series of leaning pyramids, was designed by Patricia Leighton, a Scottish artist. She describes her creation as seven saw-tooth ramps, each 36 feet wide and 135 feet long, inspired by history and homage to a local monument, West Calder's Seven Sisters.

Summer 1994 sees the arrival in Polkemmet Country Park in West Lothian of a huge stainless steel horn, 71 feet high, visible from the motorway rising out of the trees in the park. Designed by Scottish artists Louise Scullion and Matthew Dalziel, it will be like a surreal oracle and will produce beautiful sounds. A landmark sculpture commissioned by Lanarkshire Development Agency is also planned – a series of stainless steel trees, floodlit at night, marking the Channel Tunnel Rail Terminal in Scotland.

The motorway corridor between Glasgow and Edinburgh will be enhanced with twenty features, the project supported by the Scottish Office, local authorities, local firms and several multinational companies. It is good to see that the concept of involving artists in public environmental design has been revived. It has fallen into disuse in this country since the Victorian age, but it has a long history going back to Greek and Roman times when statues were used to mark out the highways. Today's artists involved in public environmental designs have a lot of people to please and road safety concerns to consider. It is remarkable, in this respect, that the project has come to fruition.

THE ISLE OF ARRAN

Arran in the Firth of Clyde is popular with Glasgow people. It is handy, just less than an hour by car ferry from Ardrossan, and it has been made accessible and saved from offensive development by the generous ownership of the Duke of Montrose. Many Highland landlords, in contrast, particularly the rich in-comers, have repelled visitors from their lands.

Climbers and walkers, campers and pony trekkers have enjoyed Arran's moors and mountains – Goatfell at 2,866ft the highest peak, lovely Glen Rosa protected by the National Trust, and wild Glen Sannox with Highland scenery of desolate grandeur as impressive and terrible as that of Glen Sligachan and the Cuillins in Skye.

Artists have found Arran a happy place to paint. The brothers Joseph Noel Paton and Waller Hugh Paton, Pre-Raphaelite painters and friends of Millais, painted there in 1854 and 1855, and William Dyce painted *A Scene in Arran* showing his family on an outing in 1859. **John MacWhirter** (1839–1911) painted at Lochranza one of the pleasing scenes of loch and distant mountains that made his fortune and reputation. He was at first Pre-Raphaelite in his subject matter, but by the time he painted *Lochranza* his broader handling and deft use of colour in landscape was masterly. His atmospheric painting *Spindrift* was painted near Loch Range, Arran. He said of it:

Balloch on Loch Lomond, photographed in 1993, little changed in the intervening years and still attracting a steady stream of visitors from Glasgow to enjoy its bonny banks and boating.

Spindrift means the spray of the sea caught up and whirled away by the wind. I saw the seaweed cart coming along when I was working one stormy day and made a note of it in my sketchbook. I afterwards made careful studies of the wet road, gravel, etc.'

John Maclauchlan Milne (1886–1957) painted *Corrie* and *Sannox* on the isle of Arran in a completely different style, bold and colourful, influenced by the Colourists and Van Gogh. He was born in Edinburgh and lived near Dundee, benefiting from a stipend paid by the Dundee marmalade manufacturers Keillers, who took up a proportion of his work and enabled him and his French wife to work in the south of France at the same time as the Colourists, Duncan Grant and other artists. On the outbreak of the Second World War he returned to Scotland, however, and settled on Arran.

Reflections, Balloch, George Leslie Hunter, c.1930 (Scottish National Gallery of Modern Art)
Hunter, like all the Scottish Colourists, was strongly aware of the effect of light and the power of colour. He found the inspiration for his best work at Loch Lomond in the 1920s and 1930s.

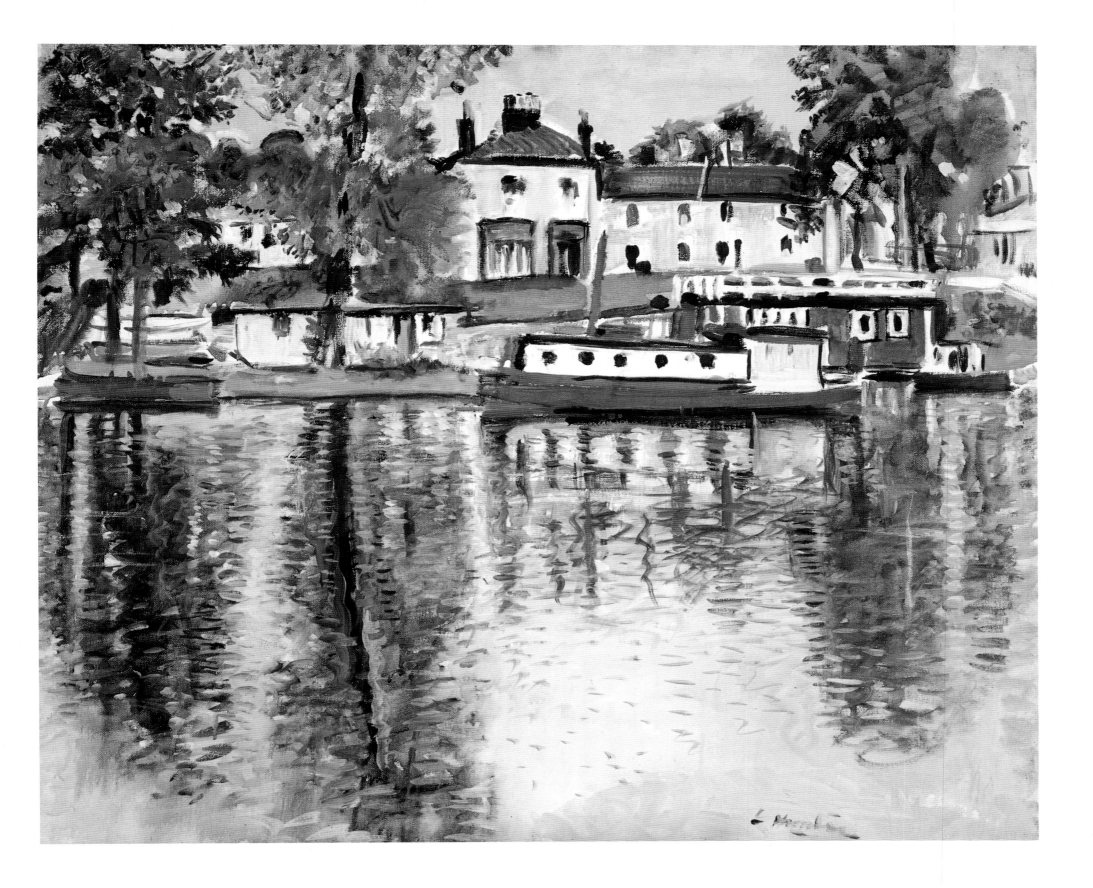

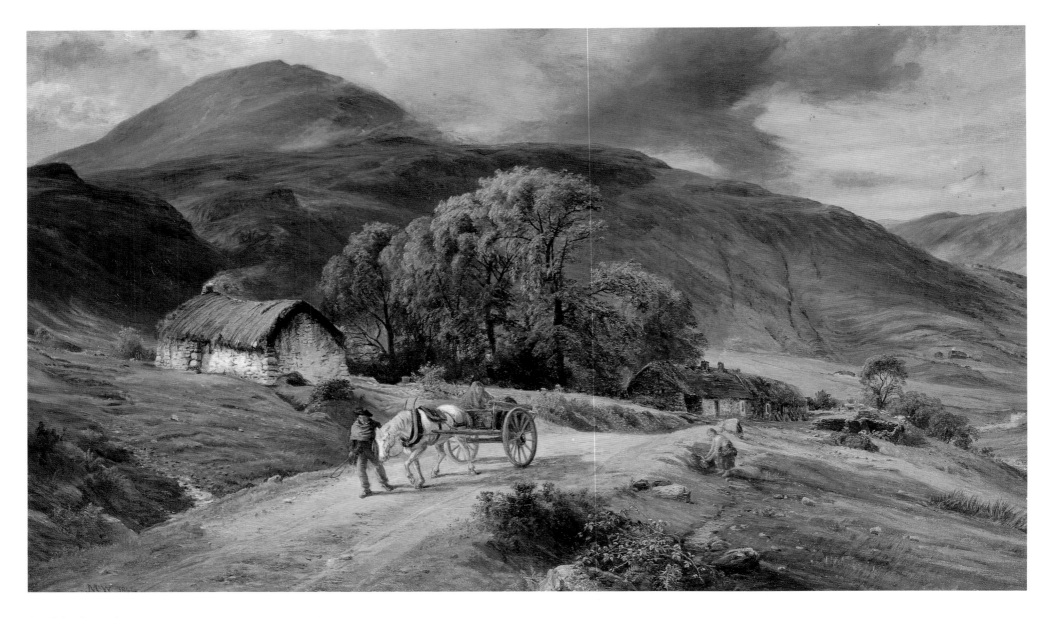

Loch Rodaya, Arran, *John MacWhirter, c.1890 (Sotheby's)*
MacWhirter's serene and warmly coloured views of the
Highlands and Islands made his fortune.

PAINTERS OF THE WEST COAST

McTAGGART OF KINTYRE

IT did not seem at all likely, when William McTaggart's name was registered in Campbeltown parish, Kintyre, in 1835, that it would become famous as the name of Scotland's greatest and most original painter. In that remote part of the west coast, his parents were Gaelic-speaking; his father was a crofter, then made a poor living carting peats for the local whisky distillery.

Yet clearly McTaggart was a born painter if ever there was one. He had the determination and confidence to match his precocious talent, together with a fierce independence, and he seemed to strike lucky. He quickly began to earn by painting portraits, but he wouldn't settle for part-time painting alongside his apprenticeship to an apothecary, Dr Buchanan. He was lucky in finding Dr Buchanan, who recognised his ability and had contacts in the world of art. William wrote to his brother Duncan: 'Dr Buchanan says he will try and get a place for me in Glasgow as I am only losing time with him I have learnt all he can learn me.'

In February 1852, with a letter of introduction in his pocket from Dr Buchanan to the Glasgow artist, Daniel MacNee, McTaggart set sail from Campbeltown on the Glasgow packet. MacNee directed him towards an art training at the Trustees Academy in Edinburgh which was free; he could support himself with portrait painting while he was studying. Here again he was lucky, for he joined the Academy in the same year as the most brilliant of teachers there, Robert Scott Lauder. McTaggart was on his way.

He soon began winning prizes, finding himself sympathetically directed towards a personal means of expression, discovering the work of artists he could respect, working among students as eager as himself in a stimulating atmosphere. His fellow students included William Orchardson, John MacWhirter, Tom and Peter Graham; his particular friend and colleague was George Paul Chalmers, whose promising career was soon to be cut short by brutal murder in Charlotte Square, Edinburgh.

McTaggart was keen to learn but self-reliant and independent. In his own words, he had 'thrown away the scabbard'. From the age of 16 he kept himself as an artist, and portraiture was essential to him from the beginning. He sent money home in response to requests for help with overdue rent, or because 'they were going to sell father's horse to pay the Roadmoney he is owin abought £2.15s he has got them Peacsified for a litel', or to assist his sister going into service: 'I was wishing you would send me what would help me to get a cloth cloack to me before I would go away.' For many summers he travelled to Dublin for portrait commissions; every summer he returned to Kintyre.

In 1859, when McTaggart was only 24, he was made an associate member of the Royal Scottish Academy. During the 1850s and 60s he was living in Edinburgh and painting commissioned pictures for a group of east coast patrons and collectors, in particular the engineer James Guthrie Orchar of Dundee whose private collection was later housed in a purpose-built art gallery in Broughty Ferry. They chose the subjects and allowed the artist to work these out in his own way, it was said, though the comments and suggestions of some patrons, such as adding a church or introducing some tombstones to a scene, must have been very testing to an artist of McTaggart's calibre and quick temper.

He married a local Kintyre girl, Mary Holmes, in 1863; in that year too he painted a picture called *Spring* which marks a wholly new departure, at once a landmark in Scottish landscape and an indication of his great potential as an artist.

In the picture two children sit daydreaming by a meadow stream. They are part of the sunlit landscape, part of the simple delight of spring in the countryside. It is a picture with such spontaneity and freshness of colour that it has the exhilaration of opening a window on the first warm day of spring. As a work of art it opened a window and let the sunlight into the gloomy world of brown tones so long in favour, the dark interiors universal in painting in France as well as Scotland; for this was the time of Courbet and Millet, ten years before the first Impressionist exhibition. From that point McTaggart broke free of the literary associations of historical genre painting with its brooding sense of morality and its sentimental overtones, and free of the medieval mysticism of the Pre-Raphaelites. From then onwards he painted from direct observation of the country around him, communicating his own deep feeling for it.

While his colleagues from the Trustees Academy, such as Orchardson, could charge hundreds of pounds for portraits in London, McTaggart charged £35 for *Spring*, but he had found the direction he wanted to go. He had always drawn outdoors; now he turned to watercolour and painted outdoors. James L. Caw, McTaggart's first biographer, stresses the importance of watercolour: 'One may say that watercolours, rather than oil paints, began to liberate his hand to express the sparkle and flicker of light, the purity and brilliance of colour and the dancing and rhythmical motion which mark all the work of his full maturity.' Later he would paint even his large oil canvases outdoors, braced against the wind with the easel propped against rocks or held in place by one of his stalwart sons in stormy weather.

From the time of his marriage, which settled and supported him, he went every summer to Kintyre which he had first loved as a boy, where his father's people had long been established on the southern part of that 'beautiful arm which Scotland stretches in greeting through the gleaming western sea towards the green shores of Ireland'. There the land is everywhere close to the sea and the sea loch, the

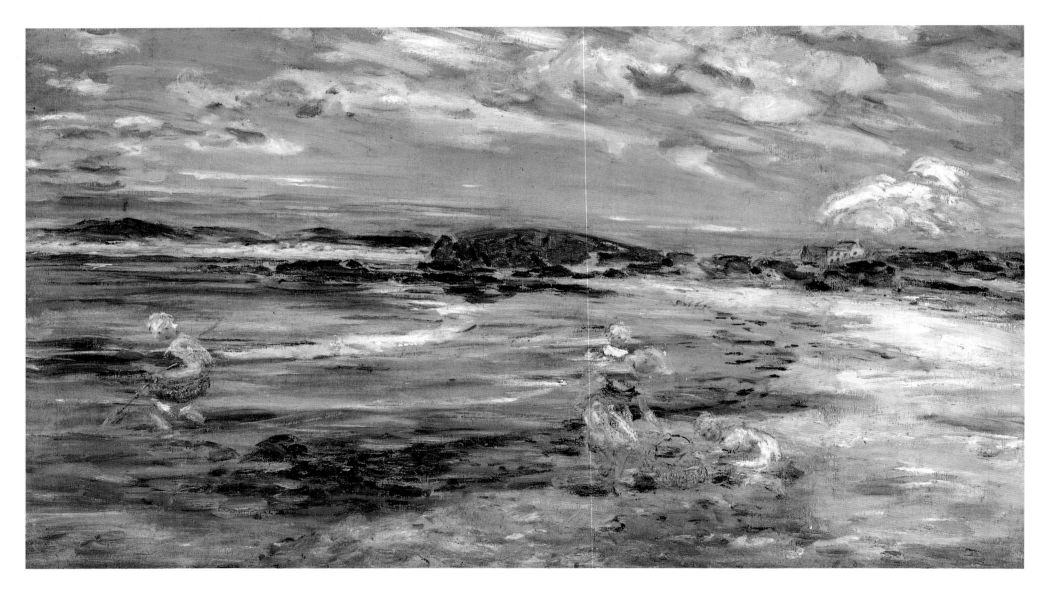

Machrihanish, Bay Voyach*, William McTaggart, 1894*
(Flemings)

Machrihanish beach in June 1993, the month that McTaggart liked best in Kintyre. The waves still break gently on the shore but a sea mist draws in.

The Wave, *William McTaggart, 1881 (Kirkcaldy Museum and Art Galleries)*
'The seaweed on the shore, the white flick of a breaking wave, the subtle modulations in colour of the advancing breaker form the whole subject of this great painting,' writes Lindsay Errington in the McTaggart exhibition catalogue.

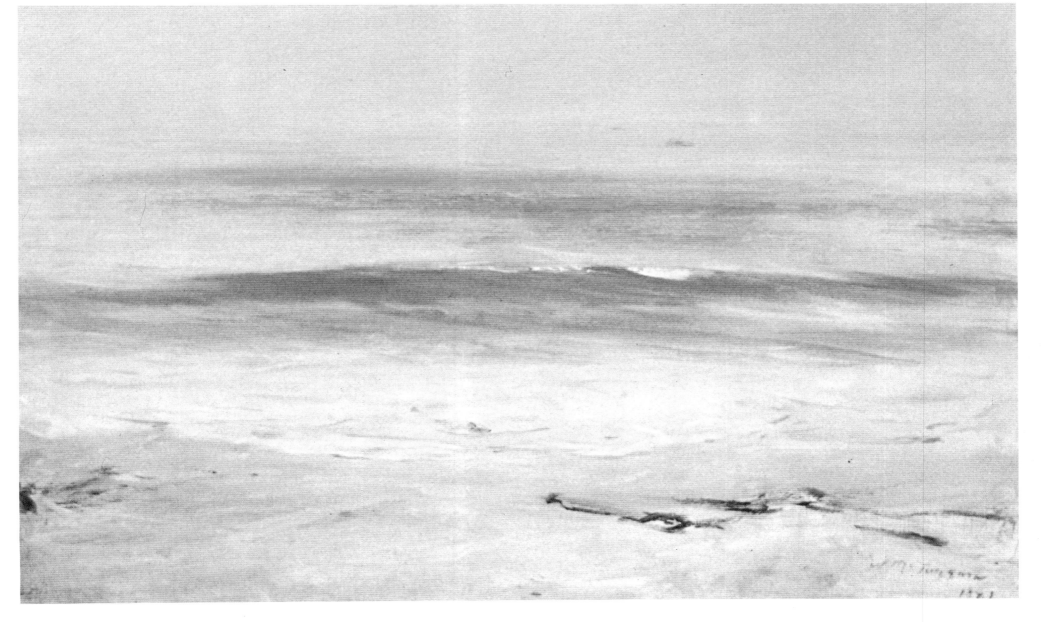

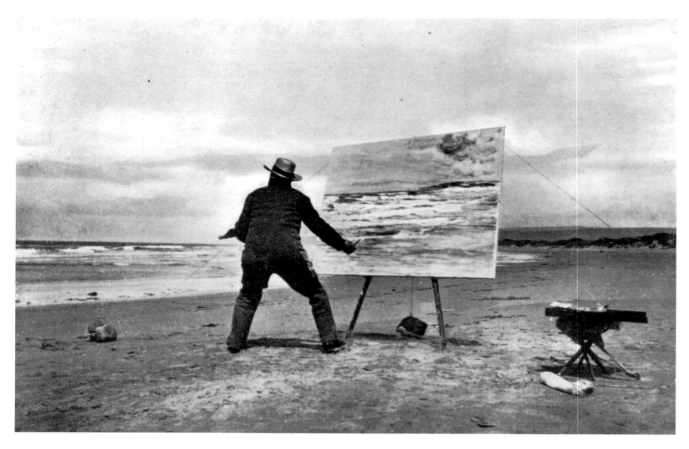

William McTaggart painting on the shore at Machrihanish, 1898.

light changing quickly as clouds come in from the Atlantic, translucent on calm summer days and lingering late on summer nights with a kind of unearthly magic.

He wrote to a friend one summer from Machrihanish Bay, where he was painting with his friend Orchar: 'We have been down here since the first of Augt and the weather has been charming... between the beauty of the sea-shore and the beauty of the Harvest fields – how happy could we be with either – its very distracting.'

He painted both – the clear blue skies and shore-line of the bay at Machrihanish in midsummer, often with local children playing in the shallows, fishing or skipping or bait-gathering or lying on the sands, so much a part of the scene that they are absorbed into it. In *The Wave* he paints a hazy tranquil sea, a quiet wave just breaking the sands, a few scraps of seaweed in the foreground, and with this wonderful simplicity makes the viewer share his vision. When he turned to landscape and painted fields of hay and barley, he evoked the same sensations of stepping into a scene which stretches not just before the

viewer on the canvas but all around, and of sharing in his own joy in it.

Dawn at Sea, Homewards is one of his most lyrical paintings, the darkness lifting from a calm sea, a yellow dawn light in the sky and a fishing boat running gently before the wind with a single curved brown sail. There is a real sense of being at sea, listening to the slapping of the water against the bows, for the undulating surface of the sea is so expressively liquid. In the later picture *The Paps of Jura*, which shows the view from Machrihanish across the water to Jura, lines of white breakers run from edge to edge of the canvas.

He didn't limit his seascapes to calm days. In one of his greatest paintings, *The Storm* of 1890, which had its beginnings at Kintyre in 1883, tiny figures are nearly lost in a swirl of stormy brushstrokes, almost thrown off their feet in the force of the wind as they try to launch a rescue boat into the heaving sea where a fishing skiff, helpless without sail, heads for the rocks. The drama is conveyed with just a few strokes of paint among the fierce spray of the white water under the darkening purple of the storm clouds. In *Running for Shelter* he creates a sense of speed and urgency in the movement of the white-topped waves and the onrush of clouds as the

weather rapidly worsens, and small boats at sea and frightened children on the shore hurry for home.

He became occupied with two major themes during the 1890s, both with a Gaelic connection. *The Sailing of the Emigrant Ship*, 1895, was one of several paintings of emigrants leaving the west coast of Scotland; and an event dating back thirteen hundred years earlier is celebrated in *The Coming of St Columba*, 1895. In the emigrant paintings he conveys the despair of those departing into stormy seas and of those left on the shores where they have been driven from their homes by the clearances, through his painting of the threatening seascape itself, with just a gleam of hope in the glimpse of a rainbow between the dark clouds.

'The mood of McTaggart's painting of *The Coming*,' writes Lindsay Errington in the catalogue of the William McTaggart exhibition of 1989 at the National Galleries of Scotland, 'with its blue sky, calm and almost opalescent pale green sea, the clarity of the morning light, and the little boat with its white sail and white robed figure at the prow, does indeed suggest a spring-like expectancy, and the hope of something wonderful arriving.' Again McTaggart expresses not only mood but human drama through his painting of the seascape itself.

So daring and unconventional a painter was bound to have his critics. Many complained at the absence of form or said that his paintings looked unfinished, and there was criticism too for the way the figures dissolved into the landscape. The painter J.D. Fergusson, a great admirer of McTaggart, made the point that McTaggart was by no means a great accepted success in Scotland during his life: 'I've seen a lot of painting. I've never seen any so good. It's always been a mystery to me how he survived and brought up his family.'

One of the reasons McTaggart survived as an artist was the support he had from the art dealer Peter McOmish Dott, who grasped that McTaggart 'was not merely a good artist but had a touch of higher genius'. Dott believed in him and bought his work, despite the lack of a market for it and despite McTaggart's determined artistic independence which increased with the years. He had always gone his own way and with his later work he left the marketplace and 'looked straight into the heart of modern art', according to Duncan Macmillan, the leading expert on Scottish art.

That his paintings looked unfinished was the same parrot cry that met the work of the Impressionist painters in France, and it raises a

Children on the Cliff Top, *William McTaggart, c.1890*
(Sotheby's)

question that has been frequently discussed – whether McTaggart was aware of the work of Monet, Renoir and the others. He was certainly not without influences in the course of his career, particularly the work of Constable which he saw for the first time at an exhibition in Manchester in 1857. There are clearly elements in Constable's work that would have appealed to McTaggart – his love of his native countryside and of painting in the open air, the importance of skies in composition, of wind, light and movement in landscape. McTaggart never painted outside Scotland; his study is of northern seas and skies. But like Constable he took to using a tinted canvas so that a warm-coloured ground set off his sparkling white and colours and captured what Constable called the 'chiaroscuro of nature'.

He went to Paris occasionally, and exhibited at the Royal Academy in London, sending eleven pictures there in nine years, but he disliked London and was never persuaded to move there by his artist friends. He was in London in 1883 when the French dealer Durand Ruel brought the work of the Impressionists to London and several Monet seascapes were exhibited, but there is no indication that McTaggart saw them. Like the Impressionists he was working entirely from nature, like them he sought to capture the transient light, mood and season, but he had found his own personal impressionistic style independently of the French painters. There are clear differences: McTaggart's figures, for example, are often an important part of the landscape and the emotion of the scene, whereas in most Impressionist pictures the figures just provide points of reference and scale. Where he worked on the same lines as the Impressionists was in capturing the moment of nature, the way it was for him at a certain time and place.

McTaggart was an original. He 'threw open a door into a world of colour and atmospheric light through which later generations of Scots have passed,' said his grandson, the painter Sir William MacTaggart. He also told the story of a distinguished French art critic studying his grandfather's painting of the storm, impressed and admiring, then realising the date and exclaiming: 'Mon Dieu, c'est impossible!'

In the same way as the work of the early Impressionists, Monet, Renoir, Sisley, Pissarro, presents an invitation to the viewer – Look at this beautiful place! – and inspires the desire to go to France and walk along the riverside under the poplar trees, so too the work of McTaggart is an invitation to go to Kintyre. Those who take up the invi-

tation are not disappointed.

Kintyre is almost an island, connected by a thread of land to the rest of Argyll – a long narrow peninsula stretching southwards from Tarbert to the Mull of Kintyre. It is a beautiful, quiet, unspoilt place.

McTaggart stayed in the piermaster's cottage near the jetty at Tarbert, on Loch Fyne; the herring fleet of old-fashioned coasters delayed putting to sea and stayed in the harbour because they knew he was painting them. He liked the busy harbour and paid many visits there, receiving the unofficial freedom of Tarbert. Visitors begin their discovery of Kintyre there, where all the bed-and-breakfast houses have fine views and serve hearty breakfasts, and there are good fish suppers to be had.

The road to the Mull of Kintyre leading down the east coast by Carradale has marvellous views over Kilbrannan Sound towards the mountains of Arran. Returning along the west coast, through Kennacraig where the Caledonian MacBrayne ferries sail to Port Ellen and Port Askaig on the island of Islay, there is the chance to see the sun set over the islands.

Either way the road has the water on one hand and the meadows on the other. Wooded green hills where rhododendrons flower spectacularly in June give way to low-lying pastures with grazing cattle and yellow flag irises dotted among the lush grasses. A string of small hamlets of white stone cottages on the west side includes Whitehouse Village, where McTaggart painted *The Village Whitehouse*; Clachan, one of the prettiest; and Ronanchan Point (the name means the place of seals and this is where to see them basking on the offshore rocks). Then a whole series of beautiful bays where the breakers spread over deserted sands leads to Machrihanish Bay, the place McTaggart loved as a child and returned to every summer to paint. He particularly liked the light of Kintyre in June, so his children would be taken from their schools, silver and bedlinen would be packed and the carriage would take them to the station. It is likely they took a steamer from Glasgow to Carradale or Campbeltown; then the children had the freedom of Machrihanish Bay and he could paint.

The modern world has intruded into this remote corner of Britain. There is now a civil air terminal

Kintyre, 1993 – the village of Tarbert on Loch Fyne where McTaggart stayed in the piermaster's cottage and painted the herring fleet.

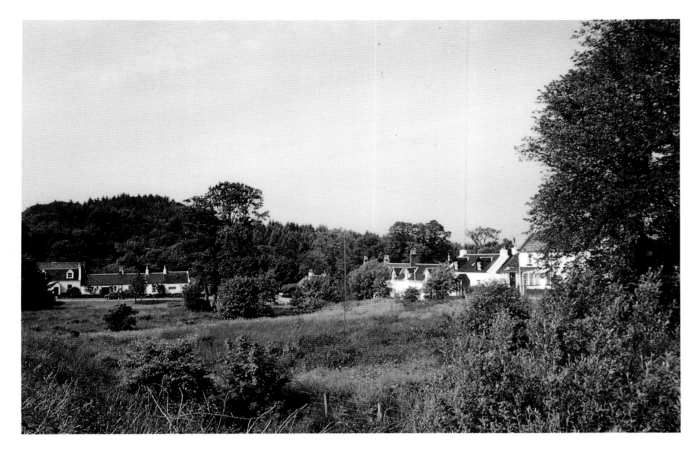

Whitehouse village, near West Loch Tarbert, which was painted in 1875 by McTaggart and is little changed today.

and RAF station close by, a personnel estate of apartment blocks behind high wire fences where sophisticated and deadly stealth bombers are sometimes glimpsed. A quarrying operation prevents access to part of the shore.

Most visitors go to Machrihanish village for the golf and there is a black-and-white club house on the sea front. Yet it is still possible to find the row of cottages where the McTaggart family stayed on their visits. It is still possible to walk on the seashore, where children play in the shallows as they did in McTaggart's day, and see the slow surf coming in from vast Atlantic ocean distances to break on the white sand and the dark rocks with a soothing unceasing sound. The clarity of the light is still as it was when he came there, opalescent and gentle, the pure air is still sweet to breathe. Long may it be so.

There has been no exploitation of McTaggart country, no commercialisation, indeed not a plaque or a reproduction picture to be found. But the opportunity is there to explore and enjoy the land and seascape he painted in Kintyre, just as it is simply to enjoy his paintings.

IONA, THE SACRED ISLE

An I mo chridhe, I mo graidh
An ait' guth manaich bidh geum ba;
Ach mu'n tig an Saoghal gu crich
Bithidh I mar a bha.

In Iona of my heart, Iona of my love
Instead of monks' voices shall be lowing of
 cattle;
But ere the world shall come to an end
Iona shall be as it was.

TRADITIONAL

Cadell discovered Iona in 1912. Its great attractions for him were the light and the rapidly changing colours of sand, sea, rocks and sky as the wind brought clouds across the Atlantic. He became a 'well-kent figure' on the island, 'remarked upon as much for his eccentricity as his talents as an artist,' according to his biographer Roger Billcliffe.

Born in Edinburgh, **Francis Campbell Boileau**

Cadell (1883–1937) trained at the Edinburgh Academy and at 16 went to study in Paris at the Academie Julien. He was aware, at that early stage, of the powerful forces emerging in France; the work of Cézanne, Gauguin, Van Gogh, and in particular the early Fauve works of Matisse and Derain had great influence on him.

He returned to work in Edinburgh, taking his subjects from near at hand – New Town interiors, fashionable women, still life arrangements – but like all the Colourists his best and brightest work was produced in France. The Scotsmen responded to the light and colour of the south of France; it liberated their work. Again and again Cadell, Peploe, Fergusson and Hunter found inspiration there. But they returned to Scotland. And when Edinburgh began to feel too narrow and fraught with artistic tensions, Cadell and Peploe found solace and inspiration on Iona.

Cadell, or 'Himself' as he was nicknamed by all the young boys on the island, found ideal subjects for his style on Iona and his landscapes became far more relaxed than his Edinburgh studio work. After the First World War, in which he served in the 9th Argyll, 9th Royal Scots and Sutherland Highlanders, he spent almost every summer on Iona for twenty years. He loved the simple, almost primitive lifestyle there and found the island raised his spirits. His colours are light in tone, his style clear-cut, stark and precise, just right for the gleaming white sands of Iona, the bare land, the far views and the dramatically changing weather conditions which he portrayed in *Port Bhan, Iona*, 1925–6, *Cattle on the Shore*, and many more. His Iona landscapes proved popular, appealing to those pent up in cities and longing to escape to an isle of dreams, and his success made it possible for him to move to a new studio in Edinburgh.

Most summers Peploe left the city to join Cadell, but whereas Cadell found subjects wherever he looked on the island, painting Cathedral Rock, the Dutchman's Cap and the Abbey, Peploe was characteristically methodical and systematic and limited his paintings to the north end of the island. He painted pale sands and intense blues and greens of the sea under cloudy skies, in a series of paintings of Ben Mor and the view of Mull. Cadell hated this particular view, but Peploe painted it in large atmospheric canvases of cool clarity which capture the light of the Western Isles in the same uplifting way that the place itself refreshes the spirit.

Samuel John Peploe (1871–1935) was at his

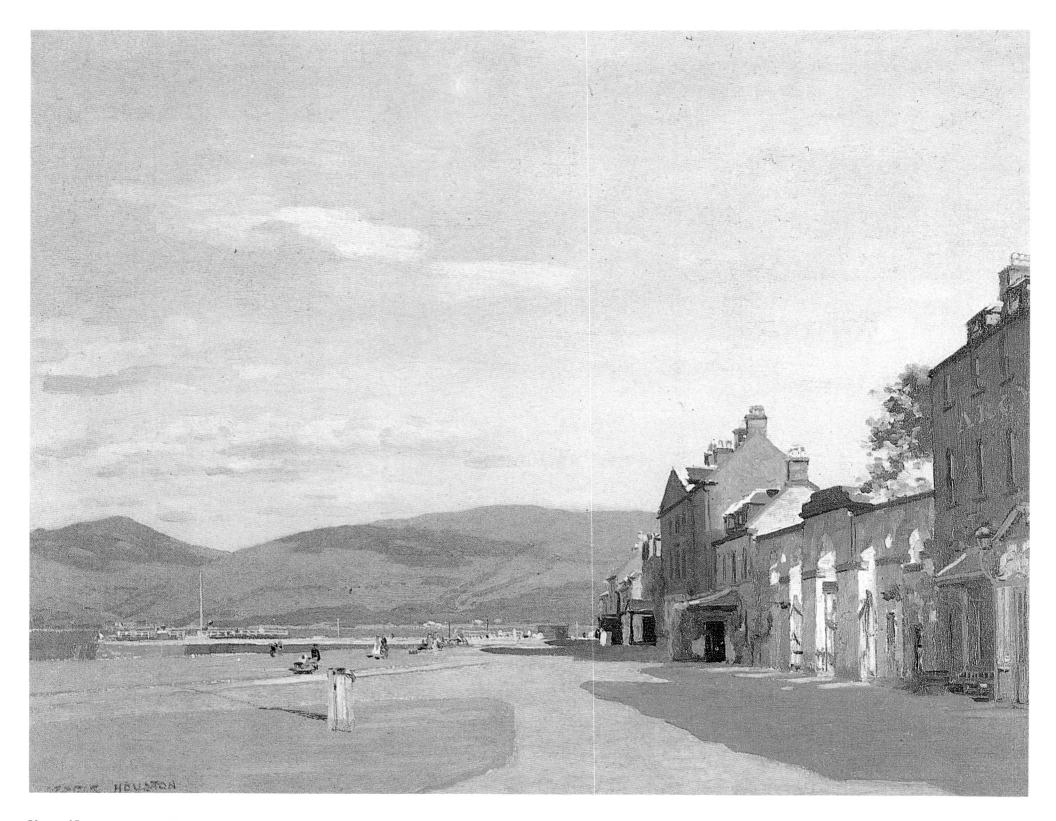

View of Inverary, *George Houston, c.1921 (Sotheby's)*

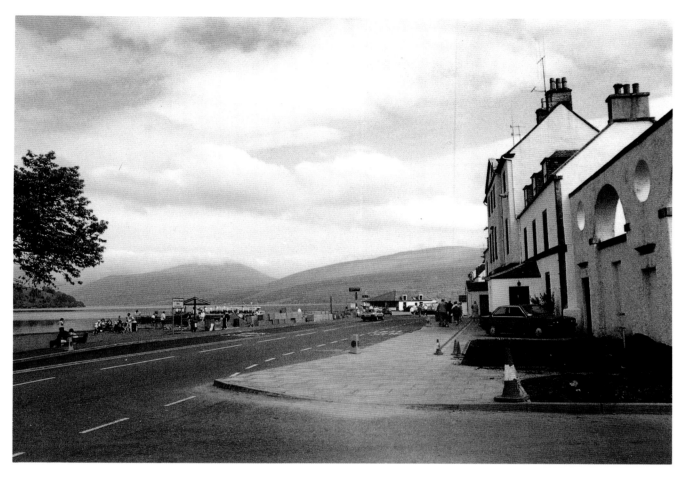

Inverary in 1993, still enjoying its splendid setting and the advantages of enlightened eighteenth-century town planning.

most successful in the 1920s, setting himself to paint the perfect still life. His contribution in this genre was unequalled and highly praised and at exhibitions his still life paintings hung alongside landscapes of Iona and the south of France, showing the same clear freshness of colour that was the hallmark of the Colourists.

With a wealthy band of supporting collectors he was well placed to experiment in the 1930s, and during those years he also became a teacher. He passed on to a younger generation of Scottish painters his careful advice and first-hand experience of the legendary figures of the art world in Paris early in the century. But he was depressed by the changes he saw in the world, the increasing urbanisation of the landscape, and he escaped to Iona to find his greatest contentment.

Cadell too found the 1930s a depressing time; his paintings became hard to sell towards the end of his life due to the general economic depression.

Iona has a profound effect on people. 'That illustrious island,' wrote Dr Johnson, 'which was once the luminary of the Caledonian regions, whence savage clans and roving barbarians derived the benefits of knowledge, and the blessings of religion. That man is little to be envied... whose piety would not grow warmer among the ruins of Iona.'

Inverary by the Sea

When Alexander Nasmyth painted *Inverary from the Sea* in 1801 he was working with the Duke of Argyll, planning the landscape design of the grounds of the castle. He presented a serene, harmonious place where the planned order of the town is part of the wider order of the natural world – the surrounding hills and calm waters of Loch Fyne.

When H.V. Morton visited Inverary in the 1930s it seemed to him to still have a feudal order about it, with the standard of Argyll flying above the four turrets of the castle when the Duke was at home, the one wide main street, the demure whitewashed buildings facing the loch, the green hills 'that lie against each other, closing in the view on all sides', and

some very fine trees. All was well-ordered and well-cared-for. He found there was over Inverary a respectful hush, and wrote that he half-expected to see the Duke of Argyll marching past with pipers, banners flying and claymores white in the sun. Instead he encountered a man on a bicycle free-wheeling down the hill at considerable speed – 'It was the first time I had ever seen a kilted cyclist!' He was told: 'That's His Grace!'

In George Houston's oil painting *View of Inverary* there is still an air of well-ordered calm in Inverary; the wide street, the shining loch, the smoothly enfolding hills and the neat houses still bear the name Argyll.

George Houston (1869–1974) was a prolific painter in oil and watercolour, specialising in the landscapes of Ayrshire and Argyllshire,

good at creating the atmosphere, climatic conditions and season in each scene. His paintings are simple and direct, with wide expanses of pasture and broad waters of lochs set against distant hills. He has been particularly praised for capturing the feeling of spring; its 'fresh tints and lingering frost bite makes a special appeal to him. He catches its crispness, and conveys its promise in a way that no other artists succeeds in doing,' wrote the critic J. Taylor in *The Studio*.

Inverary today still enjoys its splendid setting and demonstrates the achievement of enlightened eighteenth-century town planning and how well it endures. It has an immediate appeal to tourists for its calm bright sense of order, particularly after a hard drive from Glasgow.

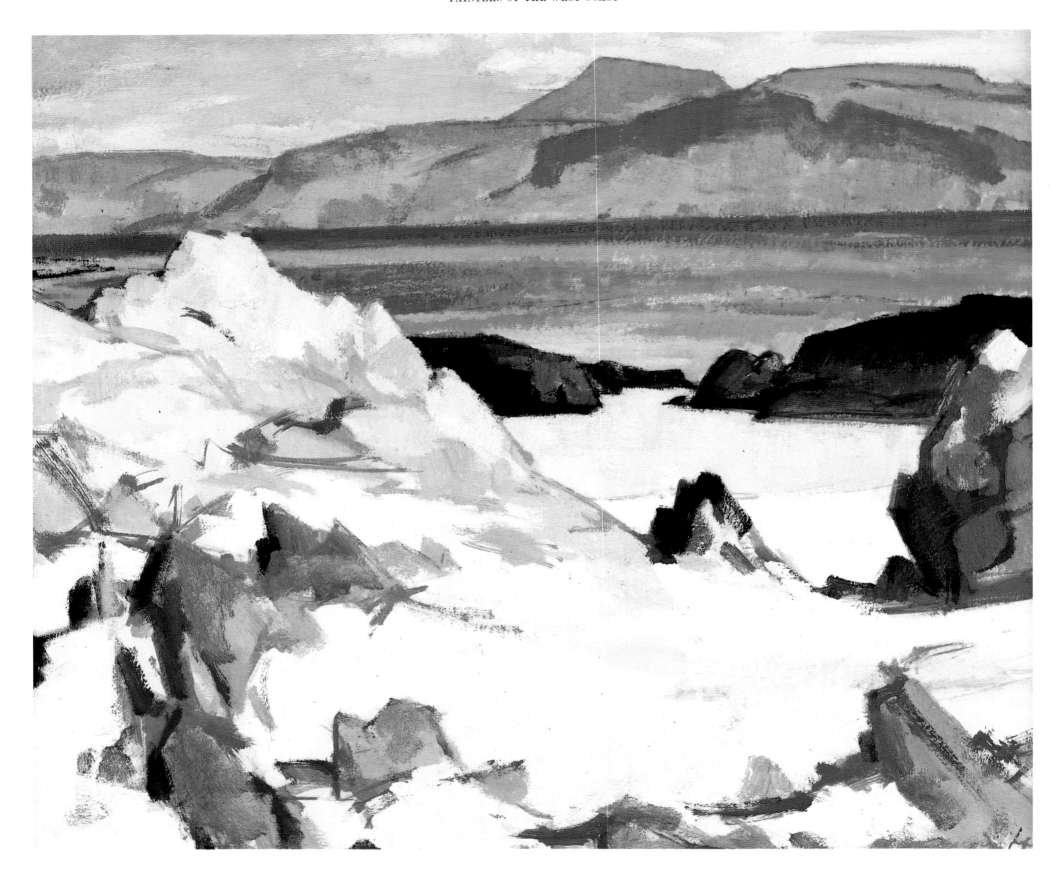

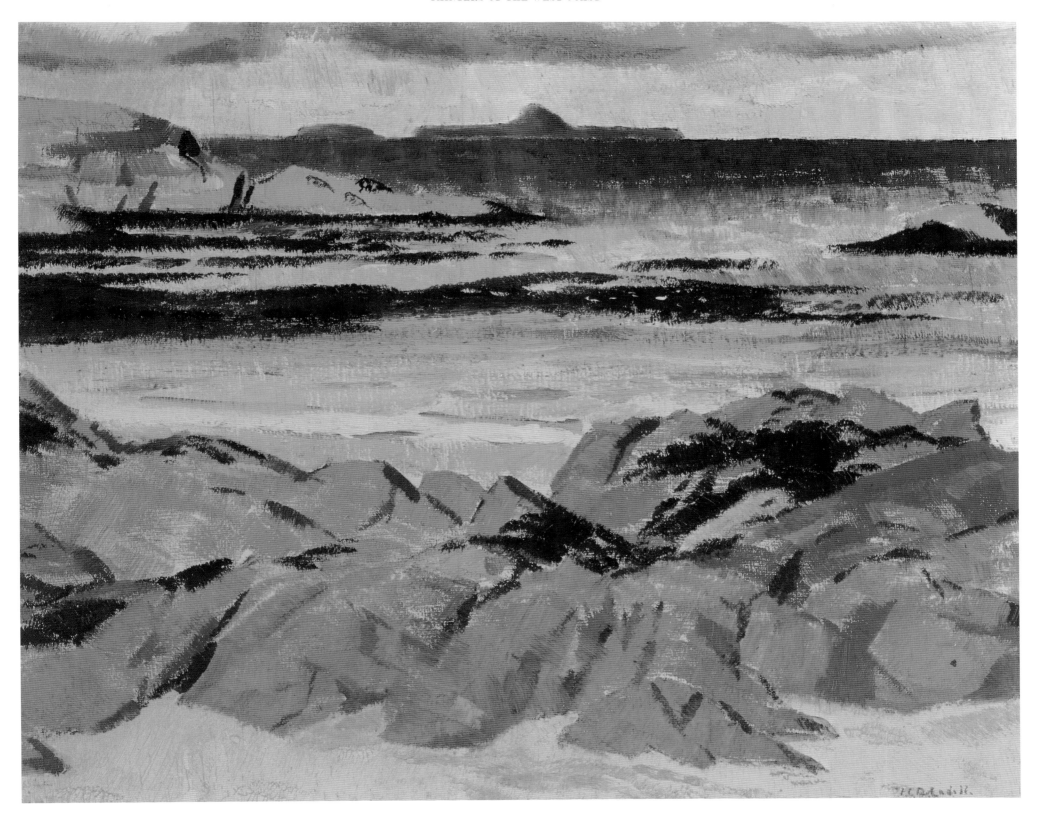

Green Sea, Iona, *S.J. Peploe, c.1928 (Flemings)*
Peploe always chose the north end of the island to paint, with a view towards Mull. He painted with a cool clarity that captures the light of the Western Isles.

Dutchman's Cap from Iona, *F.C.B. Cadell, c.1918 (Sotheby's)*

Cadell found subjects to paint wherever he looked on the island. He loved the simple life there, the bare land, the dramatically changing weather conditions; he responded with paintings clear-cut and stark, light in tone and bold in colour.

Turner produced watercolours for engravings for an exhibition of the complete *Poetical Works* of Sir Walter Scott, published in 12 volumes in 1834. His painting of Loch Coruisk appeared in Volume X in which was published as *The Lord of the Isles*. Turner made for Oban, caught the steamer to Elgol on the Isle of Skye and then took a boat across to the mouth of Loch Coruisk. He compressed the scene in the watercolour, so that the viewer of the picture looks up Loch Coruisk toward Sgurr Thuilm in the distance on the right and up the adjacent coastline and valley towards Sgurr Alasdair in the centre. Turner has made evident through these vast rock formations some 3,000 feet high the great stratifications and fissurings that 'tell of the outrage still'. Two tiny figures set off the enormity of the scene, one Turner himself sketching, the other the boatman. (Turner later told the publisher Robert Cadell that he missed his footing while negotiating the heights and would have broken his neck but for one or two tufts of grass.)

Horatio McCulloch also painted there, capturing the majesty of the bare blue mountains in *Hills in Skye*. This century Anne Redpath, on a visit in 1946, painted *Crofts in Skye*. In it she conveyed the continuing human story of the inhabitants there, sturdily making a living in a landscape and weather conditions that don't become any easier with the passing of time.

The climate in the Western Isles has been described by local folk as 'nine months winter and three months bad weather'. The difficulties of earning a living are increased by threatened cuts to the ferry services in pursuit of government economies. The lifeline for the islanders is the ferry service of Caledonian MacBrayne, which brings all the supplies they need and takes the entire catch of their fishing fleets immediately away south to London and Paris. The Skye toll bridge now being built to replace the ferry service to Skye from Kyle of Lochalsh, the preferred route of holiday visitors, is not universally popular locally, as the proposed cost of using it is more than the ferry. Yet despite these anxieties, the trend of people leaving the Western Isles has now been reversed. More people today are heading away from modern mainland stress to discover the simpler life of the Western Isles, and realising that living there all the time is the way to experience them at their most beautiful.

'All the world may buy a guide-book to the named relics of Columba's Isle,' wrote Dr Ratcliffe Barnette. 'But only love, memory, knowledge and the mystic's vision can unlock the secret of this Isle of Dream.'

'Iona, Lindisfarne and Tintagel are to me three of the most splendid names in Great Britain,' declared H.V. Morton. 'Iona is the sweetest. It has the west wind in it… the wind that goes over rocks beside the sea.'

Visitors today coming from Oban, crossing the Isle of Mull by the scenic route, taking the ferry to romantic Staffa to hear the musical sound of the sea in Fingal's Cave and see the puffins in the bird sanctuary of the Treshnish Isles, land in Iona from a small boat, often rather wet, and find it a quiet place. Often people say: 'There's nothing there.'

That nothingness is steeped in history, in legend and atmosphere. St Columba came there in 563 with twelve followers and founded a monastery. Frequently attacked by Norse raiders, the monastery fell into decay. This century it has become the home of the Iona Community who have done much to restore the beautiful interior of the cathedral. For centuries Iona was the burial place of Scottish kings and chiefs. Very little has changed there in centuries; there is very little that can change. For most visitors, as for the artists Cadell and Peploe and others, it is simply a beautiful island far out in the Atlantic where it seems possible to step off the world.

OVER THE SEA TO SKYE

The isle of Skye has a merry sound to it, perhaps because of the lilt of the Skye Boat Song learned by generations of schoolchildren. But Walter Scott described it at its most forbidding at Loch Coruisk or Coriskin:

> … rarely human eye has known
> A scene so stern as that dread lake,
> With its dark ledge of barren stone.
> Seems that primeval earthquake's sway
> Hath rent a strange and shatter'd way
> Through the rude bosom of the hill.
> And that each naked precipice,
> Sable ravine, and dark abyss,
> Tells of the outrage still.

Auchnacraig, Mull, F.C.B. Cadell, c.1920 (Sotheby's)

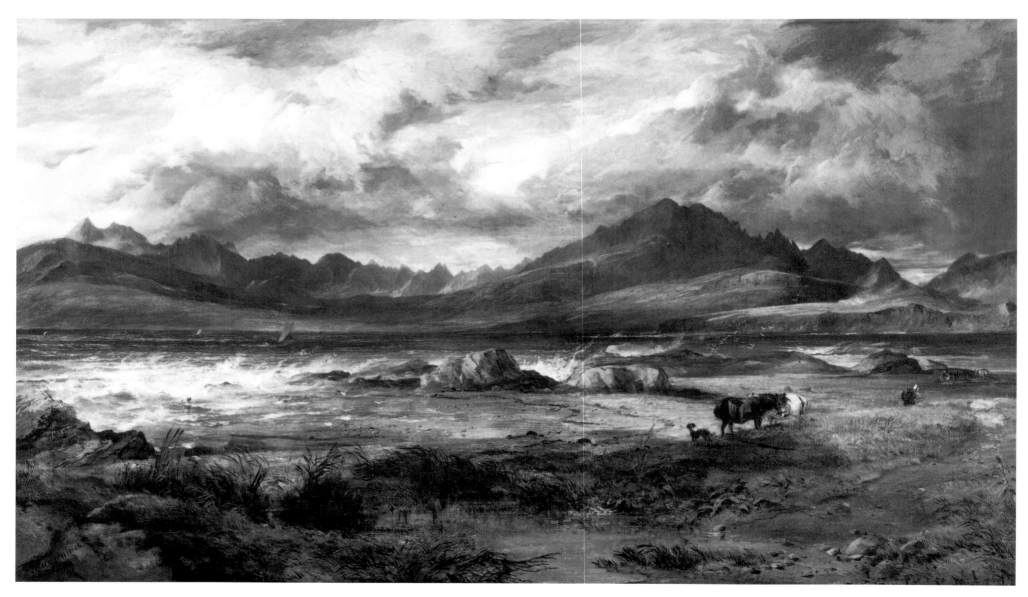

The Cuillins from Ord, *Horatio McCulloch, 1854*
*(Previously titled **Loch Slapin**) (Glasgow Art Gallery)*
The view is taken from the beach at Ord by the waters of Loch
Eishort, very near the house owned by Charles Macdonald
whose daughter, Flora, married the artist's friend, Alexander

Smith. Smith wrote of the famous mountain range in 1857: 'the
entire range of the Cuchullins, the outline wild, splintered,
jagged, as if drawn by a hand shaken by terror or frenzy.'
McCulloch has slightly exaggerated the jagged outline of the
peaks.

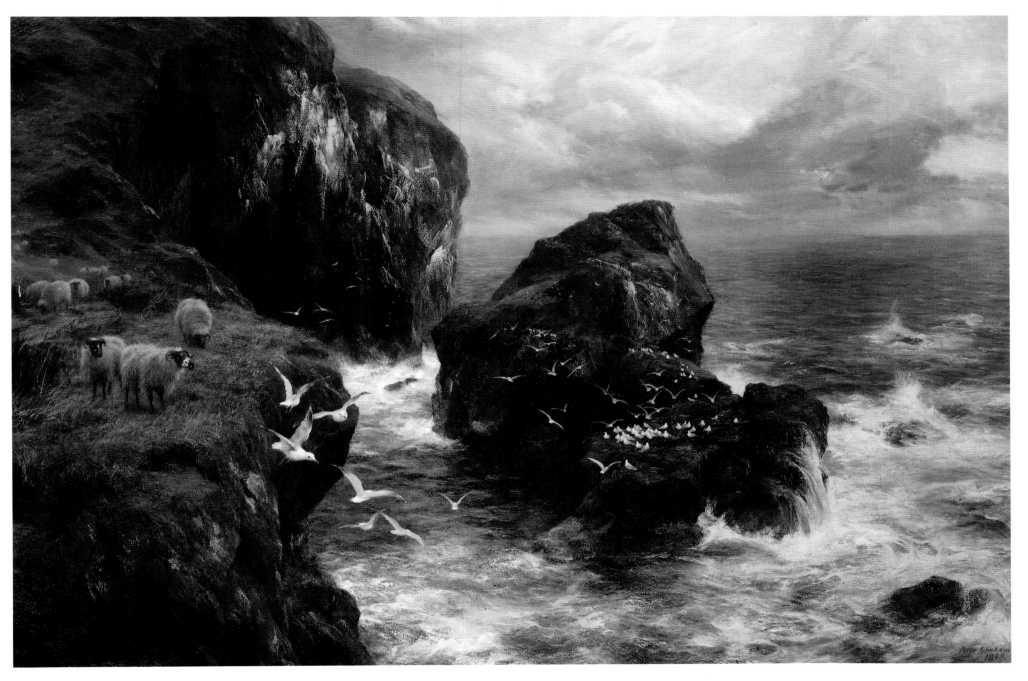

The Grass Crown Headland of a Rocky Shore,
Peter Graham, 1898 (Sotheby's)
The rocky shore is on the island of Hanna, where Graham found
the rugged, inaccessible terrain for many of his skilfully executed
and highly popular paintings.

CHAPTER FIVE

PAINTERS OF THE HIGHLANDS

MY DEAR, DEAR HIGHLANDS

Immediately after lunch on that first day, September 8th, 1848, Victoria and Albert went for a walk on a wooded hill, revelling in the solitude and the pure mountain air. Next day the royal pair, mounted on ponies and attended by Highland gillies, picnicked on Lochnagar. The legend of Balmoral had been born.

ISABEL ADAM

FIVE years after her first Highland visit, Queen Victoria laid the foundation stone of the new Balmoral, the castle Albert had planned. With every year that passed, 'my heart becomes more fixed in this dear paradise,' she confided to her journal. They had specially designed Victoria and Albert tartans in every room – in hangings, chair-covers, even linoleums – while watercolours by the Queen and the heads of stags shot by the Prince accumulated on the walls.

There is no doubting Victoria's affection for the Highlands; she loved its solitude and spent the happiest days of her life there. Prince Albert was frequently ecstatic in the mountains, the Queen in similar bliss come rain or fine weather. Her energy for expeditions and exploratory trips was prodigious. She crossed lochs in rowing boats; she went on long mountain walks and pony expeditions, dismounting where it was steep, scrambling up and down hillsides, fording rivers.

On one occasion she stayed overnight in a simple inn which could only offer tea, two starved Highland chickens, 'no potatoes. No pudding and no *fun*!' She arrived back at Balmoral at eight in the evening and declared: 'Sixty nine miles today, sixty yesterday,. This was the pleasantest and most enjoyable excursion I ever made. We ladies did not dress for dinner and dined *en famille*, looking at maps of the Highlands after dinner.'

One of the secrets of the Queen's energy, perhaps, was the formidable Atholl Brose which was made according to her recipe: 'Put one pound of dripped honey in a basin and add enough cold water to dissolve it (about a teacupful). Stir with a silver spoon and when the water and honey are well mixed add gradually 1½ pints whisky. Stir briskly until a froth begins to rise. Bottle and keep tightly closed. If liked the old fashion may be followed of pouring the liquid over a little oatmeal from which it is afterwards strained.' The silver spoon is clearly essential.

Victoria gave the royal approval to the Highlands and her subjects followed her lead. Many were attracted to the Highlands because it was a wild, beautiful, romantic place, untouched by the industrialisation that was spreading over England, Wales and the south of Scotland. It was seen through the poetry of Scott, through the music of Mendelssohn, through the oil paintings of McCulloch, Landseer, Graham and MacWhirter.

Horatio McCulloch (1804–1867) is the painter who captured best of all the Highlands loved by the Victorians. His reputation has suffered because he is remembered for his most popular painting *My Heart's in the Highlands*; but the title is misleading, for his painting of great landscape is not sentimental. His large-scale oil paintings have a grandeur that matches the subject. He loved Scotland and rarely left it, and he was highly praised by his contemporaries who claimed him as their national painter, doing for the Scottish landscape what Constable had done for more cosy English rural scenes.

'He can make you feel through his art the loneliness of mountain sides and great glens and inspire you, if you will but open your mind to receive the impression, with the feeling of religion and wonder, which growing out of the sense of that loneliness, has imbued his own spirit,' wrote the art critic Iconoclast of *Scottish Art and Artists* in 1866.

McCulloch painted *Glencoe* in 1864, an example of one of the Highland set pieces, perhaps the most famous glen in Scotland. The macabre history of the Massacre of Glencoe in February 1692 made it an essential part of the tourist itinerary as the Highlands opened up in the middle of the nineteenth century. The inn at Clachaig became a stage for coaches running between Glasgow and Fort William. Queen Victoria picnicked in the glen in 1873, protected by her manservant, the trusty John Brown, from a persistent newspaper reporter. Charles Dickens didn't like it at all: 'Glencoe itself is perfectly terrible. The pass is an awful place. There are acres of glens high up, which form such haunts as you might imagine yourself wandering in in the very height and madness of a fever. They will live in my dreams for years… the very recollection of them makes me shudder.' Lord Macaulay said: 'In the Gaelic tongue, Glencoe signifies the Glen of Weeping.' With an average rainfall of some 90 inches, Glencoe is often shrouded in mist and rain on many days throughout the year, so its name is doubly appropriate.

It became so popular with visitors that the area of Glencoe and Dalness was bought by the National Trust for Scotland in the 1930s – one of the first stretches of mountainous country to be acquired. The road was reconstructed and today there is an information centre, including a Ranger service, shop and café as well as a ski centre.

McCulloch's technical skills as landscape painter and his sense of scale and melodrama rose to the challenges of Glencoe, of Loch Maree, of Loch Katrine. He produced splendid paintings of these landscapes, successfully capturing the spirit of the place and of Scott's writings.

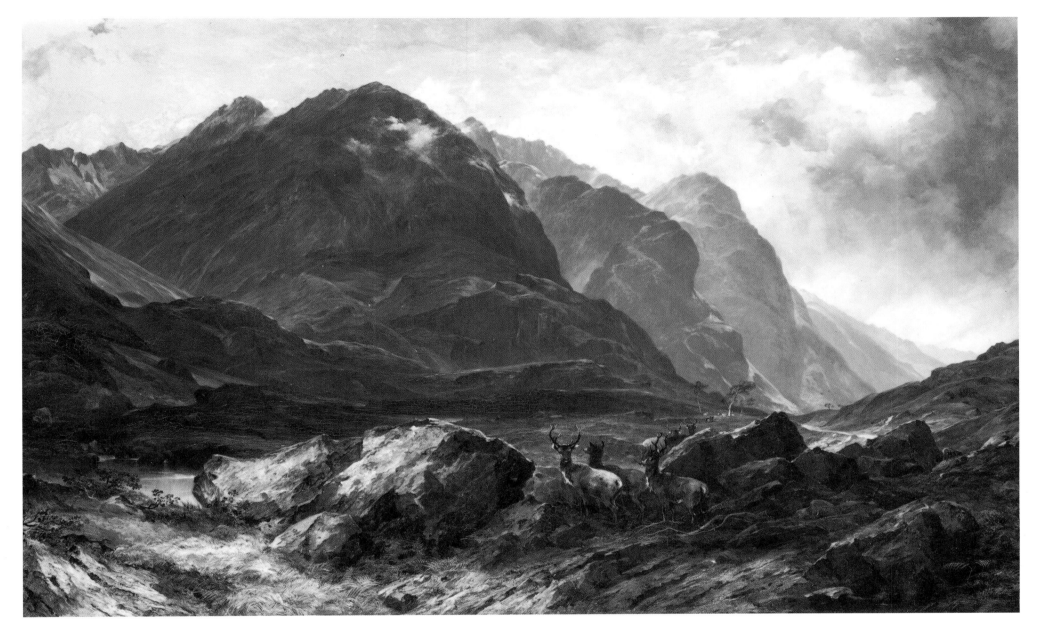

Glencoe, Horatio McCulloch, 1864 (Glasgow Art Gallery)
One of the great Highland set pieces.

Scott's poem 'The Lady of the Lake' is the story of a king who while hunting discovers the exiled Douglas and his daughter Ellen living idyllically on an enchanted island in the middle of the loch. Scott's readers rushed to the Trossachs, overwhelming the available accommodation and initiating the building of Scottish baronial hotels in the area.

The painters followed: John Thomson, Scott's protégé, exhibited a painting of Coir-nan-Urisken glen at the southern end of Loch Katrine, with a quotation from the poem; Turner in a vignette showed the scene exactly as described by Scott; Ruskin, on a Highland tour with his parents in 1838, made a pencil sketch with Ellen's Island in the foreground. Horatio McCulloch's fine oil paintings of

1866, now in Perth Museum, conveys the sense of entering an undefiled landscape of beauty and enchantment.

'Paintings like this,' wrote Frances Spalding in the introduction to the *Landscape in Britain* exhibition of 1983, 'increased the number of tourists flocking to Scott's countryside so that the myth of its inviolateness... grew less true with every year that passed.'

Visitors didn't have an easy time of it travelling in the Highlands. They might travel by sea, taking the steamer from London to Leith, but the journey from Edinburgh to Inverness took four days in the earlier part of the nineteenth century, and there were no public coaches or post horses. Crossing the lochs and firths was alarming, as there was a risk of the ferry

boats being capsized by frightened horses, so the horses had to swim behind. Yet even in Victorian times there were those who complained that the great tide of tourists pouring through the Highlands was spoiling its remoteness and that the enthusiasm of the railway travellers was annihilating the scenic beauty they had come to see. It is remarkable that at the end of another century of tourism the Highlands still retains its sense of remoteness.

Since 1859 Loch Katrine has been one of the chief sources of Glasgow's water supply, a function which has involved raising the water level by 17 feet,

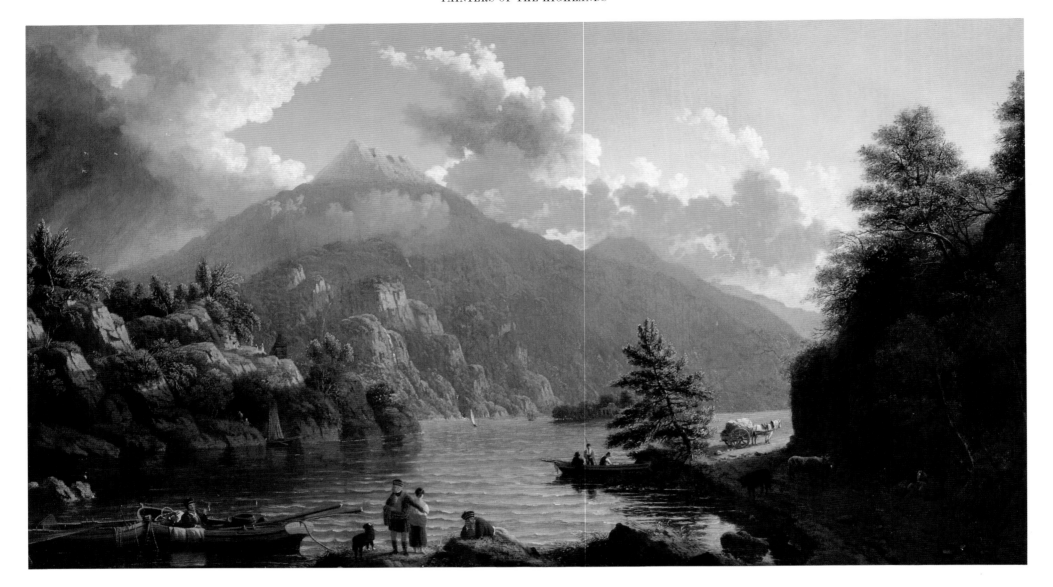

On the banks of Loch Katrine, John Knox, c.1825 (Sotheby's)
The success of Walter Scott's poem, 'The Lady of the Lake', telling of the exiled Douglas and his daughter Ellen who lived on an enchanted island in the middle of the loch, inspired many artists to paint the scene of the romantic idyll, and brought the tourists rushing there from England.

altering the shoreline of the loch from the time of Knox and McCulloch's paintings. The Trossachs – the name means the Bristly Country and aptly describes the heathery undergrowth and moorland – is properly the short gorge from wooded Loch Achray to Loch Katrine between Ben An and Ben Venue. The old pass diverges from the present road beyond the head of Loch Achray and in Scott's time

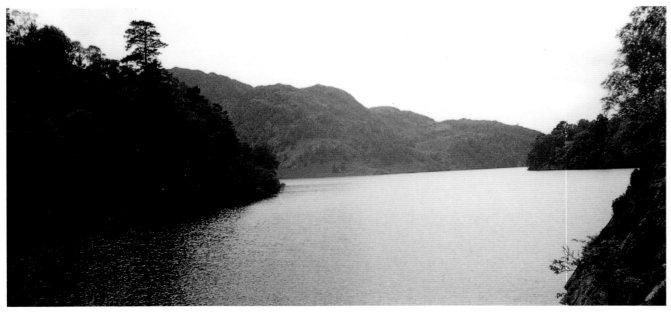

Loch Katrine, 1993. There is still a serene calm about the loch away from the crowds of visitors.

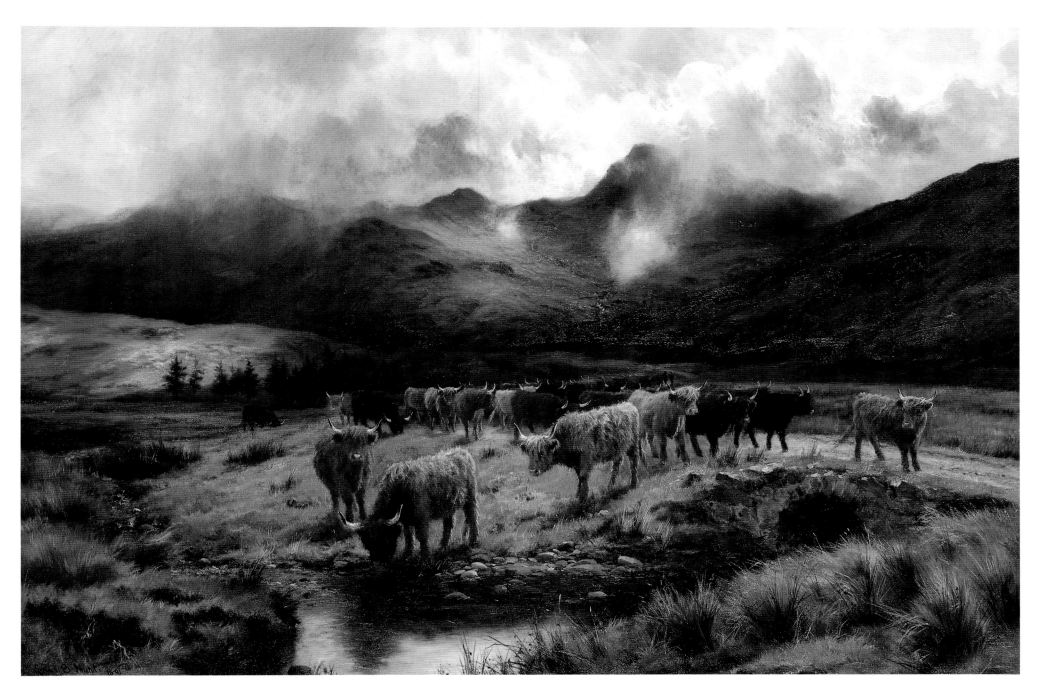

A Highland Drove at Strathfillan, Perthshire,
Louis Bosworth Hurt, 1891 (Sotheby's)
In his day, Hurt's work was highly popular with the Victorian
picture-buying public, who were highly susceptible to views of
misty peaks and morose cattle in the Highland glens.

there was no exit from the defile, 'excepting by a sort of ladder composed by the branches and roots of trees'. It was described as a rugged area of rocks and mounds, oak trees, birch, hazel and rowan, heather, bog myrtle and foxgloves. But such variety has given way to the dark tide of coniferous forest that has spread over the landscape, masking its colours and smothering the identity of many famous viewpoints.

There is now a large carpark and a cafe at Loch Katrine, and a steamer, the *Sir Walter Scott*, to Stronachlachar and Ellen's Island; visitors can board straight from their cars and coaches. For those who want to stretch their legs there is fine loch-side walking, part of the Highland Way.

In 1866, the same year as McCulloch painted Loch Katrine, **Peter Graham** (1836–1921) achieved a notable success with *A Spate in the Highlands*, a dramatic picture of a river bursting its banks and pouring in a torrent towards the viewer. It is an exciting picture that skilfully evokes the force of nature, and it set off a multitude of imitators. It also brought him a commission from Queen Victoria: *Bowman's Pass, Balmoral Forest*.

Graham, who had studied at the Trustees Academy under Scott Lauder at the same time as McTaggart, settled in London but returned to Scotland every year to paint the most rugged mountains, moody lochs and storm-lashed cliffs he could find. He was very good at capturing the brooding melancholy of the Highlands that had strong appeal to London buyers, and his dealer Sir William Agnew kept a waiting list for his work.

The Highland paintings of **John MacWhirter** (1839–1911) were also very popular and he too was a graduate of the famous teaching of Scott Lauder at the Trustees Academy. He travelled abroad a lot, particularly in the Alps and Norway, making studies of wild flowers which attracted the attention of Ruskin; his flower studies are now in the Ashmolean, Oxford, donated by Ruskin. Settling in London and painting at first in Pre-Raphaelite style, he then turned to landscape and found his greatest strength as a brilliant colourist. He used pure vivid colours in his paintings of Highland scenes – blues, green, purples, red – dispensing with the gloom and the melancholy. His lochs and glens glow in the setting sun and there is a more benign air about his mountain scenery (see page 14).

MacWhirter's books on painting were as popular as his pictures. He wrote *The MacWhirter Sketchbook*, *Landscape Painting in Watercolour* and *Sketches from Nature*. Many artists learned from these books;

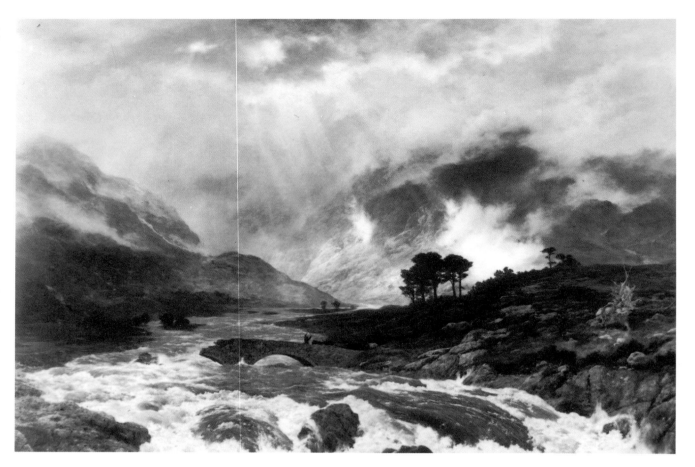

A Spate in the Highlands, Peter Graham, 1866 (Manchester City Art Galleries)

indeed some learned to forge his work and his signature and MacWhirter paintings are now being looked at closely.

Among other painters who successfully captured the romance of the Highlands for the Victorian picture-buying public, Louis Bosworth Hurt (1856–1929) specialised in misty peaks and morose-looking Highland cattle.

LANDSEER AND THE LARDER SCHOOL OF ART

Here the crow starves, here the patient stag
Breeds for the rifle.

T.S. ELIOT, *RANNOCH, BY GLENCOE*

Edwin Landseer, born on 7th March either 1802 or 1803, was born into art – his father was a leading engraver in his day – and he rapidly became a genius prodigy. With a winning blend of artistic ability, engaging charm and curly-headed good looks, he was more of a Regency man than a Victorian. His first paintings were rapturously received and he quickly discovered that rich men would pay more for a painting of a horse than of a wife. He rapidly acquired the Duke of Bedford as his patron, and the Duchess, the beautiful Georgina, as his mistress – two of her ten children were said to be his. He went on from there to become Queen Victoria's favourite painter, with his paintings of her dogs. He was a superb animal painter technically, but his great appeal to a large public was in giving animals quasi-human expressions.

He made his first visit to Scotland in 1824 to paint Walter Scott's dogs, then went on to the Highlands because he wanted to improve his landscape painting. He was captivated by the area and returned every year, sometimes twice a year, finding a new direction which led to him establishing himself as much more than a court painter of dogs. He also found a new freedom. He had no patrons to please when he painted landscape, and he established a rapport with Scottish scenery; it became a convincing background for his animal paintings. When he stayed at Balmoral, at Glen Feshie, the Bedfords' Highland estate, or Glen Quoich, the

Loch Caun, *Edwin Landseer, c.1820 (Sotheby's)*
Landseer first went to the Highlands to improve his landscape
painting and loved it so much he returned every year for the rest
of his life.

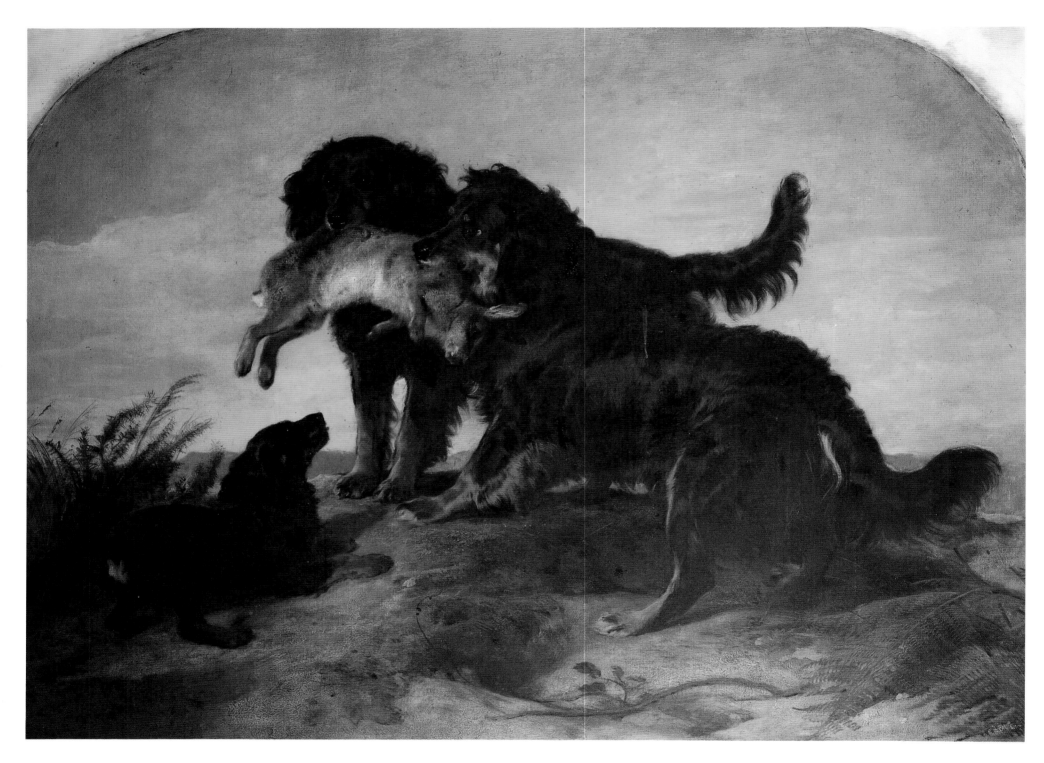

Retrievers with a Hare, *Edwin Landseer, c.1850*
(Sotheby's)

Ellice family estate, he became much involved in deerstalking, both as artist and as sportsman.

When Queen Victoria visited Glen Feshie in 1860, she described it in her diary as 'a most lovely spot – the scene of all Landseer's glory'. Landseer's Rock at Glen Quoich is said to be the scene of his most famous painting, *The Monarch of the Glen*. His name has become inextricably linked with the cruelty of deerstalking, however, through paintings such as *Stag at Bay*, which shows the wounded stag taking to the water, having vanquished one dog and awaiting the attack of another. There is an unpleasant streak of cruelty in many of his pictures. 'Who does not glory in the death of a fine stag?' he said in one letter. He liked to see fur and feather fly: 'There is something in the toil and trouble, the wild weather and savage scenery that makes butchers of us all.'

Queen Victoria typifies the combination of affection for animals and delight in their death which was characteristic of the Victorian age and is so difficult for many to accept today. After the Prince Consort shot a stag at Invergeldie, she sat and sketched the corpse with rapture, declaring it was 'a beauty', it was 'a magnificent animal'. She kept Landseer's paintings in a nobly bound volume in her private sitting room and delighted in turning over the pages, which consisted of a parade of corpses.

Landseer's morbid predilection for the dying agonies of bird and beast, with corpses in rich piles, is the British version of the Dutch Larder school of painting, and the stag-hunting spirit which kills the things it loves, mingling savagery and sentimentality. Edwin Muir, travelling through the Highlands in the 1930s, found the hotel dining-rooms 'had walls covered with pictures of all sorts of wild game, living or in various postures of death that are produced – stuffed heads of deer with antlers of every degree of magnificence'. He found these abominations of bleeding arrays of birds and beasts entirely revolting: 'It rubs in the uncomfortable fact that this is a land whose main contemporary industry is the shooting down of wild creatures.' He added: 'It is not the fault of the Highlanders but of the people who bought their country.'

In the 1950s, Ivor Brown on his Highland tour still found hotels in Braemar full of engravings of Landseer's murals depicting an array of corpses, even the gralloching (disembowelling) of a stag by a gillie.

Strange as this seems today, at an auction of Scottish landscape and sporting paintings held by Sotheby's at the Gleneagles Hotel in 1992, the highest price in the sale, £24,000, was paid for an oil painting dated 1885 by James Hardy Jnr, showing an array of dead birds and rabbits and smug-looking dogs and entitled *Setters with the Morning's Bag*.

Landseer's reputation has suffered from the reaction to his more sadistic animal pictures. It has been said in his defence that he belonged to an earlier, lustier, Regency time, when it was regarded as an interesting diversion to watch executions, lunatic-baiting, and prize-fighting between men, women, bears, dogs, cockerels. He loved the social high life, could never refuse a party invitation, and enjoyed his reputation as Prince Charming, though he refused a knighthood and Presidency of the Royal Academy because he wanted still to be one of the boys. He overworked, hated to be alone, drank too much, suffered hallucinations and near dementia at the end of his life; but he kept his good humour. Coming across an early work of his on sale in a gallery for 2,000 guineas, he was told by the unsuspecting dealer, tapping his head: 'He's gone, sir, you see. He's out of his mind. He'll never paint another.' On the way out of the gallery, seeing a Clarkson Stanfield painting also priced at 2,000 guineas, Landseer said, tapping his own head: 'My God, has Stanfield gone too?'

It should also be said that Landseer at his best was a brilliant painter of animals. It is surely only just that he should be remembered for his best work rather than his worst.

MENAGE A BRIG O' TURK

When Mr and Mrs John Ruskin and their friends John Everett Millais and his brother William set off for a Highland tour in 1853, they were in high spirits. John Ruskin, author of *Modern Painters*, had been working on his book *The Stones of Venice* and was in need of a rest. He had thrown the weight of his considerable influence into the Pre-Raphaelite cause and Millais had become his friend and protégé.

Millais (1829–1896) had founded the Pre-Raphaelite Brotherhood with Holman Hunt and Dante Gabriel Rossetti when he was only 19, with 'but one idea to present on canvas what they saw in Nature', and had been savagely attacked by the critics for it. Ruskin's defence of him had made the critics think again.

That year, 1853, Millais had painted Effie, Mrs Ruskin, as part of his picture *The Order of Release* and it had drawn large admiring crowds at the Royal Academy. Effie was fond of society, loved to attract admiration and was disappointed in her marriage, for Ruskin was high-minded and critical, ignoring the needs and desires of his pretty wife. She was perhaps ready to fall in love with Millais, who was boyish, handsome and delicate with 'the profile of an angel, curly fair hair and a cupid's bow mouth' according to his biographer, Mary Lutyens. Effie was delighted to set off on their Highland adventure and spend some weeks in his company – and to escape from her father-in-law, John Ruskin senior, who constantly criticised and tried to discredit her in her husband's eyes.

They arrived at Brig o' Turk on 2nd July with the intention of staying one night, and remained there for nearly four months, even though it kept on raining. It was the scene of Millais' painting *Glen Finlas: Portrait of John Ruskin*, and also the scene of an extraordinary love triangle.

At first everything was delightful. The party stayed at the inn, then moved to the schoolmaster's house, where they each paid £1 a week instead of £13 at the hotel. Ruskin wrote with satisfaction to his father: 'We could live in luxury in the Highlands for £200 a year.' Millais painted Ruskin by one of the rocky streams – 'a lovely piece of worn rock with foaming (it keeps raining) water, and weeds, and moss, and a noble overhanging bank of dark crag – I am to be standing looking quietly down the stream'. Millais wrote: 'I am going to paint him looking over the edge of a steep waterfall – he looks so sweet and benign standing calmly looking into the turbulent sluice beneath.'

Effie wrote that she had made herself a 'rough linsey wolsey dress', which she wore all the time, and 'with a nice Jacket and a wide-awake (hat) I am independent of weather and sit out all day on the rocks'.

They climbed Ben Ledi, they picnicked on the rocks, Ruskin compiled the 80-page index of *The Stones of Venice*, William caught the trout they ate for breakfast and lost his boots in the stream, Effie read Wordsworth and Tennyson's *In Memoriam* to them. Ruskin was impressed with the progress of the painting: 'It is beginning to surpass even my expectations – the lichens are coming out upon the purple rocks like silver chasing on a purple robe and the water – which I was nervous about is quite perfect – truly such as was never painted before.' Ruskin was seeing his own words made visible in Millais' painting.

Brig O' Turk (1993), where Millais and the Ruskins stayed four months, having intended only to stay one night.

The cottages just off the road, among them the schoolmaster's cottage where the party stayed after they left the inn.

Turk water from the bridge.

The stream almost hidden in greenery.

Millais, however, began to weary of painting in the rain: 'The horror of this climate is you start off in the morning (which is fine) of course expecting a continuance after a month's pelting, but no such thing, directly the palette is in readiness, clouds come over and down it comes again.' It was all very well, he complained, for others to recommend working outdoors close to Nature, but 'they do not know the horrors of a sprinkled palette'.

He wrote: 'Mrs R is a blessing. Her husband is a good fellow but not of our kind, his soul is always with the clouds and out of reach of ordinary mortals.' He spent more time sketching Effie with foxgloves in her hair than painting her husband, and took pleasure in teaching her to paint, but the hopelessness of his love began to affect him. He became accident-prone, hypochondriac, almost hysterical. Effie too began to suffer from facial neuralgia. They were both deeply unhappy in the situation in which they found themselves, their love repressed, unspoken, impossible.

It has been said Ruskin connived at situations where Millais and Effie were together, but it has been pointed out by Mary Lutyens that though he may have wished to be free of Effie, Ruskin admired Millais' genius too greatly to wish to lose his friend. It seems he looked to Effie to encourage Millais in his work, fearful that Millais' strength might not be equal to his genius. Art mattered most.

After their sojourn at Brig o' Turk, Millais completed the picture of Ruskin in the studio, and Effie returned to stay with her parents near Perth. Ruskin gave four art lectures to the Philosophical Institution in Edinburgh, attended by a thousand people.

The following year Effie was granted a Decree of Nullity on the grounds of Ruskin's 'incurable impotency'. The scandal of the annulment of the marriage took a long time to die down, and Effie was blamed and ostracised socially. Queen Victoria would not receive her.

Ruskin, despite everything, continued to praise Millais' work. But when Effie and Millais were married in 1855, it was said that Millais had done the chivalrous thing. Though they had a happy honeymoon on the Isle of Arran, and a family of eight children, the story did not have a truly happy ending, for her health never fully recovered from the ordeal of her first marriage and Millais felt he could never 'blot out the ruin' in her life or forgive Ruskin.

There was a happier artistic outcome. Millais and Effie lived for several years at Annat Lodge, near

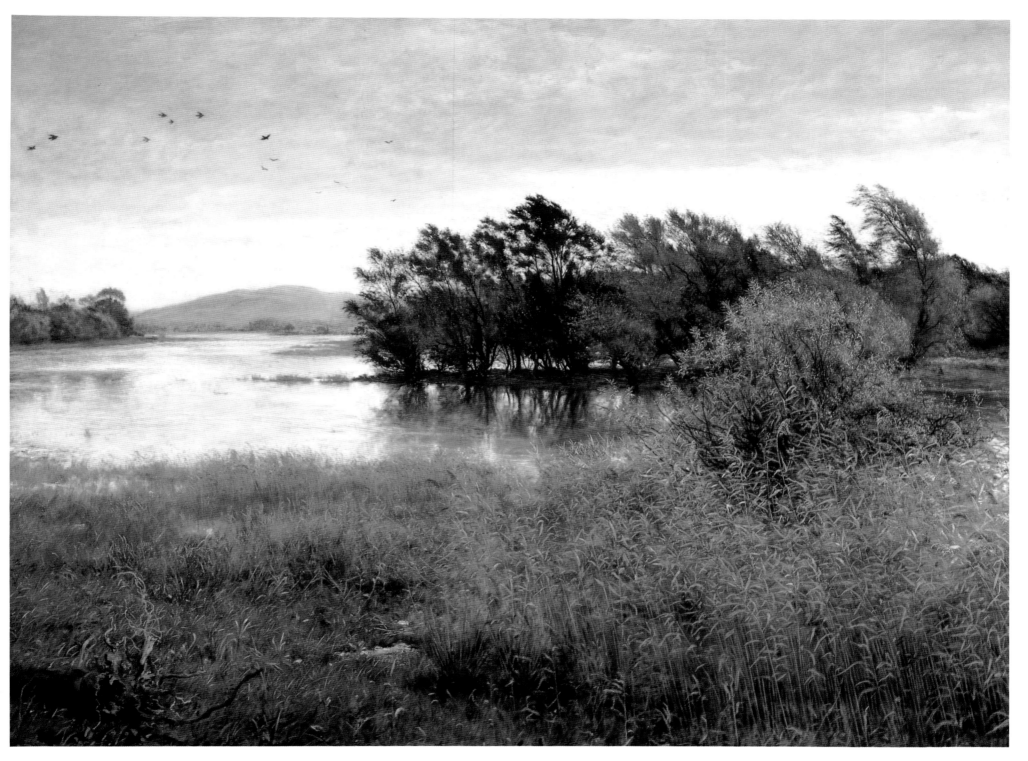

Chill October, *John Everett Millais, c.1875 (Sotheby's)*
Painted on location on a backwater of the River Tay and
notable for the beauty of its foreground detail, this painting was
an important influence on future Scottish landscape art and
greatly impressed Van Gogh.

her parents' home on the hill of Kinnoull; here Millais painted some of his best-known pictures, *Autumn Leaves* and *The Vale of Rest*. When they moved south to settle in London he continued to visit Perth regularly and painted a series of large Scottish landscapes from 1870. *Chill October*, his first pure landscape, was painted on location looking downstream from opposite Sleepless Inch, across a backwater that has now become the main course of the Tay; a special platform was constructed by the artist for the purpose. It was a heroic undertaking, a noble struggle with the elements, and the result is a picture that has set its stamp on many subsequent Scottish landscapes for the beauty of its foreground. *Chill October* impressed Vincent Van Gogh more than any other British painting he saw. He was haunted by its feeling of chill, emphasised by the silhouettes of distant migrating birds – an image that appeared in his own later landscapes.

Ruskin and Millais also influenced the new generation of gifted painters in Glasgow, who were scornful of the battalions of grand landscape artists painting so many purple peaks that they 'put up the price of purple'. Inspired by Ruskin's writings, the Glasgow Boys chose Brig o' Turk for their first summer painting location. It was an ideal base, easily reached from Stirling or Glasgow. There they chose to portray the back lanes and gardens and hillside crofts and the people themselves, becoming absorbed into the life of the village and painting with a new low-key realism. In the foreground of their pictures appear the cabbages, the newly turned earth, the rocks and stones and clumps of grass, painted in a different style with clarity and solidity.

James Guthrie (1859–1930) began painting *A Funeral Service in the Highlands* after they attended that of a farmer's son who had drowned in the river. This picture, bought by the Aberdonian collector John Forbes White, established the group's reputation.

Visitors to Brig o' Turk today will find it has not changed much since the days of Millais and the Ruskins; it is still a tiny hamlet, easy to drive past without noticing. Telegraph poles, petrol pump and tin hut serving teas have been added, but it remains heavily wooded, intensely green, the overhanging trees hiding Turk Water and the little stone bridge. The hotel where the party first stayed burnt down in the 1890s; according to rumour it was deliberately fired for the insurance money. Only the stable remains, opposite the tiny post office; it is now a private house, retaining the name Burnt Inn.

There is a small group of tile-roofed cottages just off the road, among them the schoolmaster's house where the Ruskins stayed after the first week. The little kirk attended by the party is about a mile away at Loch Achray. The stream which once had an impressive waterfall and eight feet of water with salmon trout 'leaping like little dolphins in the spray' is now only about a foot deep, due to the dam that has been built at the top of the glen. But the hamlet retains a quiet green dreaminess and seems lost in time, with only the passing traffic on its way to Loch Katrine to disturb its peacefulness.

With so much water all around and hills close by, it is usually raining in Brig o' Turk – 'nine days a week' as Millais declared. It is remarkable that this damp green place saw probably the first attempt at landscape painting out of doors in Britain.

THE FAR NORTH

The visions of the hills
And souls of lonely places.
WILLIAM WORDSWORTH

Beyond the divide of the Caledonian canal there is another Scotland. Ivor Brown described it in his book *Summer in Scotland* as a 'majesty of nothingness, infinities of emptiness never felt elsewhere on British soil, wind-scraped rock, wind-chilled sunlight, bare bone summits, a feast of scenery without humanity, a wilderness of purple, blue and grey, a waste land given over to deer where there are still the ruins of life gone'. He was reminded, however, of the Scot who said: 'I dinna like it. It's far ower sublime.'

It is a landscape cleared by man as well as nature: by the fighting of the clan chieftains, the callous savagery of the Clearances that burned out the crofters to make room for sheep, by emigration, by poverty. It is a savage solitude, left to sparse herds of mountain sheep, grouse and curlew. Yet there are signs of change in 1993, for huge Highland and island estates are now coming up for sale due to the recession and not finding buyers. For the first time in centuries, there are opportunities for the tenants and crofters to buy the land they rent from rich incoming landlords. Newspapers have observed the Clearance of the Landlords, the wheel turning full circle, and the Highlanders coming into their own at last.

D.Y. Cameron (1865–1945) headed for Sutherland, where the tourists rarely go, to paint the landscape of the far north. He found solace in the mountains but he found too that the beauty could be overwhelming, and for the landscape painter it was an enormous challenge. His great paintings of the 1930s – *Loch Lubnaig, Suilven*, and *Wilds of Assynt* (which he regarded as his finest large oil painting) – show how he rose to the challenge with an extraordinary vision of colour. He captured the drama of the scenery in an economical uncluttered style that is essentially modern and conveys a strong sense of the loneliness that is true to this region. Cameron rarely portrayed people or habitations such as crofts or farms. This sense of emptiness has been criticised as indicating Cameron's cool detachment and lack of passion, but it is through it that he catches the spirit of the place. It has a cold light, it is underpopulated, it has an atmosphere of melancholy and ancient mysteries of past centuries in its fathomless lochs and brooding mountain peaks. Here the landscape dominates man.

Just as Horatio McCulloch was the great nineteenth-century painter of the Highlands, D.Y. Cameron was the painter of the twentieth century who found inspiration in the mountains; he was in the same tradition of Scottish landscape painting as Nasmyth and McCulloch. Bill Smith, Cameron's biographer, points out that he took no part in the development of decorative style of the Glasgow Boys who painted in the Lowlands. He didn't adopt the impressionistic style of William McTaggart, who worked mainly on the coast, nor did he travel to France like Peploe and Fergusson to experience the influences of Cézanne, Matisse and the Fauves. Yet by about 1910 he had developed his own individual landscape style, simultaneously dramatic and subtle, and he controlled and refined it during the rest of his career.

He was then in his forties, established and acclaimed for his achievements, one of the foremost etchers of his day, a member of the Scottish art establishment, and by temperament and inclination a pillar of it. He achieved the double distinction of being elected to the Royal Academy both as etcher and as painter, and he was knighted in 1924.

At this stage in his career he turned to the hills, quoting Wordsworth' 'Visions of the Hills' in a speech because they held the essence of his work in

Loch Lubnaig, D.Y. Cameron, 1938 (Flemings)
Cameron rose to the challenge of painting the mountains with an extraordinary vision of colour and a spare powerful style.

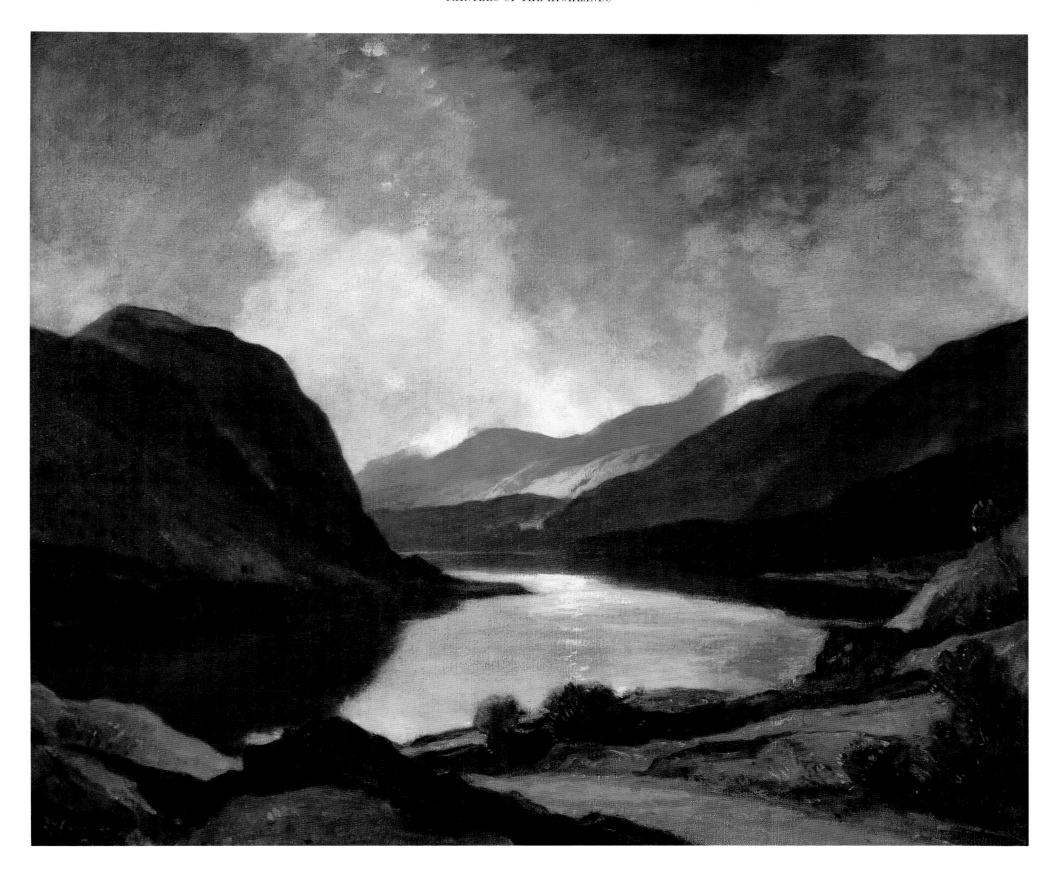

Loch Lubnaig, 1993, unspoilt and lonely still.

landscape. He was striving to capture the breadth and beauty of Scottish landscape on both a spiritual and an artistic level.

Because he was used to etching he had a strong sense of structure, tone and balance in landscape. He accentuated the tones and the mass of the land, eliminating the inconsequential detail, and in doing so captured the austere beauty of the mountains. At first, in paintings such as *The Peaks of Arran* and *The Hill of Winds*, c. 1913, his tones were subdued and dark. Ben Ledi appears often in his work. It is one of his finest prints in etching and drypoint, and he painted it many times in many moods (recalling Cézanne and his obsession with Mont Sainte Victoire). He always spoke affectionately and reverently of the mountain.

Cameron was appointed a war artist and was occupied with war paintings until 1920. The Camerons bought a house in London and he became heavily involved in work as a trustee, with much committee work and many boards to attend. He suffered a heart attack from overwork, only slowly returning to etching again.

He and his wife Jeanie had moved to Kippen, a small village near Stirling, in 1899 and they lived there for the rest of their lives. Both Camerons were ardent supporters of Kippen church. He was passionate in his desire to see beauty reintroduced into Scottish churches and believed in the need for symbolism in worship. He lectured on the subject, listing as his chief hobby 'trying to make ugly churches more seemly', and he was instrumental in the decoration and ornamentation of Kippen church with a high order of craftmanship, though his degree of ornamentation met with some resistance and accusations that he was compromising the spirit of Presbyterianism.

When Lady Cameron died in 1931, he was overwhelmed by the loss and suffered intense depression. He gave up the house in London and only very slowly found a way to regain his spirit through painting the Scottish mountains, giving himself up to his vision of the hills. His was a powerful evocation of the beauty and grandeur of Scottish landscape. Sir William MacTaggart said of him: 'He was one of the few artists who succeeded in capturing the drama of the Highlands.'

He was a romantic, and like McCulloch he appreciated the strong association of Scottish landscape with its history and literature. It was heightened for him by the feeling that he was part of it, for Clan Cameron had suffered greatly in the last risings of the Stuarts.

He sought to convey the spirit of places; in an address he gave on the Romance of Scottish History in 1928 he outlined what he was trying to achieve:

Romance in history as in the arts was that spell of mystic beauty, haunted by strangeness of form and colour, remote from the facts and feelings of common life. It did not imply lack of strength but associated itself with very noble, exalted, and even austere shapes, veiled perhaps by distance or muted by the fading light and gathering darkness. Out of these shadows of the centuries, often profound in colour and strangely lit, there emerged great figures or actions which they associated with the world of romance. The rhythm in poetry rather than prose, the tones and colours in painting rather than the forms in sculpture, were more expressive of these visions of the dream world of beauty and mystery they longed for in a life where pressure of the actual hindered the imaginative impulses which fired and exalted the heart.

It is clear Cameron's painting in the far north has influenced contemporary artists such as **James Morrison**. Morrison, born in Glasgow in 1932 and trained at the Glasgow School of Art, follows the nineteenth-century artistic tradition of painting in the open air, rarely reworking in the studio. This commitment involves a constant battle with the elements, as his chosen scenes are the bleak windswept landscapes of Rannoch moor, the Argyll coast, Morar, Wester Ross and the Assynt region, Sutherland to the north, the Torridon mountains to the west. Huge skies dominate his paintings, giving a wide sense of space highlighted by lochs and inlets of the sea; great cloud masses roll in to decapitate the mountains, and he conveys the strength of this primeval landscape and the brooding Celtic twilight. Morrison aims to present his personal discovery in landscape: man sensing his own insignificance, abandoning individual existence and becoming part of the infinity of space.

His art in paintings such as *Towards Laurencekirk*, *Summer Isles Torridon* and others at Assynt shows that he, like D.Y. Cameron, has found that the way to paint the cold landscape of the far north of Scotland is in strong colour with dramatic skies, bold simplification and rarely any human habitation in sight.

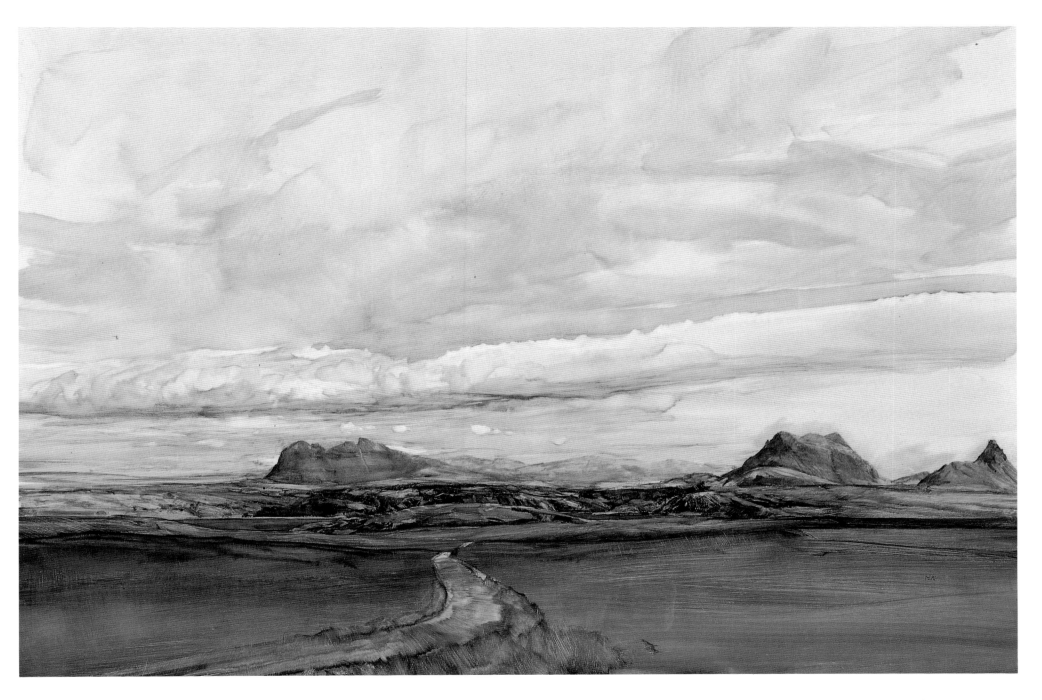

Suilven, Canisp, Cul Mor and Stac Polly,
James Morrison, 1989 (Scottish Gallery)

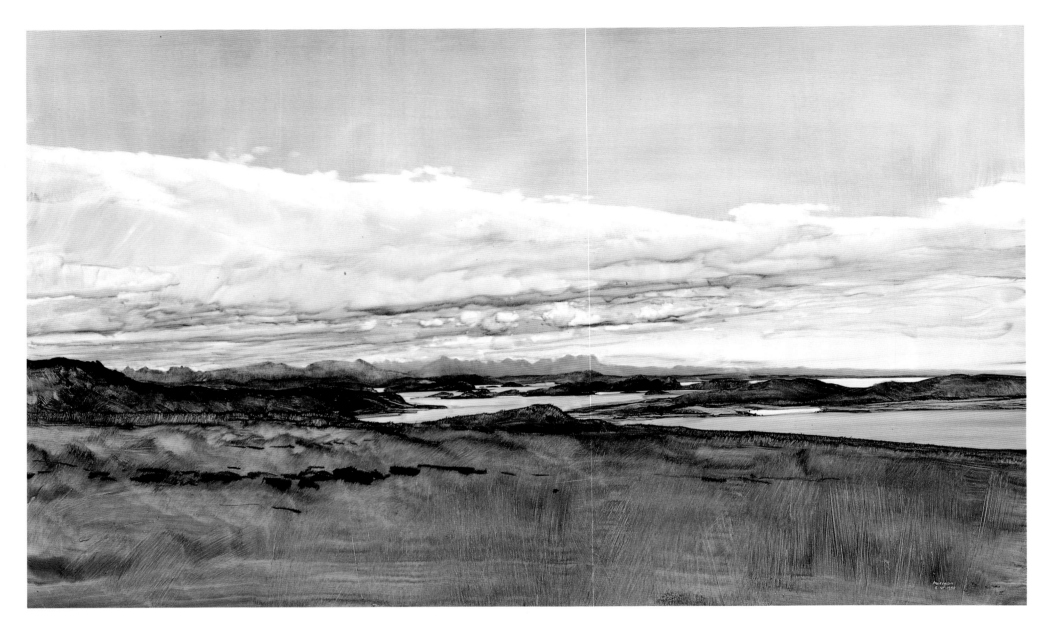

Summer Isles and Torridon, *James Morrison,*
1988 (Scottish Gallery)

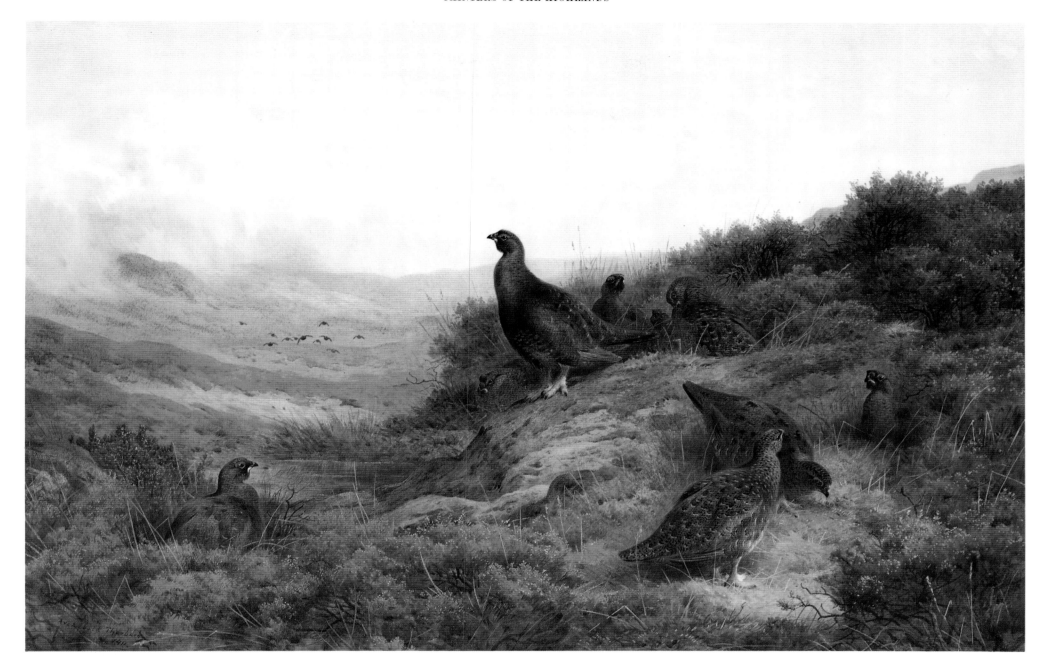

Red Grouse in a Landscape, Archibald Thorburn, from the *Thorburn Museum (Sotheby's)*

Birds in a Landscape

One of the great riches of the Highlands and the far north of Scotland is the wild life. Red deer, roe deer, pine marten, wildcat, ptarmigan and golden eagle have survived here better than anywhere else in the British Isles – and only with protection.

Gone are the artists like Landseer, glorying in the killing of game and deer. Instead the twentieth century has seen the rise of painters portraying birds and animals in a Highland setting in meticulous, loving detail. The best-known name in this genre is **Archibald Thorburn** (1860–1935), whose bird paintings are as popular today as they were in his lifetime. His compositions are a happy combination of birds with plants and landscape, the natural setting of moors, mountains, snows and flowers, all freely drawn, accurate in colour and form, and sensitive to seasonal changes.

Thorburn was born in Edinburgh, the son of a miniaturist who worked for Queen Victoria. He learnt to paint and observe nature from his father, becoming a painting prodigy and exhibiting at the Royal Scottish Academy at the age of ten. He first became well known in the 1880s, producing 268 of the 421 plates in Lord Lilford of Northampton's book *Coloured Figures of the Birds of the British Islands*. He

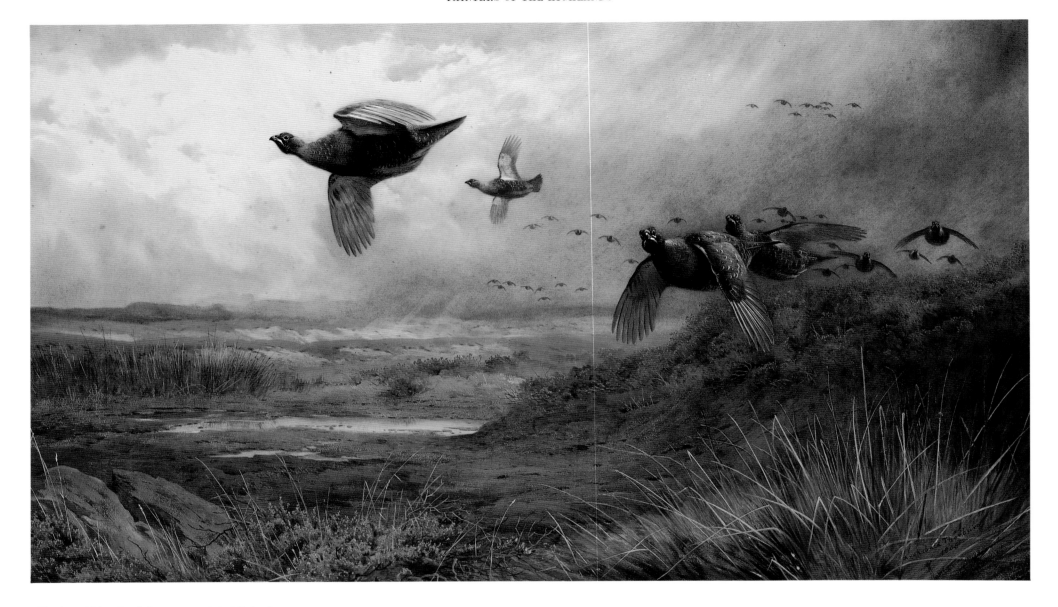

The Twelfth – Red Grouse, Archibald Thorburn, 1906
(Sotheby's)
*This watercolour was probably painted on the Perthshire hills
when the artist was staying with J. Henry Dixon of Pitlochry.
'At first far-away echo a pack of red grouse come swinging by,
disturbed at their feed grounds by the sound of distant guns on
the morning of 12 August.' Thorburn's* Birds and Mammals

continued to illustrate books; his *British Birds*
first appeared in 1915–16 and made him highly
successful.

He settled in London, as so many Scottish
artists did, but returned to Scotland each year
to draw, working these drawings up in his

studio into full-scale watercolours. He
preferred the delicacy of watercolour to oil
paint, but he painted on a large scale and with
extensive use of Chinese white so that his
pictures have the look of oils.

His keen observation and care over detail
and his knowledge as a naturalist all come
together with his skill as a painter: in subtle use
of colour and glowing tonal values in *Cock
Pheasant*; in capturing the light in a snow scene
in *Ptarmigan in the Snow*, in the gentle moor-
land colour of *The Covey Feeding*, and *Ptarmigan
on the Moors*, and as a powerful study in gold

and brown in *A Golden Eagle*.

Thorburn's favourite painting country was
way up in the Grampian Mountains where he
could find the natural surroundings for the
birds he painted. He particularly liked the
Forest of Gaick, where a path leads from Gaick
Lodge past Loch-an-Duin to a road
descending to Dalnacardoch in Glen Garry and
Glen Feshie, a wild glen now under afforesta-
tion. In this area there is now a Highland
Wildlife Park featuring Scottish mammals and
birds of the past and present in a beautiful
natural setting.

CHAPTER SIX

PAINTERS OF EDINBURGH

CITY OF ENLIGHTENMENT

The situation of Edinburgh is probably as extraordinary as one can well imagine for a metropolis. The immense hills, on which great part of it is built, though they make the view uncommonly magnificent, not only in many places render it impassable for carriages, but very fatiguing for walking.

CAPTAIN EDWARD TOPHAM

FOLLOWING in the tradition of Dr Johnson and Boswell in the eighteenth century and Wordsworth in the nineteenth, the author and poet Edwin Muir set out on a Scottish journey in 1935. J.B. Priestley had just published his *English Journey* and Muir was writing the Scottish counterpart, travelling in a 1921 Standard car borrowed from the painter Stanley Cursiter.

The first sight of Edinburgh after an absence is invariably exciting. Its bold and stony look recalls ravines and quarried mountains, and as one's eye runs up the long line of jagged roofs from the Holyrood to the Castle, one feels that these house-shapes are out-croppings of the rocky ridge on which they are planted, methodical geological formations in which, as an afterthought, people have taken to living.

Edinburgh has been well served by the artists who have captured its 'bold and stony look', from the time of Alexander Nasmyth and the building of the New Town to that of William Crozier, who brilliantly portrayed Auld Reekie on its scarp of rock in Cubist style in the 1920s.

The rocky splendour and pride of Edinburgh give it the air of a capital city with a long history. The medieval town was founded in the twelfth century, though there was a settlement on Castle Rock long before, an earthwork from the Dark Ages, probably an Iron Age fort. It began as a chartered burgh, with the merchants and craftsmen established on the long ridge below the castle, and at the foot of the ridge, closed in by Canongate, the Abbey of Holyrood, which later became a royal palace.

Edinburgh remained confined to its hill-top, hemmed in by marshes below its volcanic crag, but it steadily increased in importance for many centuries and needed more space. The city buildings grew tall – much like the French in style, with a common stair – rising to as many as twelve storeys, and set in dark stony courtyards and narrow wynds. Life was harsh there, with problems of overcrowding, unemployment, cholera, famine, riots and gangs known as 'meal mobs' attacking shops to get oats and barley for their starving families. The High Street was said to be the most densely populated in Europe.

In the last quarter of the eighteenth century a spacious New Town was designed, with wide streets, squares and crescents and elegant Georgian houses – 'houses to themselves' in the English manner, instead of storeys of tenements. The artist Henry Raeburn (1756–1823), who was born at Stockbridge in Edinburgh, ordered a new studio and residence built in the New Town and moved there in 1798. He was then without equal in Scotland, his status as a world-class portraitist established.

Taking part in the planning of the New Town was the painter **Alexander Nasmyth** (1758–1840). He was a son of the city, born in the Grassmarket, his father a successful builder. He recorded the development of the city in a series of paintings of exceptional interest in the story of Edinburgh; they were the peak of achievement in his own illustrious career.

Nasmyth had attended classes at the Trustees' Academy which was set up in 1760 'for the Encouragement of Manufacturers in Scotland' to provide instruction for pupils to follow a trade – carving, gilding, house-painting, cabinet-making, engraving, calico-printing and so on – with the emphasis on industrial design. In 1798 a separate Drawing Academy for fine artists was established. Nasmyth subsequently worked as an assistant to Allan Ramsay in London, then travelled to Italy for two years; by the time he painted views of Edinburgh documenting the city, he was well established as a topographical landscape artist.

In his standard work on Scottish Art, Duncan Macmillan describes how Nasmyth's Edinburgh paintings show his enlightened approach, his scientific, engineering and geological knowledge. In *Edinburgh from Princes Street with the Royal Institution under Construction*, 1825, overpage, the people of Edinburgh are seen at work on the city's first purpose-built building devoted to the arts:

Constructed on an artificial mound, it was quite a feat of engineering. The architect William Playfair, in black coat and top hat, is directing the work. Above him two builders are lowering a massive stone drum into position. They are using a block and tackle and the manifest ease with which they are manoeuvring the great weight of the stone demonstrates the power of mind… as Nasmyth himself so much enjoyed it in his own interest in engineering.

In *Edinburgh from Calton Hill* (see page 10), looking west along Princes Street, the citizens sit at leisure and enjoy the midsummer sunset. In the foreground, the Calton Jail is seen not as an expression of authority but as an instrument of social reform, symbolising the optimistic view of Nasmyth and his contemporaries.

At the exact centre of the composition, however, is a symbol even more central to the Enlightenment. The ideal of philosophy is represented by the cylindrical tower of the

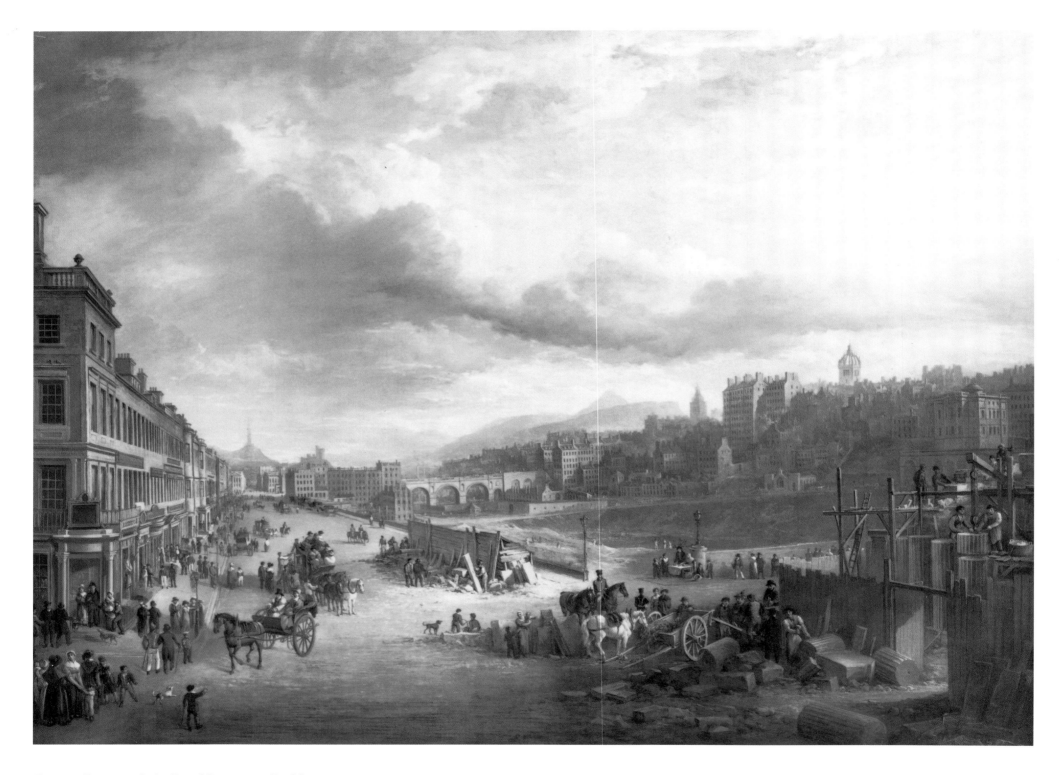

***Princes Street with the Royal Institution Building
under Construction***, *Alexander Nasmyth, 1825 (National
Gallery of Scotland)*

monument to David Hume in the Calton cemetery, designed by Robert Adam – so the philosopher from his grave continues to order the life of the people. Philosophy is appropriate in the picture too as a symbol of the utility of leisure. The people are not merely idle. Recreation is part of their claim to be civilised. Leisure, the essential condition for improvement, is in Nasmyth's view no longer the prerogative of the rich alone. It is part of the life of all the citizens in a well-ordered state.

Among a number of other fine paintings of Edinburgh, Nasmyth painted a magnificent *View of Leith from the Sea*, *A View of the High Street* and *A View of Edinburgh from St Anthony's Chapel*, all produced within a few years. It is characteristic of him that he chose to paint the city in its landscape, with a grandeur worthy of the ideals that inspired its architecture, nature and the works of man in harmony together, and the people at ease in their city.

The street life of Edinburgh has been commented on over the centuries and attributed to the similarities between the Scottish and the French people, particularly between the cities of Edinburgh and Paris. Captain Topham, an English soldier living in the city in 1775, noted 'that air of mirth and vivacity, that quick and penetrating look, that spirit of gaiety which distinguishes the French, equally visible in the Scotch'. It indicated the happy character of the nation, he maintained, and made them disregard even their poverty. Where there were differences he put them down to religion, Catholicism being the more comfortable one, 'but where the Scotch have no absolution to lift the burden of sin and stop them feeling miserable, they have something very like it – a superstitious reliance on the efficacy of going constantly to church'.

Another factor and a strong link in the Auld Alliance was the wine trade that flourished between France and Scotland for centuries, the wine fleet bringing in the precious cargo to Leith pier until in Edinburgh they were said to be knee-deep in claret. When each cargo of claret arrived a hogshead of it would be sent through the town on a cart with a horn blowing to proclaim the event. Anybody who wanted a sample had only to go to the cart with a jug and, whatever its size, it would be filled for sixpence. People were walking on a fortune in claret stored underground between Giles Street and St Andrew's Street in great vaults and cellars. The

Scots drank so much claret it was in their blood – until it was spoilt for them by the high taxes imposed by the English. Then they drank whisky.

It was noted by Edwin Muir, making his Scottish tour in the 1930s, that the citizens of Edinburgh were much in evidence taking their leisure.

> There is far more street life in large Scottish cities than there is, for instance, in London. Why this should be so, I do not know; perhaps it is a relic of French influence, which was once so powerful in Scotland, but a more probable explanation is that, in a country of few amusements, and these mostly frowned on, walking out to see the world acquired the rank of a rare pleasure.

The utopian dream for Edinburgh of Nasmyth and his contemporaries did not materialise, but the city has been remarkable over the intervening time for high points of art and artistic endeavour, interspersed with periodic economic difficulties and entrenched attitudes.

The Trustees' Academy moved into the Royal Institution Building on the Mound in 1826. It had its ups and downs over the years, often rowing with its rival the Royal Scottish Academy. In 1851, the appointment of Robert Scott Lauder was the beginning of a new era in which the Academy and art in Scotland flourished.

Robert Scott Lauder (1803–1869) trained at the Trustees' Academy himself, then travelled in Italy and achieved success in London as a historical and biblical painter. If he had stayed in London he might have achieved greater fame, but he was to play a crucial role at the Trustees' Academy. He urged his students at the Academy to plunge into painting immediately, not to restrict themselves to drawing; he stressed the need for composition; he realised the importance of colour – all ideas that were counter to academic thinking of the time, which confined students to drawing from casts of classical sculpture, not even clothed models. His own taste was for the rich colours of the Venetian school, which inspired many of his pupils – McTaggart, Orchardson, Pettie, Chalmers, Cameron, Graham, MacWhirter, and others. They all benefited from his encouragement, his infectious enthusiasm and enlightened, imaginative teaching.

When Lauder retired in 1861, embittered by his fight against old-fashioned teaching methods and lack of commercial success as a painter, the Trustees' Academy slowly faded away, leaving the

field to the Royal Scottish Academy. But Lauder's name is remembered as the inspiration of the next generation of Scottish artists.

THE BOHEMIANS OF SHANDWICK PLACE

The Edinburgh College of Art opened in 1909, inheriting from the Trustees' Academy the tradition of teaching by distinguished artists, the system that had produced so many of Scotland's finest artists, at that point most notably S.J. Peploe and F.C.B. Cadell. After the First World War, the portrait painter David Alison took over as head of drawing and painting and began to build one of the most effective art teaching teams in Britain, inspiring a steady stream of talented students.

Edinburgh groups of painters began to emerge, with artists exhibiting together, and the Society of Eight was formed in 1912 with a fixed limited membership and permanent premises at the New Gallery, 12 Shandwick Place. Membership included like-minded artists from Glasgow as well as Edinburgh, for the first time transcending the rivalry between the two cities, and including the country's most exciting talent – Cadell, Lavery, Paterson, Peploe. The annual exhibitions were a great success, establishing the Colourists' reputations. William Gillies was a member of the Society of Eight and then a founder member of the 1922 Group, a 'ginger group' of young artists including William Crozier, William MacTaggart and others.

Some of the Edinburgh artists exhibiting at the New Gallery in Shandwick Place were described as a bohemian crew, and their art and outlandish behaviour were thought to be an affront to polite society. An art critic wrote that 'half Edinburgh goes to Shandwick Place secretly desiring to be righteously shocked, and the other half goes feeling deliciously uncertain it may be disappointed by not finding anything sufficiently shocking'.

F.C.B. Cadell (1883–1937) was born in Edinburgh and after training in Paris he painted the life around him in Edinburgh – interiors rather than landscapes. Prior to 1915 he produced a series of stylish women in elegant drawing rooms – successful paintings of the period, full of vitality and atmosphere.

After his war service his style changed, becoming stark and clearcut in still life and Iona landscapes. He was successful then, and able to buy a handsome house, 6 Ainslie Place, where he entertained artists

and society. The artist Stanley Cursiter, who knew him well, described the front door as painted a beautiful violet blue, with small round trees on the doorstep in emerald green tubs, and inside a cut-glass crystal chandelier sparkling over his guests. 'He was of medium height and stout, his face was large and round and ran to chins – he wore bright clothes, shepherd-tartan trousers, lemon-yellow waistcoats, cobalt blue scarves. He was very witty, voluble, and boisterous and wrote Rabelaisian verse with great facility.'

As his work became more abstract and less saleable, Cadell moved to less expensive premises, and in 1936 he applied for financial assistance to the Alexander Nasmyth Fund for the Relief of Decayed Scottish Artists. His annual income was given as £280–£300; in answer to the question on cause of present difficulties, he answered: 'Failure of purchases, death of patrons and difficulties with my house in Ainslie Place, since disposed of.'

S.J. Peploe (1871–1935) was born in Edinburgh and trained there, having his first one-man show at the Scottish Gallery there in 1903. A change came over his work when he moved to a new lighter studio in York Place: his dark backgrounds changed to pale greys and pinks, and his still life paintings became notable for the use of white. Peploe's experience in France developed his style to a point too advanced for his Edinburgh dealer, so he put on his own show at the New Gallery, Shandwick Place. He went on to develop his own brilliant and bold colour in landscape, his own individual cool calm authority. His life was centred upon Edinburgh and in 1933 he taught for two terms at the College of Art in Edinburgh, making a considerable impression.

John Fergusson (1874–1961) had a studio overlooking the Firth of Forth where he largely taught himself to paint, but he quickly decided that Edinburgh was too limiting and headed for Paris. He painted impressionistic sketches of *Jenner's, Princes Street, Edinburgh* and *Stanleys, Princes Street, Edinburgh*, with a parade of fashionable ladies outside the shop facades. In 1904 he painted *Edinburgh from Princes Street Gardens*. He liked to work in the half-light of evening, showing an early preference for tonal values and rich colour. The influence of Whistler and his nocturnal paintings was also clear, as well as his 'art for art's sake' philosophy, which espoused the freedom of the artist to please himself first of all, then his public.

One of the most modern-looking paintings of Edinburgh was painted in 1913 by **Stanley Cursiter** (1887–1976). Born in Orkney, he was appointed director of the National Gallery of Scotland in 1930 and became King's Painter and Limner in Scotland in 1948. He was greatly inspired by the 1912 Futurist exhibition in London and painted a series of Futurist conceptions, the most famous being *The Sensation of Crossing the Street – the West End, Edinburgh*.

William Crozier (1893–1930) was a haemophiliac and died young, yet he was an important figure in the development of the Edinburgh school. As well as studying at the Edinburgh College of Art, he studied with the Cubist painter André Lhote in Paris, and his knowledge of Italy and France and their languages was helpful to his friends and contemporaries, notably William Gillies and William MacTaggart. Crozier admired the formal rigour of Cubism and this in turn affected the work of his friends.

He had been attracted to the Mediterranean because of the way the strong sunlight created powerful effects of light and shade and emphasised the solidity of masses. When painting in Scotland he encountered the problem that the Colourists had found: that the northern light didn't produce these strong contrasts between light and shade. The Scottish light softened outlines; the colours tended to merge and blend rather than contrast; there was an all-over effect of colour in the landscape without the sharp definitions that were so much a feature of art in the 1920s.

In his great painting *Edinburgh from Salisbury Crags* of 1927, he succeeded brilliantly in creating a Cubist city. The forms of the houses are simplified, detail pared away to emphasise geometrical shapes. The topography of the view is slightly shifted to keep the strongest interplay of light from the west, emphasising the sunlit fronts of the buildings, deeply shadowed facades and changing levels of roofs. In this painting Crozier is one of the first to interpret Scottish landscape in a modern form.

In 1931 the Society of Scottish Artists invited Edvard Munch (1863–1944) to show in their annual exhibition. His twelve selected paintings caused an uproar, some visitors expressing themselves in abusive terms, others rendered speechless. According to a reviewer in *The Scotsman* there was, however, 'a numerous band who are highly appreciative and who find in the Munch pictures something revealing and stimulating'.

Herbert Read, then professor of Fine Art at the University of Edinburgh, gave a talk on BBC radio, welcoming Munch and stating his belief that Munch's Nordic art, so northern in sensibility, would inspire a new national Nordic school of art in Scotland. The artist William Davidson argued that there already was a Scottish school and that Munch was a very bad model for Scottish artists. Stanley Cursiter, then director of the National Gallery of Scotland, maintained that artists should look to several sources, including Munch, for inspiration and there was no separate Scottish school. In the flourishing artistic climate of the time, the battle for the soul of Scottish art was in full swing. The dominance of the French influence on contemporary Scottish art was no longer unquestioned, but many – Fergusson in particular – argued that there was still a natural and instinctive 'auld alliance' between France and Scotland. He and many other artists continued to head for Paris and the south of France.

William Gillies (1898–1973) was one of those profoundly affected by the Munch exhibition. It came as a revelation to him and he returned to the exhibition again and again, saying that everything he had seen before now seemed tame and spineless. Later he acknowledged that his abiding influences were Nature and Munch. After the Munch exhibition he embarked on a series of landscapes, in both oil and watercolour, that were full of emotion, dark and brooding with echoes of Munch but moving towards a freer, lighter style that was his own. He was later impressed by Paul Klee when Klee's work was shown in Edinburgh in 1934, but Gillies' own character, love of Scottish landscape and enjoyment of life counterbalanced the gloomier influences of Expressionism, and he never became an abstract painter.

Gillies had studied at the Edinburgh College of Art and showed a precocious gift for portraiture. He was called up in 1917 but went back to college after the war. He was considered the *enfant terrible* of his day, but later he found himself at the heart of the artistic establishment, appointed head of painting at Edinburgh College of Art and becoming principal 1960–66. His art did not suffer from his teaching work, as has happened in the case of some other artists, and he continued to paint landscapes around Temple, the tiny village 15 miles from Edinburgh where he lived with his mother and sister from 1939. He ranks alongside Charles Rennie Mackintosh as the leading Scottish watercolourist of the century;

Scott Monument, John Lavery, c.1888 (Clydesdale)

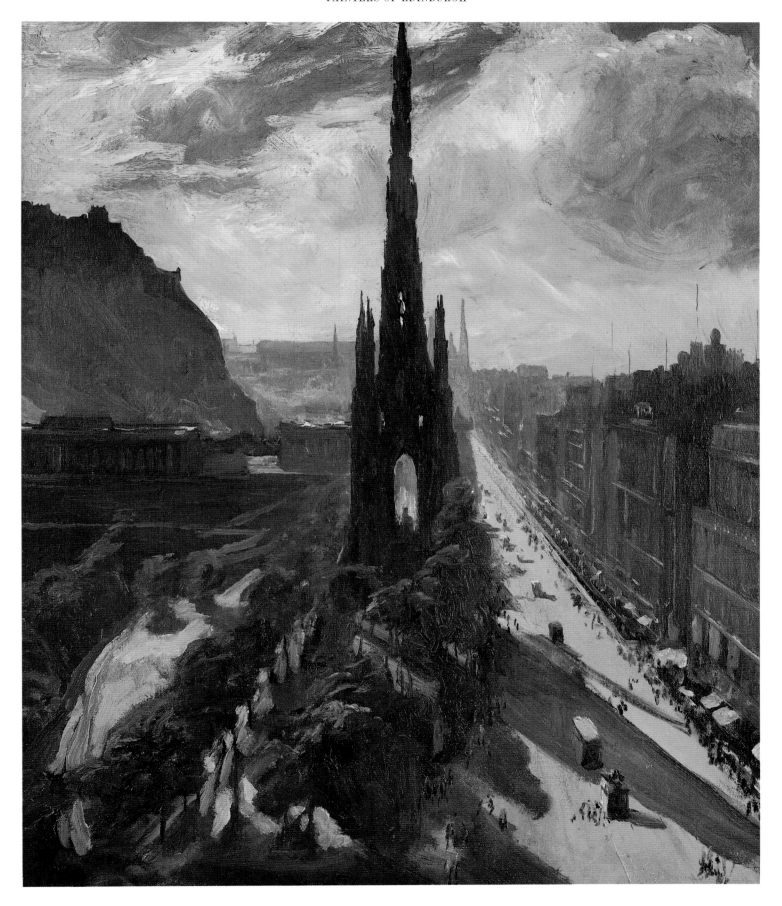

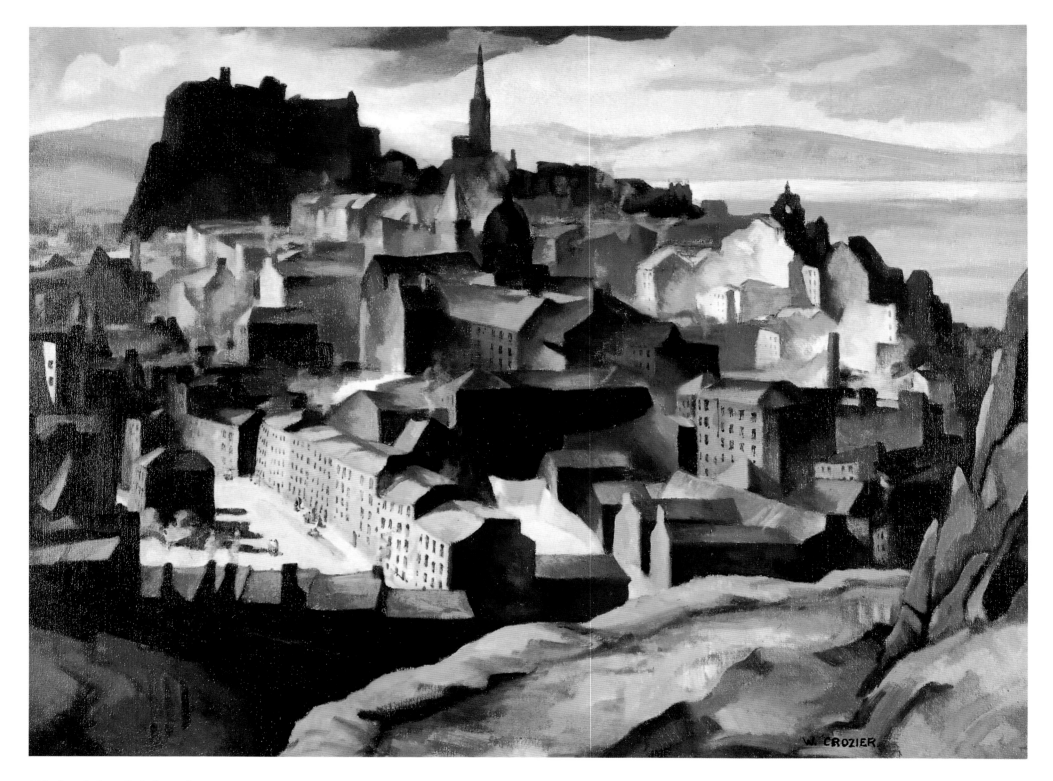

Edinburgh from Salisbury Crags, *William Crozier, 1927*
(Scottish National Gallery of Modern Art)
Crozier creates a Cubist city, simplifying the forms to geometric
shapes. He was one of the first to interpret Scottish landscape in
a modern form.

The Linn, Roselyn Glen, *William McTaggart, c.1890*
(Sotheby's)
Established at Broomieknowe in 1889 where he had a studio
and gallery built, McTaggart often walked to Edinburgh;
he found the landscape he liked to paint close around him.

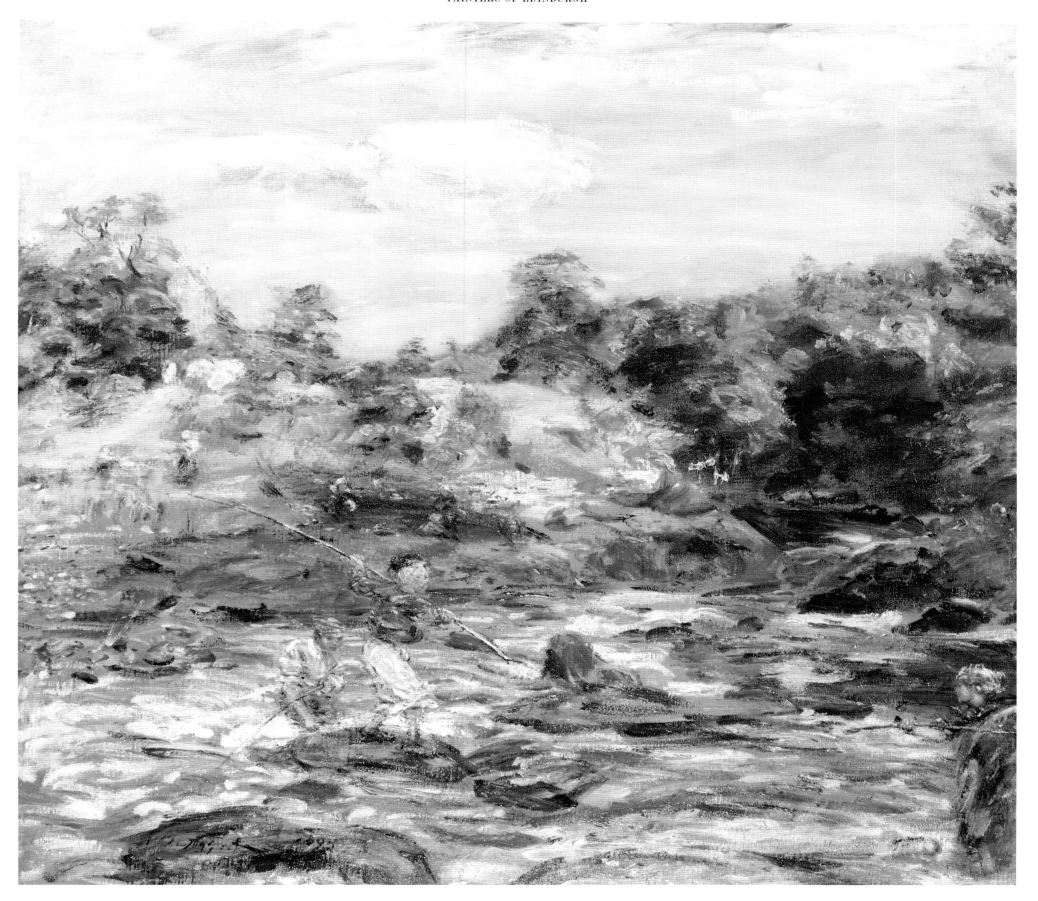

he was dedicated to both teaching and painting, and was heaped with honours including a knighthood in 1970 – one of the most memorable and well-liked of Scottish painters.

Anne Redpath (1895–1965), a contemporary of Gillies, trained at Edinburgh College of Art and moved to the city in 1949. Her flat in London Street became a regular meeting place for her artist friends and was attractively portrayed in the oil painting *Anne Redpath's House, London Street, Edinburgh* by Robin Philipson, a fellow artist and teacher at the college. She was the first woman to become a full member of the Royal Scottish Academy and painted with an exceptional degree of individuality. Her landscapes encompassed her home countryside of the Borders and her travels in Europe, but she never painted Edinburgh. 'She found she had to be distant from her subject to capture its essence,' says her biographer Patrick Bourne.

She was for a time president of the Society of Scottish Women Artists, but later changed her mind about the continuing need for a separate society for women. By the 1960s women had overcome the difficulties of exhibiting in the male-dominated art world by sheer force of talent. A trio of Scottish women artists had made it happen – Anne Redpath, Elizabeth Blackadder and Joan Eardley.

WALKING DISTANCE FROM EDINBURGH

Life is sweet, brother,
GEORGE BORROW, *LAVENGRO*

Broomieknowe, Midlothian, where William McTaggart lived from 1889 until his death in 1910, was seven miles from Edinburgh and he often walked to the city, enjoying the landscape and the exercise.

He had a studio and gallery built at Dean Park in Broomieknowe, with terracotta walls and a barrel roof, excellent lighting and views of the countryside beyond the garden. To this retreat he withdrew, away from the distractions of Edinburgh and the affairs of the Academy which made him impatient (he complained that the meetings always went on too long). He married again after the death of his first wife in 1885, and again enjoyed a happy home life with a young wife and a second family.

His concentration on his painting was so intense that he became notorious for his vagueness, even forgetting his own name. The story is told by Lindsay Errington of how McTaggart encountered two of his own children in the lanes near Dean Park; it was clear 'he felt he ought to know them, for he lifted his hat, but it was equally obvious that he did not really remember who they were'.

At the time he lived at Broomieknowe it was still rural, a deep valley of the North Esk river, with views over farmland and the boldly silhouetted outlines of the Pentlands and the Moorfoot hills beyond. His paintings during the last twenty years of his life reflect his surroundings – *The Harvest Moon*; *Winter, Broomieknowe*; *Hayfield, Broomieknowe*; *Green Fields, Sandy Dean*. He continued to experiment right to the last, and the range and variety of his work was extraordinary. He painted as a poet, with original imagination, with a lyric rapture in landscape, with more sparkle than Constable and, as James Caw his biographer wrote, 'a high sunshiny pitch of lighting and brilliance of colour that made his work unique'. He continued to paint seascapes when he went to Machrihanish or the east coast, but landscape was an equal choice as suitable views were close at hand. He painted winter and snow scenes, remarkable for the light and energy they radiate. Autumn was his favourite season, however, and his autumn landscapes, *The Barley Field, Sandy Dean* and *Harvest Moon*, glow with amber warmth.

In 1901 McTaggart asked his dealer McOmish Dott to organise an exhibition of 32 of his oil paintings in Glasgow, Edinburgh and Dundee, large canvases including *Consider the Lilies*, *The Storm* and *Dawn at Sea, Homewards*. The reason for this change from his usual seclusion and dislike of exhibiting was that he wanted £5,000 for the engineering business set up in 1898 by his son Hugh, which was encountering early financial difficulties. MacTaggart Scott and Company, Mechanical Engineers, was duly lent £5,000 by the artist from the proceeds of the sale (since repaid). Today the firm is proud to acknowledge that its survival as an engineering company was assured by art, and it contributed £5,000 towards the cost of the catalogue of the 1989 William McTaggart exhibition at the Royal Scottish Academy, Edinburgh.

At the time McOmish Dott wrote to McTaggart suggesting that the pictures should be shown in Paris, as there was little commercial appreciation in Scotland of his later work, and that 'Paris wd understand and put a sort of stamp on them & then the other places wd follow'. McTaggart rejected this suggestion with Celtic vigour. Perhaps if his Scottish loyalties had allowed this to happen, however, his work might today be more widely known outside Scotland. Even the impressive 1989 exhibition of his work did not travel beyond Scotland.

Evidently McTaggart himself didn't care about that; he said about his critics: 'They will change, I cannot'. His confidence hadn't wavered since his boyhood days of painting in Kintyre; he just wanted to paint in his own way – and clearly he enjoyed it. His works conveys the strong impression that 'Life is sweet, brother', in fact his last unfinished painting has the title *The Wind on the Heath* from George Borrow's *Lavengro*: 'There's the wind on the heath, brother. If I could only feel that, I would gladly live for ever.'

Broomieknowe today is a quiet and leafy suburban road of large Victorian houses standing in their own grounds behind high gates and stone walls, with little to be seen of McTaggart's landscape and a busy city ring road near.

Travelling a little further from Edinburgh, there is still green and rolling countryside around the tiny village of Temple. William Gillies moved there from Edinburgh in 1939 with his mother and sister. It was a return to the kind of countryside where he was born at Haddington, of fertile farmland and open moor, with the river South Esk cutting through deep valleys and sheep grazing on the austere hills. He said it felt like going home.

He would quote Walter Scott on the beauties of these hills; when he had been 'for some time in the rich scenery about Edinburgh, which is like ornamented garden land, I begin to wish myself back again among my own honest grey hills; and if I did not see the heather, at least once a year, I think I should die'. Gillies became a familiar sight in the countryside on his motorbike, stopping to paint watercolour landscape with quick spontaneous skill, as many as five or six in a day. He was exceptional for his draughtmanship and fluent watercolour technique and his ability to give his pictures a friendly intimate quality with popular appeal. He is well remembered in the area for his kindness, and local people were pleased and proud for him when he was awarded his knighthood.

Temple is still a small village with less than 100 inhabitants living in the row of cottages either side of a minor road, its gently sloping street familiar from so many of Gillies' paintings. Its name derives from the roofless medieval church which was the chief Scottish seat of the Knights Templar before that order was suppressed in 1312. The only other

The Garden – Winter Sunshine, *William Gillies, c.1945*
(private collection)
Gillies moved to Temple in Midlothian in 1939; his home there,
the village and the surrounding landscape provided the subject
matter for his later work.

Temple, 1993.

A stone set in the front wall of this house reads: 'Sir William Gillies 1898–1973 lived and worked here'.

The gently sloping village street is familiar from many of Gillies' paintings.

sign of significance in the village is a stone set in the front wall of one of the cottages: 'Sir William Gillies 1898–1973 lived and worked here'.

Another of Gillies' friends settled in nearby Lasswade, which has now become a residential outpost of Edinburgh, outgrowing the village status it had when William Wordsworth and his sister Dorothy visited Walter Scott and his new bride there in 1798. At Lasswade **William MacTaggart** (1903–1981) freed himself from the long shadow of his grandfather's greatness and painted with a full-bodied colour and conviction that grew out of the association with his contemporaries Gillies and Crozier, long sojourns in France, and the influence of Munch. He was partly responsible for the Munch exhibition that had so much impact on Scottish artists; it was brought to Edinburgh by the Norwegian artist Fanny Aavatsmark, who later became his wife.

In his later years the red soil of East Lothian, north of the Lammermoors, had a special appeal for him, and red pervaded all his paintings in the form of autumn and winter suns, poppies and red earth. He was greatly involved in the artistic life of Edinburgh that flourished after the Second World War, and until his retirement with a knighthood in 1969 was largely responsible for the series of art exhibitions that have enriched the Edinburgh Festival.

RICH HISTORY IN ART

Inevitably landscape artists have been inspired by the wealth of castles, monuments and churches in the area, and the way they enhance the landscape. Ruins of former grandeur have strong appeal, with all the romance of past glories and inspiring deeds still clinging to them. As the stone edifices crumble, arches and broken walls framing the view, the work of man blends with nature and slowly returns over the centuries to its natural form.

The wooded ravines and ruined castles on the River Esk between Roslin and Hawthornden, not far from Edinburgh, have attracted lovers of the picturesque since the eighteenth century. Nasmyth sketched his good friend Robert Burns, a tiny figure in front of Roslin Castle, and the artist's son James Nasmyth described how 'Burns went down under the great Norman arch, where he stood rapt in speechless admiration of the scene. The thought of the eternal renewal of youth and freshness of nature, contrasted with the crumbling decay of man's efforts

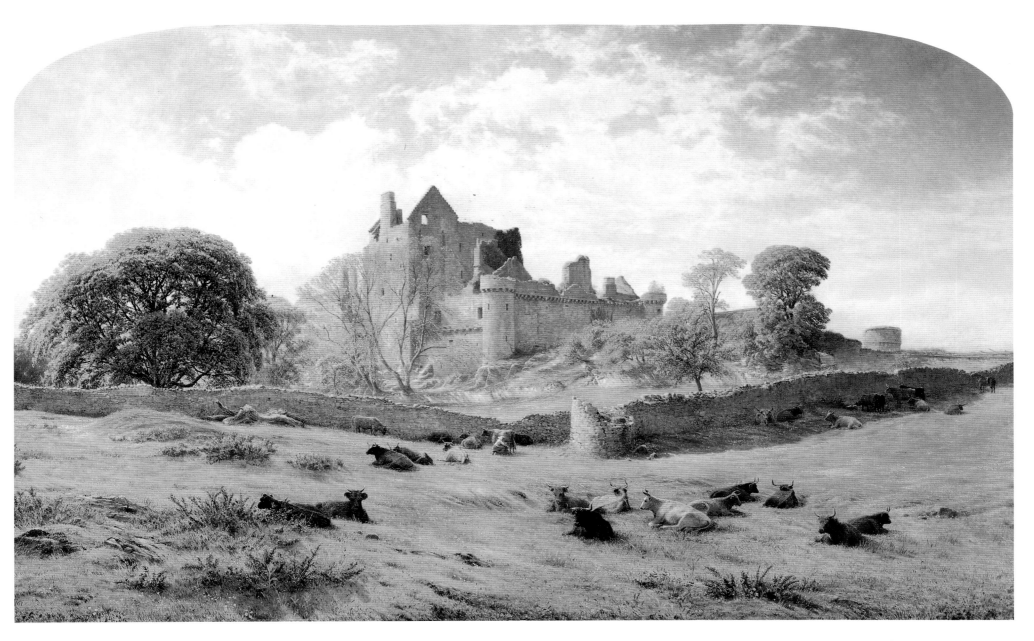

Craigmillar Castle, *Waller Hugh Paton, c.1868 (Flemings)*
Typical of this artist is the wide view of castle walls, stately trees
and grazing cattle, with an arched top to the painting.

Craigmillar Castle, 1993.

The view from Craigmillar Castle towards Edinburgh.

The castle is still well preserved and well cared for, but it is not possible to photograph it from the same viewpoint as Paton chose for his painting: the adjoining field has been sold.

the countryside stretching to the coast and Arthur's Seat in Edinburgh, was one of Mary Queen of Scots' favourite residences. It was here that the bond was signed that Darnley, 'sic ane young fool and proud tirrane', should be 'put off by one way or uther' – with or without her connivance. The castle attracted **Waller Hugh Paton** (1828–1895) who painted the noble ruin on its green hillside. He liked to paint an entire picture on the spot, influenced by the true-to-nature philosophy of Millais and the Pre-Raphaelites, and also by Ruskin's Edinburgh art lectures of 1853 which he attended with his brother Noel.

The two Paton brothers painted in Arran frequently and also in Perthshire, where Millais painted. They were clearly influenced by friendship with Millais, but they could not be persuaded by him to go to London and join the Pre-Raphaelite brotherhood. Noel Paton later turned to religious painting, but Waller continued to paint landscape with accurate detail and dramatic effects of light and sunsets. His painting *Outlet of Loch Achray* is an outstanding example of his ability to capture the lovely light on the water; *The Black Pool, Killiecrankie* has the same warm serenity in the scene. His painting of *Craigmillar Castle*, like many of his pictures, has an arched top and shows a wide view of the castle walls, stately trees and resting cattle, giving the castle a serene look, battles and murders long forgotten.

Visitors to the castle now still find it impressive, despite the modern development creeping towards it, but it is not possible to see the castle from the same viewpoint as Waller Hugh Paton as the adjoining field where he set up his easel has been sold by the Trust responsible for the castle.

Paton's view of the castle is undoubtedly superior to those of the postcard photographs available in the castle grounds. As Ruskin said in 1858: 'Such a lovely picture as that of Waller Hugh Paton's must either speak for itself, or nobody can speak for it. If you scotch people don't know a bit of your own country when you see it, who is to help you to know it.'

Paton was a prolific and popular artist in his lifetime, but his popularity declined with the reaction against Pre-Raphaelite art. More recently the quality of his work has once again been appreciated, and a 1993 exhibition, *Waller Hugh Paton – A Scottish Landscape Painter*, gave great pleasure in St Andrews and in Edinburgh.

to perpetuate his work, even when founded upon a rock, as Roslin Castle is, seemed greatly to affect him… this sketch was highly treasured by my father, in remembrance of what must have been one of the most memorable days of his life.'

Craigmillar Castle, with its far-reaching views of

PAINTERS OF THE EAST COAST

NORTH SEA FISHING VILLAGES

SCOTTISH artists have been attracted to the fishing villages on the east coast because the weather can be seen there at its most spectacular, with winds and stormy seas battering the bare and rocky shores. The coast is studded with tiny protective harbours where the boats find safety and houses huddle in steep streets.

From the villages of St Monance, Pittenweem, Anstruther and Crail in Fife, up the coast to Carnoustie, Arbroath and Catterline, in the last century the herring fleets of trawlers and steam drifters with tall funnels would set out into the North Sea and head north for Shetland or south down the English coast to Yarmouth. The little harbours were always busy and packed with boats then, with all the action attendant on putting out to sea and returning with a good catch or a poor one. The small fishing communities, who took on the sea at its most hostile, mended their nets and made a living.

There are no herring boats left in these harbours now. There has been a long slow decline of the fishing industry since the last war; small operators have had to give way to the big trawler fleets and small harbours such as Pittenweem to large fishing stations like Aberdeen. Recent regulations to conserve fish stocks have meant restrictions on the number of days trawlers can spend at sea, but boats limited to 80 days' fishing a year cannot make a living.

The decline is not apparent at first because there has been some deft cosmetic work along the coast. There are pleasure boats in the harbours today, and money has been spent in the preservation areas to attract summer visitors. The waterside houses have smart paint and a new role as weekend or holiday cottages, while the museums on the tourist trail depict life as it used to be for the fishing community.

The south-facing harbours along the Firth of Forth, with their steep and narrow streets and protecting harbour walls, still have the appeal that makes a good picture. St Monance in particular has the look of a Scottish St Ives, though there are more photographers there with cameras than artists at their easels.

Sam Bough (1822–1878) developed an interest in marine painting during the late 1850s when he was living in Edinburgh and exploring the fishing villages of the Fife coast. He believed strongly in 'meeting Nature face to face', and was one of the pioneers of painting in the open air, armed with a multicoloured umbrella. He often asked local boatmen to take him out, and he would sketch the coast from the sea in an open boat rocking in the swell. He was considered somewhat eccentric, but was popular nonetheless with the fishermen and accepted as an artist portraying the life of the village. His most effective pictures show fisherfolk and labourers on the beach, dumpy figures wrapped up in warm clothes, collecting seaweed or loading carts.

Bough could convey the detail of a busy scene, capture the light off the wet sand and the feeling of a fresh salty wind blowing. Examples of his great powers of observation can be seen in *Pittenweem*, 1874, a painting full of movement, in the tranquil atmosphere and subtle lighting of *West Wemyss Harbour*, and in *Early Morning at Sea*, 1877, a pure study of the light on the water and delicate mackerel clouds above.

His work shows the influence of Turner, and of Horatio McCulloch who was his contemporary and friend, though the two artists later quarrelled. Bough was a man of independence and strong words, and this artistic argument became legendary as it seems the two artists' dogs also took part.

Bough was a cheerful robust character, born in Carlisle the son of a shoemaker, who came to be associated with the Scottish school. He had rebelled against formal education at an early age; he went to London to study engraving as an apprentice and rebelled against that as well, returning to Carlisle on foot. Subsequently he worked as a scene painter in Manchester, where he enjoyed painting the woodland and landscape scenes.

Not getting paid for his work in Manchester because of the failure of the Queen's Theatre, he arrived penniless in Glasgow in 1848 to work in the theatre there and married the opera singer Isabella Taylor within three months of their first meeting. But he seemed unable to settle happily into a job. He preferred the bohemian life, walking mile after mile in the Border country to seek out interesting views to paint, often accompanied by an old Highland soldier called John McDougal, who had fought at Corunna and Waterloo and was a great teller of tales of the Highlands. Bough liked to accentuate his unconventional lifestyle with outlandish clothes, wearing a cloak with a red Turkish turban. He would fall into debt and struggle out of it by selling his paintings for very little; his studio was in a constant state of chaos.

But he was developing all the time as an artist, finding a broad, open style. He established a relationship with Blackie, the publishers, and was commissioned to do illustrations for them for over twenty years. He found friends and patrons and became successful, and ten years after his penniless arrival in Scotland he was earning a living by his painting and becoming one of the most important watercolourists of his day.

He enjoyed success; he was elected to the Royal Scottish Academy and his work fetched good prices, enough for the old bohemian to buy a large house in Morningside, Edinburgh, in 1866.

Bough produced watercolours with particularly effective skies – coastal scenes of calm and tranquillity in moonlight or at sunset, romantic loch-side castles, and night scenes with the moon half-hidden

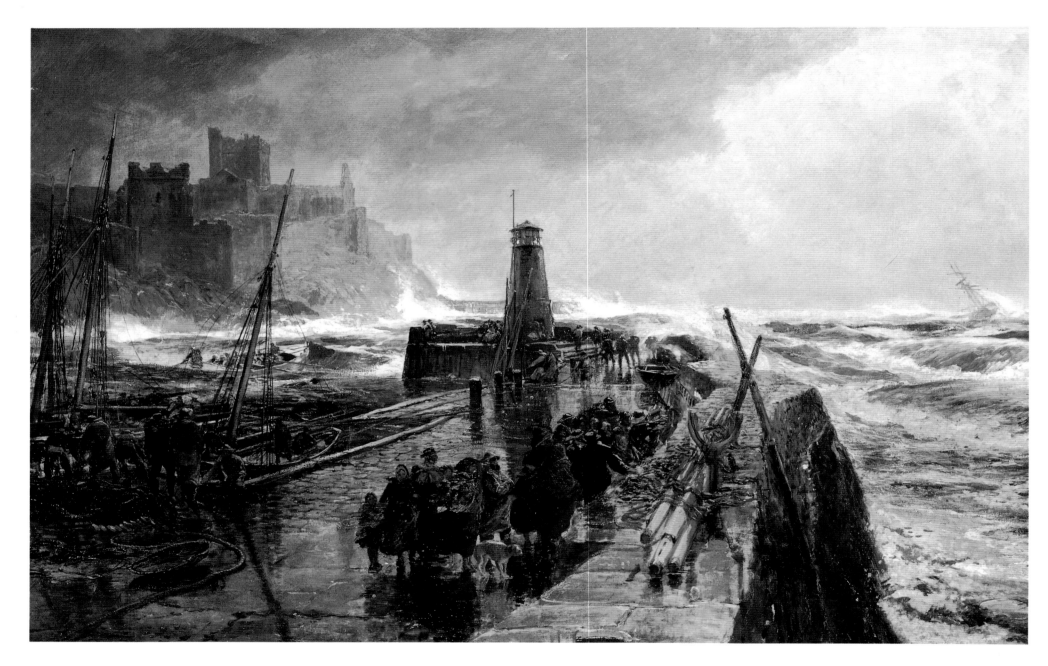

A Fishing Harbour*, Sam Bough, c.1858 (Sotheby's)*
The view is thought to be St Andrews, Fife. Bough made a
speciality of painting the Fife seaports in all weathers, often
working from an open boat just offshore.

The Storm, *William McTaggart, 1890 (Kirkcaldy Museum and Art Galleries)*
The exceptional storm of 1882, when many fishing boats broke up on the rocks and the crews were lost within sight of watchers helpless on the shore, inspired McTaggart's great painting which was begun on the west coast.

behind dramatic anvil-shaped cloud formations, with boats, harbour walls, figures and buildings silhouetted against the night sky – all technically difficult to do in watercolour.

He travelled abroad, painting in the Rhineland and in Holland, as well as in the Lake District; but he always preferred to work in Scotland, saying: 'I wonder at folk going away so much on foreign travel in search of the picturesque, when we ourselves have such fine and varied scenery on every hand.'

William McTaggart worked on the east coast as well as the west, painting the very different seascapes there. He visited Crail, Westhaven and Carnoustie frequently in spring and autumn during the 1880s. He was knowledgeable about boats, and knew the differences between the fishing methods on the east and west coasts and the dangers to which the fishermen were exposed. The tragedies of shipwrecks in tumultuous seas were particularly in the news at that time, with an exceptional storm in 1882. The herring boats from every village on the northeast coast suffered in it; many were driven helplessly towards the land, breaking up on the rocks within sight of watchers on the shore. Those on shore would glimpse the head of the mast as a boat was lifted up by the fury of the ferocious waves, and could see men clinging to the hull as it was buried in a trough of the sea, yet were unable to launch a lifeboat or rescue them.

McTaggart chose this theme for several of his east coast paintings – *After The Storm – The Return of the Missing Boats*; *In the Equinoctial Gales, taking Crail Harbour*, and his masterpiece *The Storm*. This painting was begun in an 1883 version in Carradale, Kintyre, where McTaggart took a house with a view of the west coast, but the dramatic scene portrayed in the 1890 version was realised through his experience of east coast weather and his own imagination.

The fishing village of Crail appealed particularly to **W.Y. Macgregor** (1855–1923) and he took a house there for five months in 1884. Crail, its charter granted by Robert Bruce, had the unusual privilege of allowing trading on the Sabbath. Its wide Marketgate of handsome seventeenth and eighteenth-century houses, well restored, looks remarkably similar to Macgregor's view, *Crail*, of 1884, with the sixteenth-century Tolbooth and its gilded salmon weather vane in the centre. Macgregor, born in Finnart the son of a Glasgow shipbuilder, was one of the leading figures in the Glasgow school. His older status and more resolved style made him the father figure of the Glasgow Boys. In 1878 he spent

the summer with James Paterson, painting on the east coast at St Andrews, Nairn and Stonehaven, and they began using larger brushes and thicker paint.

He encouraged the young artists to be bold: 'Hack the subject out as you would were you using an axe, and try to realize it, get its bigness.' He illustrated his own theory in his painting *The Vegetable Stall*, 1883, one of the major Glasgow paintings, in which the vegetables are almost sculpted with colour. *A Cottage Garden, Crail* is a reflection of the realities of village life rather than the grand panoramas of fine scenery. It is a painting in full sunlight, high in key with clear bright colour. But later Macgregor found himself out of sympathy with the direction the Glasgow group were taking towards decorative art and he concentrated on watercolour painting, distinctive in style with strong charcoal outlines.

Fife also attracted **George Leslie Hunter** (1879–1931), the most unpredictable of the four Colourists. He painted at Largo on the beach, and at Ceres, a village on the left bank of the Ceres Burn. Ceres lies in a fold of the hills, with a village green, an ancient hump-backed bridge over the bright running burn, attractive old cottages and a high-standing church towering like a cathedral. In *Ceres, Fife* Hunter

chose a viewpoint of the church across the cottage gardens; though some trees have grown up, the scene has changed little in the intervening years.

Hunter first visited Fife in 1919, painting *Harbour in Fife*; *Near Largo*; *Sunrise over the Harbour*, *The Beach, Largo* and *Farm Buildings, Fife* in the 1920s. Then, restless and unsettled, still seeking the quality of light he had known in California in his youth, he went off to the south of France.

At this time **William Gillies** (1898–1973) travelled with a fellow student, William Geissler, to France in the autumn of 1923. Considered the *crème de la crème* of Edinburgh students, they found themselves dismissed condescendingly at the *atelier* of the renowned Cubist painter Andre Lhote in Paris as 'accomplished but academic'. Gillies said later that his Paris experience had been a cruel disappointment, but he came back from Paris more inspired by

Ceres, 1993. The trees have grown taller but little else has changed from the viewpoint Hunter chose in the village.

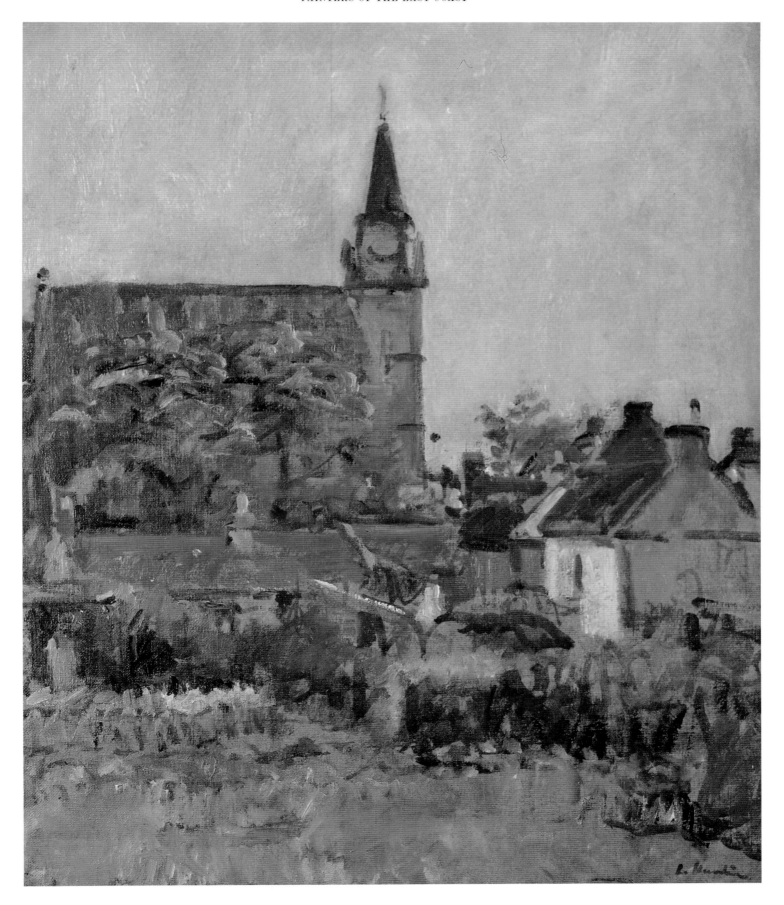

*Crail, 1993. William Macgregor painted **Crail** around 1885; the wide street, with its fine buildings, looks remarkably similar today.*

Derain than by Lhote. Indeed, there is a dash of the bold Fauvist about Gillies' colourful landscapes of the 1930s – when he was living in Edinburgh and painting on the east coast – *The Harbour*, c. 1938, *St Monance*, 1935 and later *Beached Boats*, 1950.

Later he painted frequently at Anstruther using watercolour and ink on paper, producing works such as *Painting the Boat, Anstruther* in 1950 and *Anstruther, from the Harbour Wall*, c. 1948. He said he was particularly attracted to the east coast fishing villages because they had so much weather, with stormy skies dominating the landscape; in fact he found it difficult to paint on clear still summer days, preferring the structure and movement of clouds and the changes in the light. His watercolour scenes are complex and detailed, the intricate lobster nets and rigging on the boats precisely rendered, and he was so faithful to the topography that the views he painted can be identified exactly today.

The painter who identified most strongly with the stormy seas of the north east coast was **Joan Eardley** (1921–1963), who began to paint at Catterline in 1950. This fishing village is situated on a cliff-top ridge, its cottages scattered about on top of the cliff, its little harbour below and the solitary stack of Forley Craig offshore. In 1700 it was regarded as the best creek in the parish and became a notorious smugglers' haunt. As a result, a coastguard watch house was build in 1750. Joan Eardley bought the cottage No. 1 Catterline in 1953 for about £30. It had no water or electricity, but according to her sister that sort of thing never bothered her. Later she bought No. 18 Catterline on the other side of the bay, which did have water and electricity, and from then on she used No. 1 only as her studio. She had a studio in Glasgow, still, but when there were reports of storms on the east coast she would hurry to Catterline to paint, clamping her canvas to an easel held in position by boulders.

Born of Anglo-Scottish parents in Warnham, Sussex, Joan Eardley studied at Goldsmiths College, London, and the Glasgow School of Art, and travelled in Italy and France. She had her first one-woman show in Glasgow in 1949 and then

St Monance, 1993, the tide coming in, the houses smartly painted – a fine village for artists, but no herring fleet is in evidence these days.

St Monance, *William Gillies, 1935 (Bourne Galleries)*
A dash of Fauve influence.

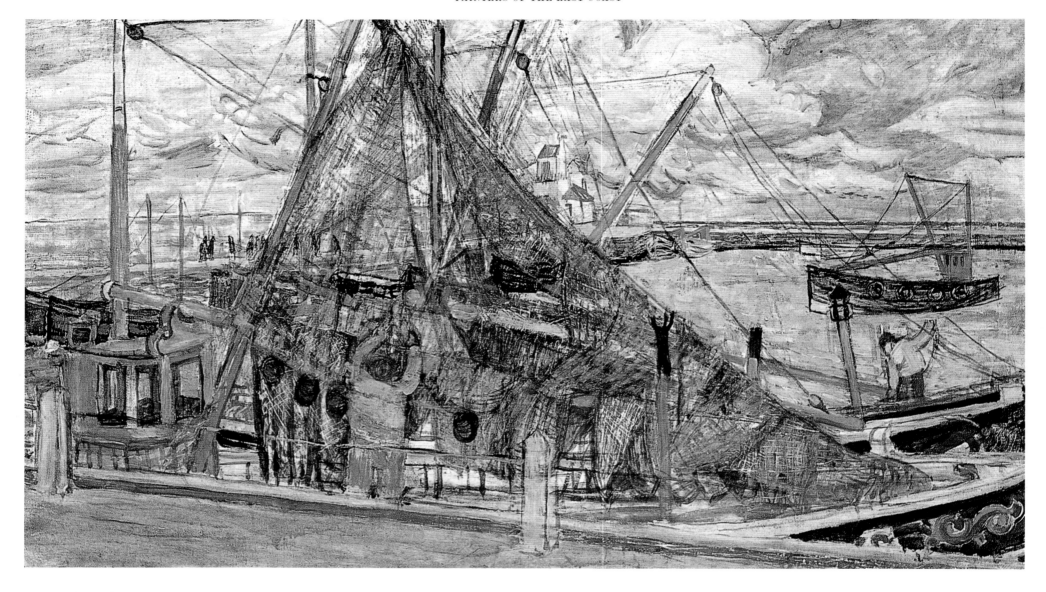

Fishing Boats, Arbroath, Joan Eardley, *(private collection)*
This picture was painted about 1947 and Joan Eardley
presented it to her sister as a wedding present.

Arbroath, 1993. Joan Eardley painted **Fishing Boats,**
Arbroath *from this viewpoint, with the harbour and a windy*
sky seen through a web of fishing nets.

devoted much of her time to painting in the depressed areas of Glasgow, producing haunting portraits of slum children.

In her powerful seascapes painted at Catterline, expressive brushwork and thick paint convey the force of the sea and wind. Her painting *The Wave* of 1961, in homage to McTaggart's painting of the same name of 1881 (see page 55), does not so much look like a wave breaking on the shore as make the viewer feel the energy and movement of the foaming water. Although the mood of the two paintings is quite different, McTaggart's wave breaking gently on the sand at Machrihanish while Eardley's wave crashes on the rocks at Catterline, the two paintings demonstrate how close McTaggart was to the abstract, how far ahead of his time, and how inspiring an influence on Scottish painters.

At Catterline Joan Eardley first began to produce landscapes in chalk and charcoal, powerful studies with much of the force of Abstract Expressionism. She attempted to lose herself in landscape, almost uniting with nature, and some of her oil paintings included collaged layers of earth and vegetation under thick sweeps of paint. *The Wave* was one of her last paintings and like much of her other work, conveys the feeling that life is hard and sometimes too much to bear. The viewer, like the artist, is almost engulfed by the undertow of despair.

Catterline is the present home of the artist James Morrison. He too is attracted by the immensity and force of the North Sea and there is an uncompromising grimness about his paintings of the seascape and the barren land. But above the horizon the great lift of the sky dominates his pictures, making the landscape look insignificant as huge armadas of clouds fill the canvases, surging with life, colour and movement and a wild optimistic freedom.

THE KALEYARD SCHOOL

The monks of Melrose made gude kale
On Fridays, when they fasted,
They wanted neither beef nor ale
As long as their neighbours' lasted.

WALTER SCOTT

Kale or cabbage was the staple diet of the poorer people in Scotland in the eighteenth and early nineteenth century, rather as potatoes were the staple diet in Ireland, though it was not so palatable. It may seem hard to believe they lived on cabbage, but it is confirmed by literature: Here is Walter Scott's Mrs Saddletree, a character in *The Heart of Midlothian*, comforting the hero who has had bad news: 'But ye are no gaun awa, and looking sae poorly – ye'll stay and take some kale wi' us?' A plate of cabbage, it was hoped, would restore and comfort him after hearing the news that the beautiful Effie Deans was imprisoned in the Tolbooth and likely to be hanged.

It has been suggested that kale may have been used as a synonym for dinner, but it does seem that for the poorer people it *was* dinner. Every cottage had its cabbage patch, and when the Glasgow Boys headed for Cockburnspath to paint the down-to-earth reality of country life they found that to live in a rural community was to live among cabbages. And so they painted them.

They adopted a new technique for their new naturalism. Just as they had rejected the grandeur of romantic Highland panoramas, now they turned away from the bold sweeps of colour and painted in chunky square brushstrokes, like a spade piled with earth; instead of majestic purple, they chose earth-brown and cabbage-green and grey. Cabbages brought them success and they were dubbed the Kaleyard school, just as they had irreverently nicknamed their predecessors Gluepots (see page 15). In time the kaleyard became a symbol for honest social realism.

The Glasgow Boys had first come together as friends, battling against conditions that were not encouraging to the younger generation of painters. In 1877 the Glasgow Art Club had rejected applications for membership from four of them – Macgregor, Paterson, Walton and Guthrie – and the artists scattered to work in London and in France. The group in France – Lavery, Kennedy and later Melville – painted at Gres-sur-Loing, taking to the French habit of working in a rural artist's colony, as the Barbizon painters and then the Impressionists had done at Fontainebleau. At intervals they returned to Scotland, keeping up with the work of their friends.

In the summer of 1883, Guthrie set out with Walton and Crawhall for Fife, instead of the familiar painting ground of Brig o' Turk, and not finding anywhere to their liking they moved south to Cockburnspath. This was an area new to artists, though John Thompson and others had painted at Fast Castle and at St Abbs Head a few miles further south on the coast. The Glasgow painters were not looking for an artist's colony, a Scottish Barbizon; but they were followers of Bastien Lepage and his new ideas of social realism in art. They said they wanted to find a place where a painter could be accepted on the same terms as any other artisan in the village, not mending shoes or selling seed-corn, but recording the everyday life of the village where he lived.

The vigorous green shapes of cabbages appear in the foreground of their pictures at Cockburnspath. **James Guthrie** (1859–1930) painted *A Hind's Daughter* in 1883 (a hind being an agricultural worker), in which the girl in the centre of the picture stares directly out of the cabbage-patch, knife in hand, in mid-task, absorbed in what she is doing. The cabbages all about her shine bright and green, in a setting of dug earth and landscape painted with strong colours in an even light. This picture established the Scottish artists' strength and individuality, unromantic and without sentimentality. Guthrie's colleagues followed his leadership, Kennedy painting *The Cabbage Patch*, Spence *In the Cabbage Patch*, and Henry *A Cottar's Garden*. Melville also painted *A Cabbage Garden*, and Hornel depicted rows of cabbages *In The Town Crofts*.

Guthrie was a central figure in the group and the one most closely identified with Cockburnspath. He spent three successful years living and working there, recording the life of the village, and some of his most memorable pictures were painted there: *Schoolmates*; *Fieldworkers Shelter from a Storm* and *Grandfather's Garden*. He was joined in the summer by his friends but stayed on in the village with his mother in the winter when they returned to Glasgow.

He was born in Greenock, the son of a minister of the Evangelical Union Church, and first studied law before turning to art. He moved to London, where a meeting with John Pettie the history painter led to Guthrie coming under the powerful influence of Bastien Lepage, whose truthfulness in dealing with rural life in the Lorraine countryside was the subject of much contemporary discussion. It appealed to the thinking of Guthrie and his friends who rejected the Gluepot school of painting – the mawkish sentimentality of history pictures with a moral – as exploitation of the poor and lacking genuine sympathy.

After a time Guthrie found he was artistically lonely in Cockburnspath during the winter when his friends returned to Glasgow. He became depressed with his work: 'when the light were right, the shadows were wrong, when the shadows were right, the lights were wrong,' he wrote, and in disgust he put his foot through the picture he was working on and decided to give up painting. His cousin James Gardiner received a postcard from him, asking for the University calendar, as he was going to take up

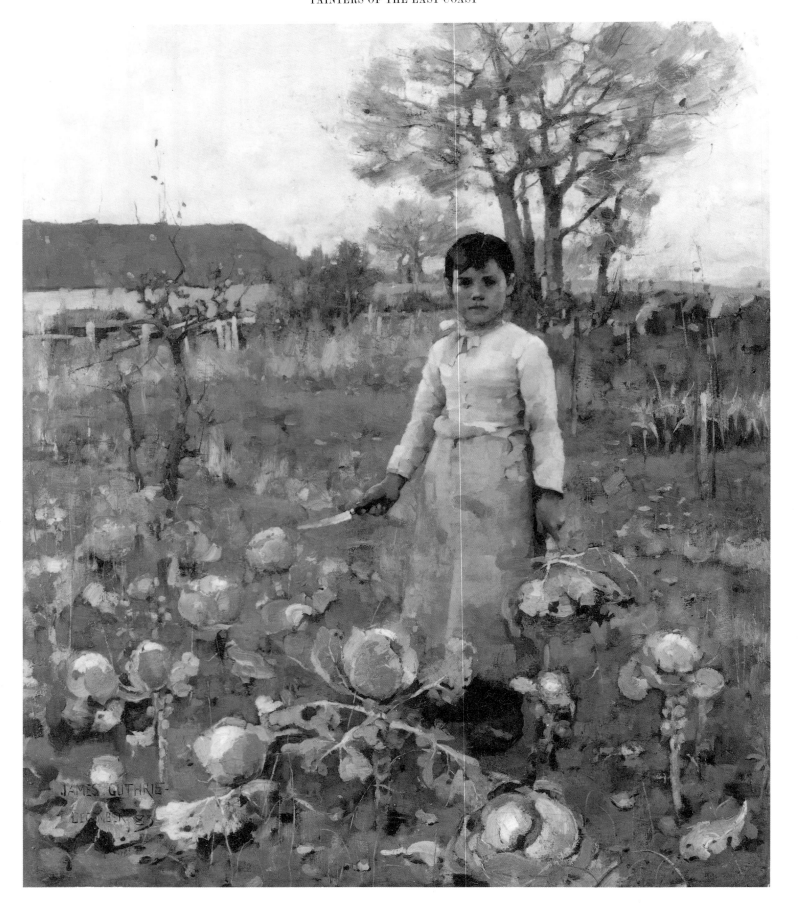

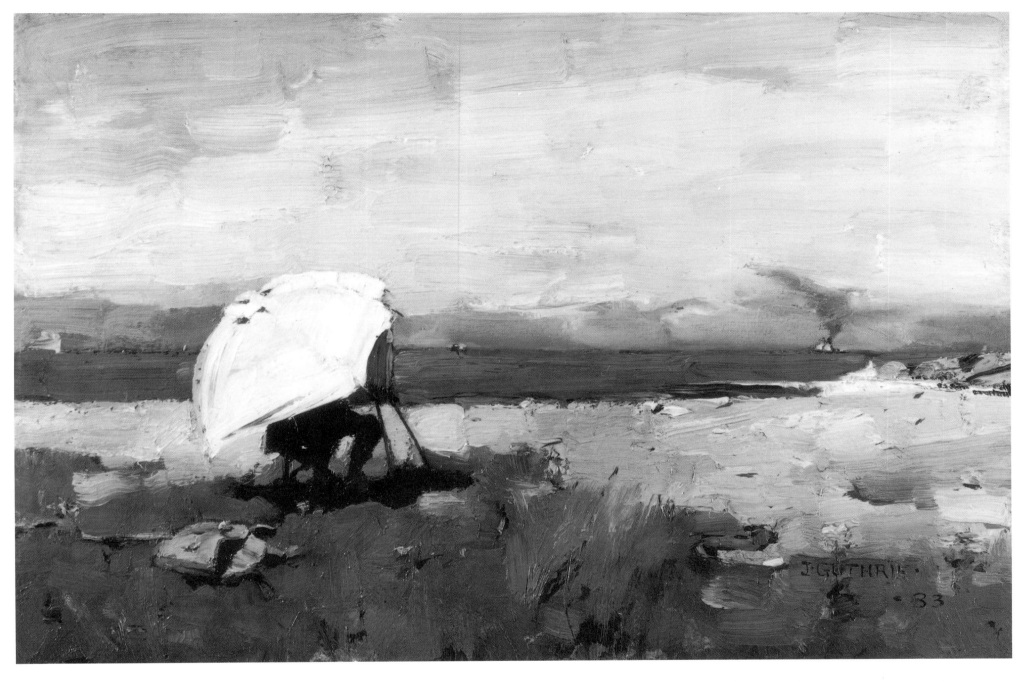

The Hind's Daughter, *James Guthrie, 1886 (National Gallery of Scotland)*
This picture was painted at Cockburnspath and epitomised the new social realism in the painting of the Glasgow Boys.

law or medicine instead. Gardiner managed to dissuade him, however, and got him a commission to paint a portrait of his father. Guthrie returned to Glasgow and successfully launched his assault on the establishment in Edinburgh and London; success came in 1888, with his election to the Royal Scottish Academy and the Glasgow Boys' strong presence at the Glasgow International Exhibition. By the 1890s he was accepted and respected, but his innovative period was past.

The time spent in Cockburnspath was rewarding to the young group at the time when they were

Hard At It, *James Guthrie, 1886 (Glasgow Art Galleries)*
Painting outdoors at Cockburnspath, which became the summer home of the Glasgow painters.

rejected in Glasgow. They were on their own and they had to forge their own way forward. Working together, they were on their mettle, striving to impress each other – a great spur to youthful endeavour.

Walton painted *The Fishing Village – Cove*, a tiny harbour at Cockburnspath; Melville worked on his painting *Audrey and Her Goats*; Henry painted *Noon*,

one of the finest of the Cockburnspath pictures, already showing the bravura and gusto of his future style.

Cockburnspath at that time has been described by James Caw in his biography of Guthrie:

> Cockburnspath, called Co'path locally, is situated some seven or eight miles from Dunbar, in the narrowing belt of cultivated country between the high pastoral uplands of the Lammermoors and the bold rocky coast along the North Sea. Wind-swept and somewhat austere in aspect, but with gently swelling contours running seawards like great rolling waves, and with the woodlands crowding into the deep intersecting deans for shelter, though here and there mustering in groups in the hollows or venturing in thin lines of sentinel trees along the hedgerows, the surrounding landscape has a spaciousness and dignity and a character quite its own… Pends [paths] lead to other cottages in gardens behind, where, on a green knowe to the east, a Pre-Reformation church with squat and narrow round tower stands above a hollow in which a rush-fringed pond twinkles. As a rule quiet pervades the square, for it is off the main road and there are few visitors, but for a few summers in the early 1880s nearly every cottage had an artist lodger and easels were to be seen pitched in the gardens or the square, in the fields close by, or near the little harbour in the rocks below the cluster of white cottages at the Cove, perhaps half a mile away.

Cockburnspath today is little changed – the village turning its back on the sea, grey stone houses, church and cross protected by the hillside from the North Sea winds, and the landscape as austere as ever. The village scarcely gets a mention in modern guidebooks, except for the fact that it was the birthplace of John Broadwood, the piano design pioneer, and that the church has a distinctive round sixteenth-century beacon tower.

The artists have gone – and so too have the cabbage patches. Cabbages are grown in fields now, and the front gardens of the houses in Cockburnspath have neatly edged lawns and well-kept flower beds.

Great events of Scottish history have taken place not at Cockburnspath but at nearby Dunbar, where over the centuries the Scots were defeated in battle,

Cockburnspath, 1993. The village was chosen by the Glasgow painters in the 1880s as a complete break from the romantic Highland scenery. It remains a plain village with its back turned on the sea, set in an austere landscape.

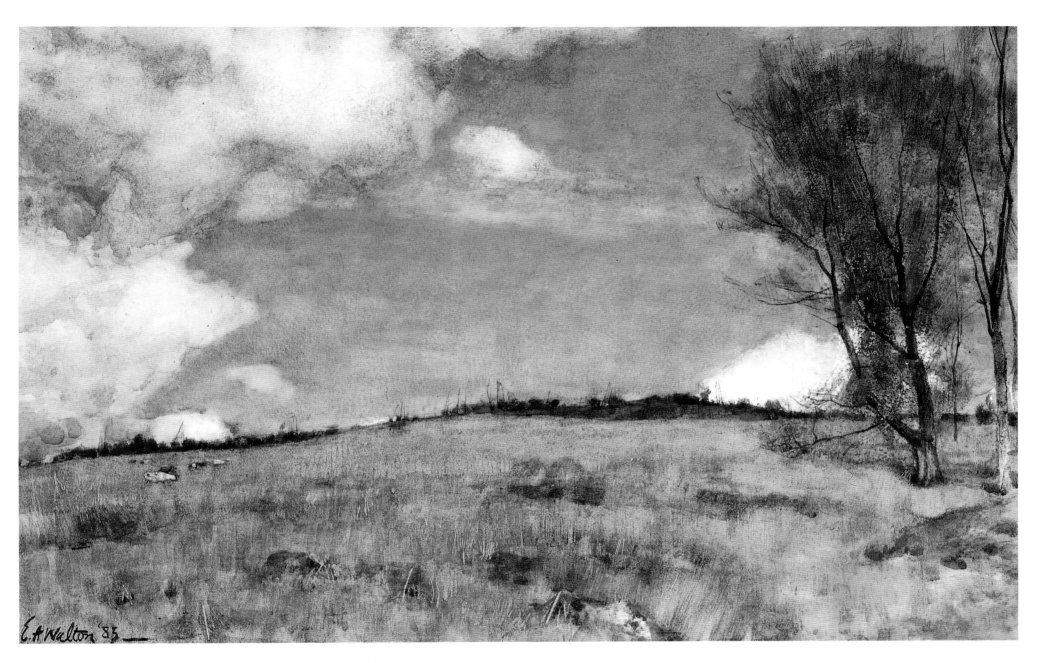

In Springtime, E.A. Walton, c.1887 (Sotheby's)
Walton was one of the Glasgow group of artists painting in the open air at Cockburnspath in both oil and watercolours.

Black Agnes Countess of Dunbar heroically defended the fortress, Mary Queen of Scots took refuge with Henry, Lord Darnley, and Cromwell defeated the forces of Charles II and destroyed the castle, using its stones to improve the harbour.

But just as the rebellious young French painters set up their easels in the glades of the forest and ignored the historic château of Fontainebleau, so the irreverent Glasgow Boys ignored the drama and romance of Scottish history at Dunbar and concentrated their talent at Cockburnspath, immortalising with their art the humble kaleyard.

McINTOSH PATRICK OF DUNDEE

James McIntosh Patrick was born in Dundee in 1907, where both his father and elder brother were well-known architects, and he has lived in Dundee all his life, except for periods of study at the Glasgow School of Art 1924–8 and service in North Africa and Italy during the Second World War. He chose to train at the Glasgow School of Art because he admired the values of Melville, Guthrie, Lavery, Henry and others of the Glasgow school of painters, which he wryly admits to confusing at the time with the institution itself. His early watercolours were in the style of Melville and impressionistic, but a summer vacation working in Provence was the source of his most profound influences – the Italian Quattrocento artists, particularly Piero della Francesca and Mantegna.

McIntosh Patrick made his debut in the flourishing etching market in 1927 and was able to leave art school with an assured income for his work. He produced mostly landscapes of Scotland and Provence, with a strong sense of place and a growing preoccupation with man's effect on his environment, the blending of landscape and architecture.

In the 1930s the boom in etchings declined and Patrick had to look for other ways to earn a living; he taught part-time at the college at Dundee and produced drawings of local landmarks commissioned by the *Dundee Courier*. He returned then to painting and one of his first oils, *The Three Sisters, Glencoe*, 1934, changed his fortunes and his direction, giving him the support of the Fine Art Society, which is still his agent today.

He then began a series of landscape paintings, beginning with *Winter in Angus* – paintings which have, in the words of his biographer Roger Billcliffe, 'become the archetypal icons of the Scottish pastoral

View of the Tay Bridge, 1993, from the wall outside the artist's home in Dundee.

landscape, a landscape that has been cultivated by man for hundreds of years'. Farmers have worked for practical reasons, creating as they do so a landscape whose pattern of fields and hedges, trees and farm buildings never seems threatening or unwelcoming. 'Man-made, not God-made' is how McIntosh Patrick is said to prefer nature. He synthesises his landscapes from a series of drawings and watercolours made on the spot in the countryside around Dundee, assembling his sketches in the studio to get the balance and design he wants.

That he has an unerring visual memory and creates the right balance and pattern is proved by the large number of people who feel that they know exactly the sites of the paintings, and by the commercial success of his paintings in reproduction.

In the 1930s, he painted *Springtime in Eskdale*; *Autumn, Kinnordy* and *Midsummer in East Fife* to complete his four seasons series; these pictures were hung at the Royal Academy in London and consolidated his reputation. There was official concern at the time that the countryside should be recorded as it was, before it was changed by mechanisation and when there was the fear that it could be devastated in war. In England the Ministry of Labour commissioned landscape paintings by Rowland Hilder, Eric

Ravilious, John Nash and others that were a record of rural England, and in his own way Patrick did the same in Scotland.

His painting *Autumn, Kinnordy* had pride of place on the front cover of the 1983 *Landscape in Britain* exhibition in London. He has endeared himself to a wide public by leaving out the telegraph pylons and modern eyesores. 'It's not that I paint what I see, more that I see what I paint,' he says.

Demand for his original paintings outruns supply and there is always a waiting list, while reproductions adorn sitting rooms and living rooms in Scotland and abroad. They are bestsellers in America and the Lord Provost Thomas Mitchell asserts that 'every second expatriate Dundonian probably has a print of his famous *Tay Bridge from My Studio Window*'. Inevitably his success has been held against him; critics have been suspicious that such popularity has been earned by the routine production of pictures that will sell. But this is one of the problems that the successful artist has to face, and McIntosh Patrick working alone, outside the mainstream of modern developments in Scottish painting

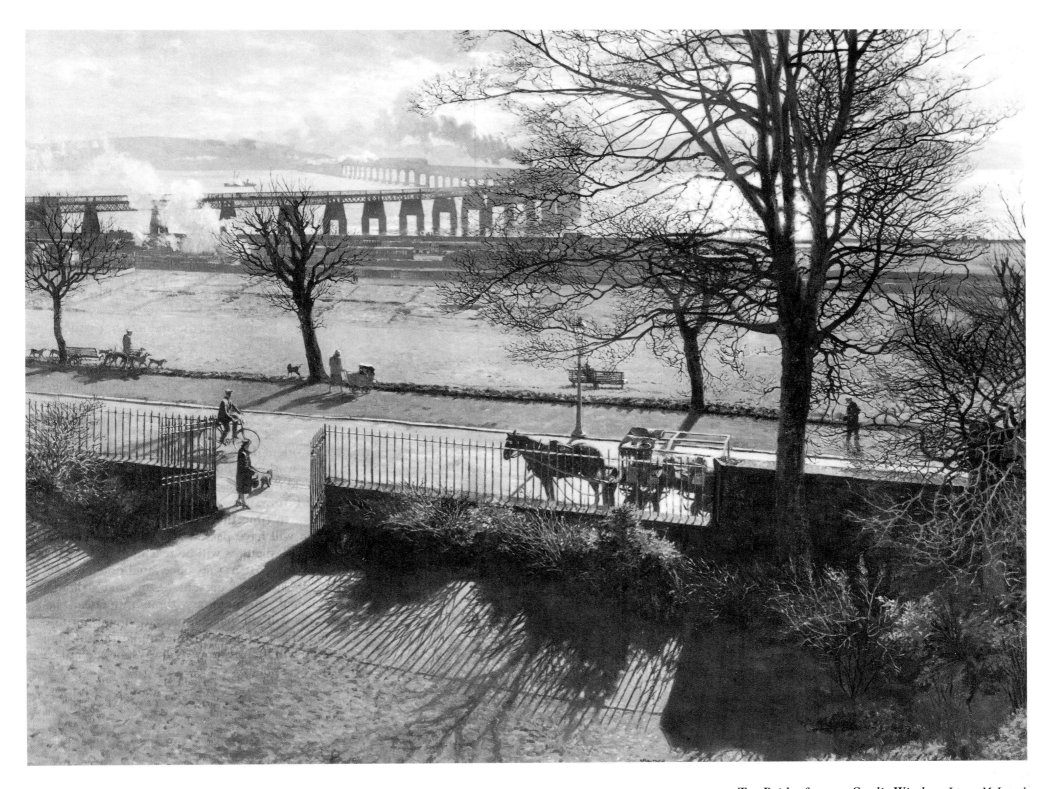

Tay Bridge from my Studio Window, *James McIntosh Patrick, 1948 (Dundee Art Gallery)*

in Glasgow and Edinburgh, has been true to his own artistic beliefs.

All his working life he has held up a frame to the Angus landscape, in all weathers, in all seasons, to paint his own vision of it. In the process he has discovered new techniques and ingenious methods both for keeping his paint fluid and his paper dry and for keeping himself warm, for painting in the open air in a northern climate has not become much easier than it was in the time of Millais.

To drive through the Angus countryside today is to move back to a gentler time and rediscover an unspoilt landscape. Lanes wind over the hills, oaks and elms stand immemorial in the fields where the oyster-catchers fly, farm buildings shelter in the hollows, and in the early summer, hedgerows are full of wild flowers in profusion, including many that are usually seen only in gardens – lupins and azaleas, laburnum and rhododendrons. This is the pastoral world at its most beguiling, just as it is in McIntosh Patrick's paintings.

William Blain, in his introduction to the 1967 McIntosh Patrick exhibition in Dundee, sums up:

> The architectural and engineering influences of his early days have given him an understanding of how mountains hold themselves together, the purpose of trees in the landscape, how fields are formed. Under his fields are a network of drains; they are fields in which farm folks work. His houses have rafters and beams behind the stones and slates; they are lived in. His furrows have been ploughed and sown upon. In time the scenes he has commented upon will have passed away. James McIntosh Patrick's pictures will be teaching men to look at what is past, as they once taught men to look at what was present. Objective though personal, documentary though poetical, his works will still have appreciation and purpose and effect. Honesty in the application of high skill, will then, as now, as always, be seen to be the best policy.

Angus countryside, 1993. All of his working life McIntosh Patrick has painted his own visions of the Angus countryside, leaving out modern intrusions such as white lines on the roads.

Glamis village from the viewpoint McIntosh Patrick chose for his painting in April 1946.

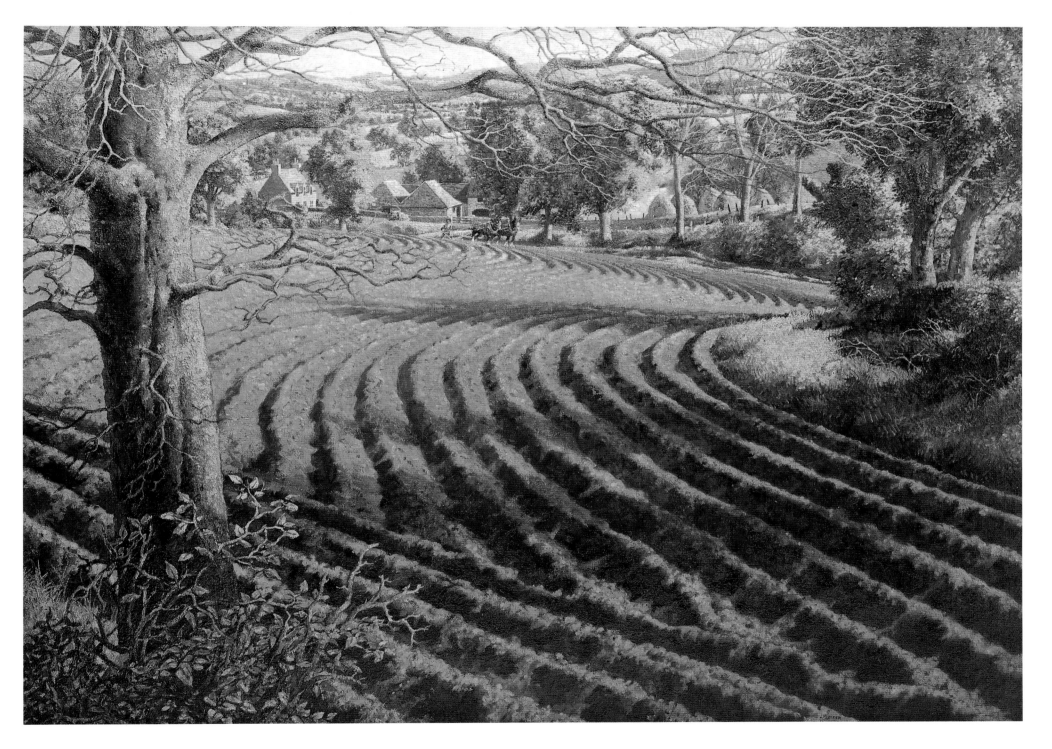

Spring Ploughing, *James McIntosh Patrick, c.1950 (Clydesdale) Scottish pastoral landscape, cultivated by man for hundreds of years, was painted by McIntosh Patrick in a meticulous style that remains extremely popular.*

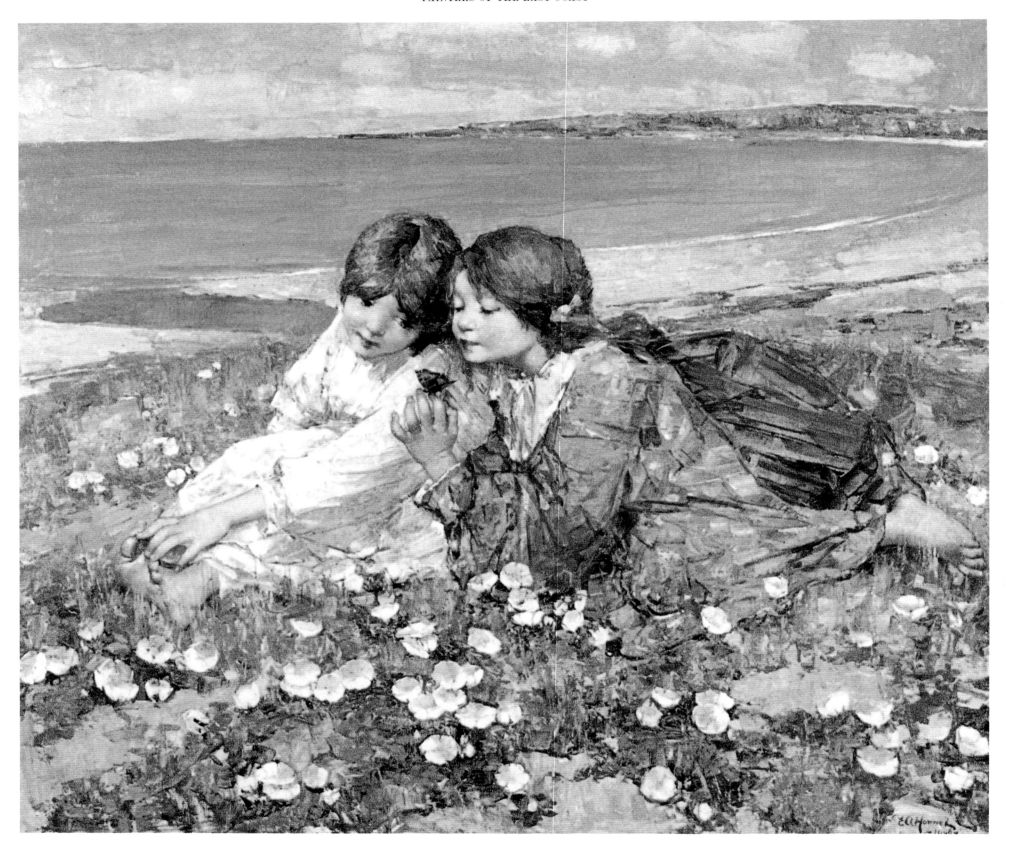

Seashore Roses, *E.A. Hornel, c.1920 (Kirkcaldy Art Gallery)*
Kirkcaldy Art Gallery in Fife has a remarkable collection of Scottish landscape paintings, *benefitting from the generosity of the collector John W. Blyth. This is the most popular of all paintings there.*

SELECTED BIBLIOGRAPHY

Scottish Painting 1460–1990, Duncan Macmillan (Mainstream 1990)

Scottish Painting 1837–1939, William Hardie

Landscape in Britain 1850–1950, Frances Spalding (Arts Council. Hayward Gallery 1983)

The Discovery of Scotland, James Holloway and Lindsay Errington (National Gallery of Scotland 1978)

William McTaggart 1835–1910, Lindsay Errington (National Gallery of Scotland 1989)

The Dictionary of Scottish Painters 1600– 1960, Paul Harris and Julian Halsby (Canongate Publishing and Phaidon Press 1990)

Scottish Watercolours 1740–1940, Julian Halsby (Batsford 1986)

British Impressionism, Laura Wortley (The Studio Fine Art Publications 1987)

William McTaggart RSA, James L. Caw (James Macklehose 1917)

The Glasgow Boys, Roger Billcliffe (John Murray 1985)

The Scottish Colourists, Roger Billcliffe (John Murray 1989)

The Art of J.D. Fergusson – A Biased Biography, Margaret Morris (Blackie & Son 1974)

W.G. Gillies, A Very Still Life, W. Gordon Smith (Atelier Books 1991)

Anne Redpath, Patrick Bourne (Atelier Books 1992)

D.Y. Cameron, The Visions of the Hills, Bill Smith (Atelier Books 1992)

Millais and the Ruskins, Mary Lutyens (John Murray 1967)

Landseer, The Victorian Paragon, Campbell Lennie (Hamish Hamilton 1967)

Scottish Journey, Edwin Muir (Mainstream Publishing 1979; first published 1935)

Summer in Scotland, Ivor Brown (Collins 1952)

In Search of Scotland, H.V. Morton (Methuen 1929)

The Heart of Midlothian, Walter Scott (Melrose edition, Caxton Publishing Co Ltd 1827)

Charles Rennie Mackintosh, Glasgow School of Art, (Richard Drew Publishing 1987)

BIOGRAPHICAL INDEX OF SCOTTISH ARTISTS

Faed, Thomas 1826–1900
Younger brother of John and James, painted emotional scenes from Scottish life that were very successful – *The Mitherless Bairn, The Last of the Clan.* Technically expert and skilful.

Fergusson, John Duncan 1874–1961
Born Leith, studied Paris and settled there, painting portraits in Fauve style. His work reflected interest in music and dance. Returned to Glasgow and painted powerful Scottish landscapes. 46, 47

Flint, Sir William Russell 1880–1969
Born Edinburgh, trained as lithographic draughtsman, had virtuoso technique. Became famous for book illustrations and watercolours of Scotland, France, Italy, much sought-after.

Geddes, Andrew 1783–1844
Born Edinburgh, studied in France after 1814. Established reputation as portrait painter with elaborate historical costumes. Also produced excellent etchings.

Gillies, Sir William George 1898–1973
Born Haddington, East Lothian, studied Edinburgh, graduating in 1922 and forming the 1922 Group. Influenced by Munch; painted landscapes, fishing villages, interiors and still life. 20, 88, 92, *93*, 100, *103*

Graham, Peter 1836–1921
Born Edinburgh, studied Trustees' Academy, painted figure compositions then landscape. Notable success in London with *The Spate* and commission from Queen Victoria. Very popular. 67, *72*

Guthrie, Sir James 1859–1930
Born Greenock, influenced by Bastien-Lepage, became central figure in Glasgow group, painted at Brig o' Turk and Cockburnspath and established new genre with *A Hind's Daughter.* 105, *106, 107*

Harvey, Sir George 1806–1876
Born St Ninians, Perthshire, studied Trustees' Academy. Painted historical and genre pictures, moving Scottish domestic scenes – *Quitting the Manse* – and landscapes.

Henry, George 1858–1943
Born Ayrshire, studied Glasgow, worked with Glasgow group then with Hornel at Kirkcudbright. His most successful innovative work was done there – *Galloway Landscape.* 17, 25, 27

Herdman, Robert Inerarity 1828–1888
Born Rattray, Perthshire, studied Trustees' Academy. Historical paintings and popular Pre-Raphaelite portraits of single girl in a landscape. Watercolour landscapes of Arran and Mull.

Hornel, Edward Atkinson 1864–1933
Born New South Wales, settled Kirkcudbright, worked with Henry and influenced by him. Later developed dense rich colour and patterned landscapes with figures, Japanese style; very popular. 25, *33, 114*

Houston, George 1869–1947
Born Dalry, Ayrshire, specialised in landscapes of Ayrshire and Argyllshire. Skilled at creating atmosphere, seasons, weather, particularly springtime scenes. 59, *60*

Houston, John b. 1930
Born Buckhaven, studied Edinburgh, married fellow student Elizabeth Blackadder. Paints human figure, landscapes and seascapes in powerful colour.

Hunter, George Leslie 1879–1931
Born Rothesay, brought up in California and worked as illustrator there. Returned to Scotland, influenced by Cézanne. Became one of the Colourists, painted Fife, Loch Lomond and south of France. 48, *51*, 100, *101*

Hurt, Louis Bosworth 1856–1929
Well-known in the Victorian times for his large oil paintings of Highland scenes with cattle. 71, 72

Johnstone, William Myles 1893–1974
Born and studied Edinburgh, painted pastels in America then moved to Kirkcudbright 1940. Friend of E.A. Taylor and Jessie King; painted spare delicate landscapes there.

Johnstone, Dorothy 1892–1980
Born and studied Edinburgh, linked to Glasgow group through family and friends. Highly regarded portraits, figure studies – *Cecile Walton* – good eye for fashion and style.

Johnstone, William 1897–1981
Born Denholm, Roxburghshire, studied Edinburgh and Paris, travelled in California, London, Scotland, living rough. Painted abstracts, influenced by Surrealism – *A Point in Time.* 25

Kennedy, William 1859–1918
Born Glasgow, studied in Paris, influenced by Bastien-Lepage, one of Glasgow group working with Lavery. Sense of urban realism evident in his most famous painting – *Stirling Station.*

King, Jessie Marion 1875–1949
Born New Kilpatrick, studied Glasgow. Delicate, individual illustrative style. Also designed jewellery, tiles, fabrics, etc. Married E.A. Taylor, lived in Paris and Kirkcudbright.

Knox, John 1778–1845
Born Paisley, worked in Glasgow as portrait painter. Turned to landscape and is known for panoramic views – *Loch Lomond, Old Glasgow Bridge* and *The First Steamboat on the Clyde.* 70

Lauder, Robert Scott 1803–1869
Born Edinburgh, studied Trustees' Academy, travelled Italy. Painted historical and biblical pictures in London. Became Master of Trustees' Academy, outstanding and influential teacher. 87

Lavery, Sir John 1856–1941
Born Belfast, studied Glasgow and Paris, worked at Gres-sur-Loing. His 1885 painting *The Tennis Party* one of the major achievements of the Glasgow group. Later official war artist. 42, *89*

MacBryde, Robert 1913–1966
Born Ayrshire, studied Glasgow, met Colquhoun and worked together as the 'two Roberts'. Painted mostly still life in angular decorative designs, also lithographs and stage sets.

McCulloch, Horatio 1805–1867
Born Glasgow, worked and lived in Edinburgh. Great love of Scottish Highlands, Western Isles. Colourful fresh approach to landscape, painted on the spot, very popular. *13*, 40, 66, 68, *69*

Macdonald, Frances 1874–1921
One of the group of artists and designers known as the Glasgow Four; married Herbert MacNair, another of the Four. Painted watercolours, often morbid and sad, often with her sister.

Macdonald, Margaret 1865–1933
Sister of Frances, studied at Glasgow School of Art together during time of Fra Newbery, married Charles Rennie Mackintosh. The Four produced watercolours, architectural designs.

Macgregor, William York 1855–1923
Born Finnart, worked Glasgow, ran a life class in his studio which became a centre for Glasgow group. His masterpiece was *The Vegetable Stall*, a major Glasgow painting. 100

Mackintosh, Charles Rennie 1868–1928 Famous for his art nouveau architectural designs and leader of the Glasgow Four. Painted watercolours and finally broke free of architecture to paint landscape, mostly in south of France. 44, 45

McTaggart, William 1835–1910
Born Campbeltown, Kintyre, studied Trustees' Academy. Early work in portraits changed to free atmospheric Impressionist and individual style of landscape and seascape painting of rare quality.
 2, 53, *54, 55, 56*, 91, 92, *99*

MacTaggart, Sir William 1903–1981
Born Loanhead, grandson of William McTaggart, studied Edinburgh. Influenced by Munch, painted landscape, still life and flowers in strong colours and Expressionist style. 94

MacWhirter, John 1839–1911
Born Edinburgh, studied Trustees' Academy, travelled in Europe. Settled in London, established reputation painting Highland landscapes in glowing colour and writing on painting. 15, 50, *52*, 72

Melville, Arthur 1855–1904
Born in Angus, studied in Edinburgh, worked with Glasgow group in Gres-sur-Loing. Travelled to Middle East and developed sparkling watercolour style with special wet technique. 48, *49*

Milne, John Maclauchan 1886–1957
Born Edinburgh, lived near Dundee, worked in France in the 1920s and 30s. Returned to Arran to paint landscape. 50

More, Jacob 1740–1793
Designer of stage scenery and landscape painter. His series of paintings of *Falls of Clyde* were first ambitious Scottish landscapes. Later worked with Ramsay in Rome. *38*, 39

Morrison, James b.1932
Born Glasgow and trained Glasgow School of Art. Landscape painter specialising in north of Scotland and Canada. 80, *81, 82*

Nasmyth, Alexander 1758–1840
Born Edinburgh, studied Trustees' Academy and with Ramsay in London. Influenced by Italian art; early landscapes were classical but became more Scottish and atmospheric, many paintings topographical. *10*, 85, 86

Newbery, Francis Henry 1855–1946
As director of Glasgow School of Art, developed it into leading centre of art training. Encouraged art talent, particularly Mackintosh and friends. Painted landscape.

Oppenheimer, Charles 1875–1961
Born Manchester, studied there and Italy. Lived Kirkcudbright, painted views there and in Ayrshire, in fresh realistic style which was popular. Also painted landscapes in Italy. *28, 29*

Orchardson, Sir William Quiller 1832–1910
Born Edinburgh, studied Trustees' Academy, worked in London with Pettie, painting historical and domestic scenes that were very popular. His best known work was *Mariage de Convenance*.

Paterson, James 1854–1932
Born Glasgow, trained in France. Worked with Macgregor, was part of Glasgow group, then settled Moniaive and concentrated on painting landscapes there. Also worked Edinburgh and Europe. 34, *35*

Paton, Sir Joseph Noel 1821–1901
Born Dunfermline, friend of Millais and painted Pre-Raphaelite subjects, literary and allegorical – *The Reconciliation of Oberon and Titania*. Painted landscapes in Arran with brother.

Paton, Waller Hugh 1828–1895
Brother of Noel. Painted Scottish landscapes on the spot, in Arran and Loch Lomond, popular in his time. Work now being appreciated again. *95, 96*

Patrick, James McIntosh b. 1907
Born Dundee, studied Glasgow and Paris, began as an etcher. Turned to watercolour and oil landscapes of Angus countryside in all seasons; English in style, highly successful. 110, *111*, 112, *113*

Peploe, Samuel John 1871–1935
Born Edinburgh, studied Trustees' Academy and Paris. Early still life and figure paintings. Most successful of the Colourists; worked with Fergusson in Paris, Cadell in Iona. *19*, 28, *31*, 61, *62*, 88

Pettie, John 1839–1893
Born Edinburgh, studied Trustees' Academy, friend of McTaggart. Worked with Orchardson in London, made his name as history painter – medieval, Civil War, Scottish – *The Highland Outpost.*

Philipson, Sir Robin b. 1916
Born Lancashire, lived in Gretna, became a teacher and central figure in Edinburgh group. Influenced by Gillies, painted Expressionist series on cathedrals.

Philip, John 1817–1867
Born Aberdeenshire, son of a shoemaker, determined to be an artist. Modelled his work on Wilkie's genre painting, travelled in Spain. Favourite of Queen Victoria for his Scottish scenes.

Pringle, John Quinton 1864–1925
Born east end of Glasgow, studied art at evening classes. Ran an optical repair shop and painted in spare time. Individual and informal style now much admired. *40, 42*

Raeburn, Sir Henry 1756–1823
Born Edinburgh. Great talent as portrait painter recognised early, became established as the leading portrait painter of the day. Painted groups in a landscape – *Sir John and Lady Clerk of Pencuik* one of the finest.

Ramsay, Allan 1713–1784
Born Edinburgh, studied Rome, Naples, worked in London and Edinburgh. Court painter to George III, international reputation as leading portraitist.

Redpath, Anne 1895–1965
Born Galashiels, studied Edinburgh, married and lived in France. Returned to Hawick and painted Scottish and European landscapes, interiors; influenced by Matisse. 21, *24*, 92

Runciman, Alexander 1736–1785
Born Edinburgh, studied Rome, excelled as history painter. Painted decorative panels for Penicuik House, a landmark in the move from murals to classically based landscape painting.

Scott, Tom 1854–1927
Born Selkirk, influenced by Bough, painted watercolour landscapes of the Borders. Expert on Border history and literature. *22, 23*

Shanks, Duncan F. b. 1937
Born Airdrie, studied Glasgow. Paints Scottish landscape in modern style, exhibits London, France, Rio de Janeiro. 40

Taylor, Ernest Archibald 1874–1951
Landscape painter, etcher, designer. Married Jessie King and lived Paris and Kirkcudbright; friend of Peploe. Established atelier in Paris and art summer school in Arran.

Thomson, John, of Duddingston 1778–1840
Studied art with Nasmyth, moved to the manse at Duddingston and painted the loch in all lights and seasons. Painted with Turner, illustrated Walter Scott's novels. 37

Thorburn, Archibald 1860–1935
Born Edinburgh, artist prodigy. Illustrated *British Birds* 1915–16 and enjoyed great popularity. Lived in London, returned to Inverness-shire each year to paint birds in seasonal landscape. *83, 84*

Walton, Edward Arthur 1860–1922
Born Renfrewshire, worked with Glasgow group. Painted outstanding series of watercolours in Helensburgh. Lived Chelsea, friend of Whistler and Lavery, then returned to Edinburgh. 42, *109*

Wilkie, Sir David 1785–1841
Born Fife, studied Trustees' Academy. Immediately impressed with his ability to draw characters and became known as the Scottish Teniel. Great popular success in London, paintings – *The Reading of the Will*, etc – well known through prints.

Williams, Hugh 1773–1829
Born at sea, studied with Nasmyth, painted watercolours of Scotland, then of Greece. Became known as 'Grecian' Williams, for his Greek views. Popular figure in Edinburgh society.

Index of Places Illustrated

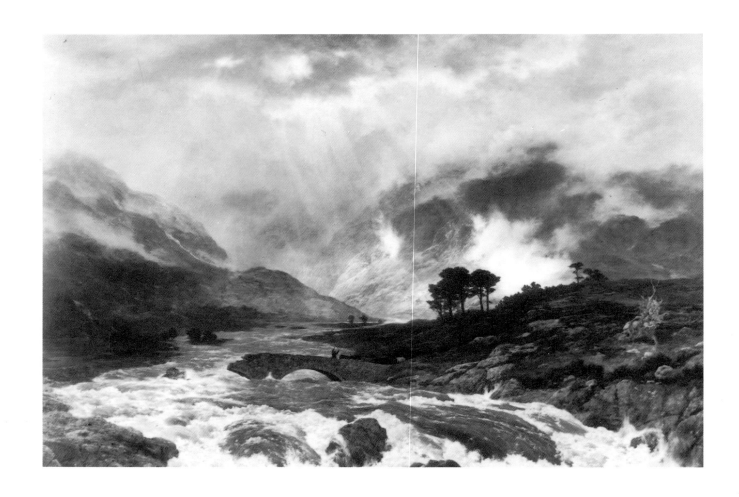